W9-ABH-726

Stepping-Stones

Stepping-Stones

A Journey Through the Ice Age Caves of the Dordogne

Christine Desdemaines-Hugon

Foreword by Ian Tattersall

Yale

UNIVERSITY
PRESS

NEW HAVEN AND LONDON

Published with assistance from the foundation established in memory of Amasa Stone Mather of the Class of 1907, Yale College.

Designed by Mary Valencia.
Set in Minion type by Tseng Information Systems, Inc.
Printed in the United States of America.

Library of Congress Cataloging-in-Publication Data

Desdemaines-Hugon, Christine, 1946–
 Stepping-stones : a journey through the Ice Age caves of the Dordogne / Christine Desdemaines-Hugon ; foreword by Ian Tattersall.
 p. cm.
 Includes bibliographical references and index.
 ISBN 978-0-300-15266-1 (cloth : alk. paper) 1. Art, Prehistoric—France—Dordogne. 2. Cave paintings—France—Dordogne. I. Title. II. Title. A journey through the Ice Age caves of the Dordogne.
 N5310.5.F7D47 2010
 709.01'12094472—dc22
 2009039258

A catalogue record for this book is available from the British Library.

This paper meets the requirements of ANSI/NISO Z39.48–1992 (Permanence of Paper).

10 9 8 7 6 5 4 3 2 1

For my husband, Franck,
our three daughters, Kareen, Maya, and Laura,
and our seven grandchildren,
Léo, Chloée, Jean, Jules, Samuel, Félix, and Jim Roméo

Contents

Illustrations

Foreword

There can be few experiences more overwhelming than encountering, for the first time, the finest of the Ice Age cave paintings of southern France and northern Spain. This art, mind-bogglingly ancient though it is, reaches across the millennia, reminding us that the Cro-Magnon artists who created it were *us* in the most profound of senses. Never before in the long history of human evolution had such art been created, and in its expressiveness and power it has rarely been equaled since. Sometimes miraculously preserved, sometimes sadly faded but eloquent nonetheless, it speaks to something profound and essential in the human spirit.

Of course, the societies to which the Cro-Magnon artists belonged, and the environments in which they improbably flourished, are long gone. Besides their art, nothing remains to tell us about them except the detritus of their everyday existences. Limited as they are, these archaeological traces are ample evidence that the Cro-Magnons had complex, nuanced interior lives, and had forged a hugely complex relationship with the world around them. Clearly, these early *Homo sapiens* were symbolic, just as we are, re-creating the world in their heads in a way no other living organism had or has ever done.

We should not be surprised, then, that Cro-Magnon cave art was evidently far more than mere decoration: that it went well beyond simple aesthetics or literal representation, to embody and explain its makers' view of the world and their place in it. There can equally be no doubt that the very spaces in which it was made possessed a significance to the artists that lay well beyond the mundane. Sadly, though, the material record is frustratingly silent on issues beyond the technical. The Cro-Magnons bequeathed us only the most indirect clues to the systems of belief that informed their

lives and their art; in all likelihood the details of those beliefs are lost beyond recovery.

Still, we are today every bit as curious as the Cro-Magnons evidently were, 20,000 years ago; and when we leave the special places where their art has been preserved, we cannot help but be assailed with questions, answerable or not. Just who were those artists? How did they live? What motivated them? What did their art mean to them? And why did they create it in such mysterious and sometimes spectacularly inaccessible places?

When your head is ringing with such issues, there is no better companion than Christine Desdemaines-Hugon. An archaeologist by training, with a specialty in the symbolisms of small-scale Cro-Magnon "portable" art, she is also the preeminent English-language guide to the Ice Age decorated caves of the Dordogne region. In a quarter-century of sharing these astonishing sites with specialists and the general public alike, she has gained an extraordinary familiarity with them. And over years of personal study, she has developed a subtle understanding of the harmonies and complexities of these unique spaces.

In this book Christine takes the reader to five of the most renowned decorated caves in the vicinity of Les Eyzies, the French "capital of prehistory" on the Vézère River: Font de Gaume, Combarelles, Cap Blanc, Rouffignac, and Bernifal. This judicious choice runs the gamut: vast interiors and intimate ones; caves and rock shelters; polychrome paintings and delicate engravings; bas-reliefs and finger tracings; bold animals and obscure geometric symbols. Christine's accounts resonate with her affection for these ancient Ice Age haunts, each so different from all the others. Her descriptions are suffused by her intimate knowledge of the images, and of the places they adorn. And her interpretations are informed by her unique way of seeing with the eyes both of an archaeologist and of an artist.

Stepping-Stones is the culmination of many years of thought and experience, and consulting this remarkable book before visiting any of these Ice Age sites will add immeasurably to the experience of novices and seasoned aficionados of Paleolithic art alike. But beyond this, the book is a tour of the entire late Ice Age, weaving in a wealth of information from sites all over Europe to produce a remarkable tapestry of the Cro-Magnon world.

Of course, Cro-Magnon art is ultimately more to be experienced than

explained. Nothing can compare to the experience of standing in front of one of these extraordinary works and absorbing its mute power. Nonetheless, a sensitive and knowledgeable guide can add vastly to the viewer's experience (or even if need be, substitute for it), precisely by showing what can be explained or discerned, and what cannot. Nobody does this better than Christine Desdemaines-Hugon.

Ian Tattersall
American Museum of Natural History, New York City

Preface

This book is a personal approach to Paleolithic cave art and, more generally, an ode to our ancestors' intelligence and creativity. It is inspired by my long-time wish to share with others the cave experience as a whole and Ice Age art in particular, in all its complexity and subtlety. Although we do not know what reasons lie behind the art, we still have the immense privilege of being allowed to see it and measure the extraordinary talent and sensibility of Cro-Magnon artists. What readers will discover in the cave art will bring them into contact, in an immediate and tangible way, with people who lived in the Vézère Valley some 14,000 years ago, people just like ourselves. The gradual recognition of the fine quality of the painting, engraving, and sculpting techniques—which haven't changed since—will allow the readers to imagine the hand at work. The subtlety of line and shading, the individual character and expression of each animal, the gentleness of the animals' manner, the vast realm of schematic and nonfigurative imagery will open up new perspectives in the approach to the mind and spirit of these early modern humans.

The reader is taken on a journey in time, slowly, step by step, through five major Ice Age art sites, each of which is open to the public, each with its own individual character and magical beauty.

One of the reasons why I embarked on this account is that I find it unfortunate that so much is written about caves that are closed to the public (Lascaux, and the recently discovered Cosquer, Chauvet, and Cussac caves), whereas there are marvels nearby that are accessible. As a result, most people are convinced that only a privileged few can actually see the real thing. I'm hoping that this book will offer new perspectives for those who wish to delve deeper into the origins of human creativity. For this, I furthermore propose a parallel exploration of another kind: a description of the evolution of human-

kind, from our 6 million–year–old African origins to the remarkable Upper Paleolithic cultures that flowered between 40,000 and 11,000 years ago, descriptions of the first tools and their growing sophistication, of the oldest habitations and the earliest burials, of the Neanderthal populations and their disappearance, of Cro-Magnons' arrival from Africa and their expansion, of the dawn of artistic expression and the wealth of cultures that subsequently developed all over the European continent.

Another reason to have written about those distant times is to dispel some common prejudices on the subject. The descriptions of elaborately decorated bone tools and weapons, of the fine needles and the thousands of beads, pendants, and other forms of body ornament, will enable readers to picture these tall, handsome Cro-Magnon people as altogether different from the popular caricatures of them. By appreciating the symbolic and abstract content of their art, readers will become aware of the complexity of beliefs and traditions, which will take them beyond a first-degree pictorial interpretation of the art.

I have dedicated several chapters to the remarkable engraved designs on stone, bone, and antler objects. Thus the reader can measure the wealth of cultural expression during Paleolithic times, not only cave art but also "portable art," found for the most part at habitation sites. Hundreds of everyday objects, including tools and hunting weapons, are decorated with motifs of all sorts, from detailed animals and stylized humans to geometric designs. There are beautiful statuettes, and also countless random fragments of stone, bone, and antler covered with engraved images. The profusion of these elaborate portable art forms will give the readers some insight into the cultural sophistication of Paleolithic societies and the time they had available for such prolific creative activities.

I briefly discuss my own research in this domain, with results that evolved far from my original focus. The structural analysis of the designs on bone and antler objects (of similar proportions) took a surprising turn: I discovered that the distribution of the designs differed according to the function of the object. The design on a spear's shaft, for instance, does not have the same graphic structure, or distribution of components, as that on a chisel of similar shape and size, nor of that on a semicylindrical rod. Even from a fragment, I can now identify the object thanks to these graphic distinctions.

This shows that even personal objects were subject to rules and traditions as far as their decoration was concerned, thus revealing, in turn, the existence of strong societal conventions.

The four caves and one shelter that I have chosen to describe belong to the same Magdalenian cultural epoch, and are situated in the Vézère Valley in the Dordogne (France), close to Les Eyzies, where Cro-Magnons were first discovered. A chapter is dedicated to each one: Font de Gaume cave for its magnificent polychromatic paintings, Combarelles for its network of hundreds of delicate engravings, Rouffignac for its finger-drawn designs and wonderful representations of more than 150 mammoths, Cap Blanc for its sculpted frieze of horses and bovids—including a spectacular life-size horse—and finally Bernifal for its more secretive work. At first glance they all seem so different—the caves themselves varying considerably—yet the reader will soon be aware of how much they have in common, despite the several thousands of years that they cover: the restrictive subject matter and recurrent themes, the figures' interrelations, and certain complex symbols and stylistic options, for instance.

I make a point of describing the imagery in as much detail as possible in order to enable the reader to imagine the figures on the walls, dancing in the wavering light of grease lamps—and to visualize the itinerary within the cave as well, a profound initiation in itself. My emphasis on the complexity of certain panels, of the figures' interactions—seemingly random but not so—of the juxtaposition of figurative and nonfigurative subject matter, and of their integration with the cave walls themselves—will allow the reader to grasp the impossibility of understanding the meaning of it all in the absence of any written record.

One aspect of the art that is rarely mentioned but which I stress because it strikes me as particularly remarkable, is how modern it is, how close it is to contemporary art forms. The reader will be surprised, for instance, to see how cleverly the artists found ways of representing movement, with trompe l'oeil effects such as perspective (unequaled again until the Renaissance), three dimensions, and even cubism! Picasso himself saw true masters at work here. Even more spectacular are the deliberate forms of stylization and abstraction, which are reminiscent of twentieth-century art. Matisse's line drawings, Dubuffet's meandering abstract designs, Braque's cubism, Bran-

cusi's sculptures, and Chagall's joyful whirling parades, to name but a few, are in the back of one's mind throughout the journey. A journey that brings us unexpectedly within arm's reach of Ice Age modern humans: through their art, we feel akin to them, we perceive an intelligence and a sensibility similar to our own. And time becomes irrelevant.

Could it be that the expression, and the recognition, of beauty is, in essence, intemporal and universal? *Stepping-Stones* is a book for all readers, particularly for those who care to venture on paths that might bring them a little closer to understanding something about past (and present) humanity.

Acknowledgments

For all that I have learned over the years, many thanks to my professors at the University of Bordeaux I, including Jean-Phillippe Rigaud, Henri Laville, Jean-Marc Bouvier, Françoise Delpech, and André Debénath for the archaeology; Bernard Vandermeersch, Henri Duday, and Eric Crubezy for the anthropology; and Michel Lenoir, Jean-Michel Geneste, and Harold Dibble for the flint technology. As part of our course, we had the experience of excavating the 350,000-year-old site of La Micoque, in a frost-covered Vézère Valley (and were rewarded by exceptional finds and steaming platters of roast chicken and potatoes that André Debénath went all the way into town to fetch us for lunch), which irresistibly anchored me in the field of archaeology for evermore.

To Jean Clottes for his guidance during my first thesis.

To archaeologists who have offered their friendship and steady support over the years, especially Georges Sauvet, Jean-Luc Piel-Desruisseaux, and Michel Garcia, for the countless times we have talked about the art, the caves, and symbolic expression. The inspired ideas of others, such as Alain Roussot, Michel Lorblanchet, Denis Vialou, Gilles and Brigitte Delluc, Geneviève Pinson, Gilles and Carole Tosello, and Denis Taux, put them high on the list of those who have contributed in one way or another.

To the owners of certain caves who have shared their treasures with me: Jean, Marie-Odile, and Frédéric Plassard at Rouffignac, Robert Bégouen at the Volp caves, Yvon Pémendrant at Bernifal, and the unforgettable Monsieur Lapeyre at La Mouthe cave.

To the local cave guides of Font de Gaume and Combarelles, with their intimate knowledge of these caves.

To Colette Dulluc, for her help in the bookshop of Font de Gaume.

To René Castanet, owner of the Castelmerle sites in the Vézère Valley, for all the wonderful moments spent in his wise company, learning how to make flint tools, visiting his museum, and hearing his vivid stories about the past. He and his family are, to my mind, the true guardians of the Valley.

I am deeply grateful to the following people who have contributed to the accomplishment of this book:

To Ian Tattersall, who encouraged me to write it in the first place, and whose unfailing support and precious advice have not ceased since.

To my first three readers: Madeleine Boogerman, my sister Maureen Luden, and Michelle Press, for their warm and constructive responses.

To the reviewers for their judicious comments.

To my friends Elisabeth Heseltine, Claude and Michèle Braunstein, and Hélène Mackenzie-Peers for their invaluable help with, respectively, editorial assistance, maps, and computer work.

To the Musée National de Préhistoire's staff, especially the curators Jean-Jacques Cleyet-Merle and Alain Turc for their support, Jacqueline Angot-Westin for her help in the library, and Philippe Jugie for his photographs.

To Alain Roussot, Thierry Raimbault, and Norbert Aujoulat at the Centre National de Préhistoire for their photographs. (Uncredited photos in the book are my own.)

My very special thanks go to Jean Thomson Black, whose prompt response, efficiency, and open-mindedness have made this publication come true.

And to my husband, whose loving encouragement and good cooking have accompanied my efforts through the years that it took to complete this book.

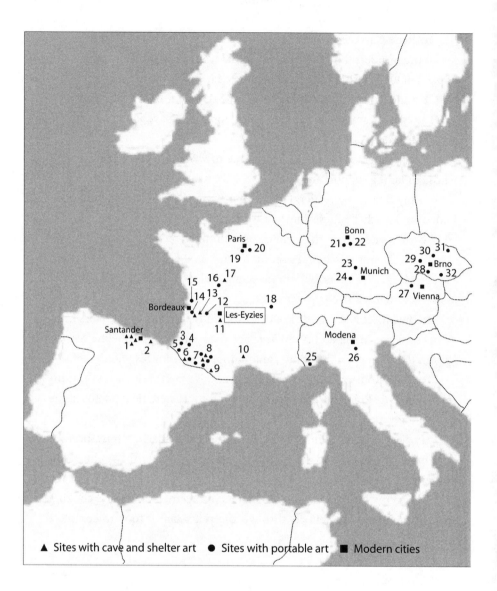

Map of the Upper Paleolithic sites discussed in the text

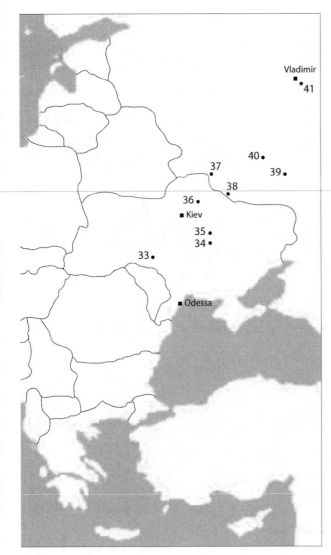

1. Altamira
 Monte-Castillo caves
 Hornos de la Pena
 El Pendo
2. Covalanas
3. Duruthy
4. Brassempouy
5. Isturitz
6. Labastide
 Gargas
7. Arudy
 Espélugues
8. Volp caves
 Maz d'Azil
 Gourdon
 Lespugue
 Bedeilhac
 Montespan
9. Niaux
10. Chauvet
11. Pech-Merle
12. Le Morin
13. Le Gabillou
14. Pair-non-Pair
 St Germain-la-Rivière
15. St Césaire
16. La Marche
17. Roc-aux-Sorciers
18. Solutré
19. Etiolles
20. Pincevent
21. Andernach
22. Gonnesdorf
23. Holenstein-Stadel
24. Vogelherd
25. Grimaldi
26. Savignano
27. Willendorf
28. Dolni Vistonice
29. Brno
30. Predmosti
31. Petrkovice
32. Moravany
33. Molodova
34. Meziritchi
35. Dobranichevka
36. Mezine
37. Eliseevitchi
38. Avdeevo
39. Kostenki
40. Gagarino
41. Sungir

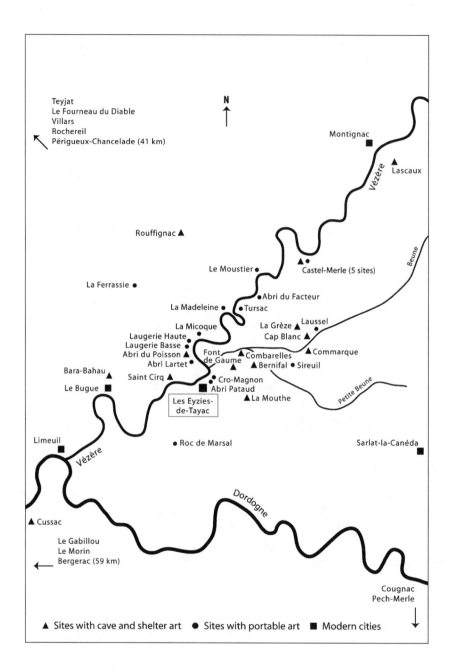

Map of the Vézère Valley and nearby sites discussed in the text

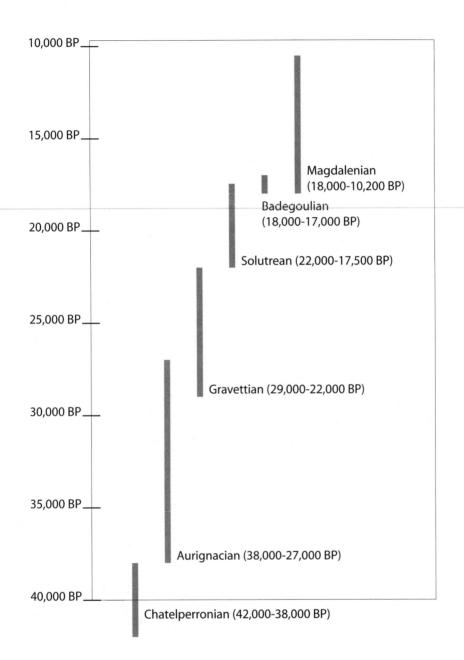

10,000 BP	
15,000 BP	
	Magdalenian (18,000-10,200 BP)
	Badegoulian (18,000-17,000 BP)
20,000 BP	Solutrean (22,000-17,500 BP)
25,000 BP	
	Gravettian (29,000-22,000 BP)
30,000 BP	
35,000 BP	
	Aurignacian (38,000-27,000 BP)
40,000 BP	
	Chatelperronian (42,000-38,000 BP)

Approximate chronology of the Upper Paleolithic. Note: BP is before present.

Stepping-Stones

Freshly Plowed Fields in the Vézère Valley

The first time I held a Mousterian flint sidescraper, I was overcome by a wave of sympathy and admiration for its Neanderthal creator, some 75,000 years old. The perfectly shaped tool fit naturally in the palm of my hand, the curved, finely flaked working edge neither too sharp nor too blunt, ready to do its job, possibly scraping hides.

This was about 25 years ago. I was with the curator of the Musée National de Préhistoire in his garden overlooking the Vézère River, where he had spread out hundreds of Mousterian stone tools for me to sort. This was his way of introducing me to the complexity of flint technology. As I labored, separate piles of similar types of tools gradually emerged: those with scraping edges, notched or denticulated (with wide serrations), those that were pointed, sharp as a blade, thick or thin, large or small; those that were simple flakes with no chipped retouches; those, on the contrary, that were finely shaped on certain edges; and, finally, bifaces, fully flaked on both sides.

I learned that you judge a tool not by what it looks like but by what it can do. At first glance, most of these didn't look like much, but they were good

tools (as we know from experimental replicas that have demonstrated their efficiency), which is probably why they didn't change much during the more than 250,000 years of the Middle Paleolithic.

Not long after, searching over our recently plowed fields, my eldest daughter, Kareen, who was about 10 years old at the time, ran excitedly toward me, proudly holding a superb Levallois point, certain that she had found some exceptional treasure—and she had. The texture of the cream-colored flint, usually hard and shiny, had become chalklike and fragile inside with time, and I could see where a tiny notch had been made by the plow (Fig. 1). Levallois technology, at least 250,000 years old, is a brilliant way of making the best and most economical use of flint, by planning and predetermining a series of tools layer after layer, in contrast to improvised or opportunistic production.

My three daughters and I regularly enjoyed hunting for tools over the freshly overturned earth washed by the first heavy rains. Heads low, we methodically scanned the surface backward and forward, boots heavy with mud, picking up flint artifacts of all kinds, not only Mousterian but also Neolithic.

I imagine Neanderthal hunter-gatherers living where I live now, camping out in the open more than 75,000 years ago. Under a nearby vaulted cliff shelter called the Roc de Marsal, they buried a young child, who left the best-preserved Neanderthal child skeleton found so far in Europe, now exhibited at the Musée National de Préhistoire in Les Eyzies (Dordogne). At least 70,000 years later, only a few thousand years ago, agricultural Neolithic communities settled in the same place, both cultures leaving behind surprisingly similar stone artifacts. Of course, the Neolithic period is known for its superb polished stone tools, but basic, more common techniques remained virtually unchanged.

Elaborately made artifacts are rarely found intact in the fields here around my home. But I have one such find, discovered one evening as I was hiding behind tall grasses, hoping to see some deer. Instinctively, my hand felt blindly around the base of the tall stems and came up with an equilateral triangular Mousterian biface. It is elegantly flaked on both sides, flat and slender, its edges each measuring 9.5 centimeters, its elaborately worked surfaces and balanced proportions making it look more like a work of art than

a tool or weapon. Unfortunately, the plow that had surfaced it had also broken off a small portion of one angle, and the altered chalklike inner section contrasted with the shiny cream-colored worked surface (Fig. 2). For years, I had searched for such a piece without success, and there it lay, meant to be found.

Only recently did I learn that this biface was made out of flint from Bergerac, more than 40 kilometers away, and that the Levallois point found by my daughter in the same field is of the characteristically veined flint from the vicinity of Bélves, 15 kilometers distant. It's strange that the only two remarkable pieces that have surfaced in my fields are both made out of non-indigenous material and were found in parts of the field that are far from those abundantly filled with more ordinary artifacts.

Years later, my anthropology studies at the University of Bordeaux opened the doors to prestigious collections that I had always dreamed of seeing. In the quiet of dusty museum rooms, studying the carved designs of hundreds of Magdalenian bone and antler tools and weapons gave me similar thrills: bringing them into the light once more, out of protective drawers and boxes, measuring, examining, and drawing every detail, discovering small hidden figures underneath the more obvious ones, pausing to admire the delicate designs, never forgetting that these were actually held and appreciated by a man or woman some 14,000 years earlier, imagining the hand that made the tool, decorated it, used it.

It's an eerie feeling, eavesdropping on these Paleolithic people, witnessing immediate practical preoccupations and needs and the intelligence with which solutions were found, finding out how tools were made, guessing how they were used, and sensing the irrepressible pride and pleasure the artisans must have taken in embellishing these objects, as we would today.

◆

I was prepared for the art. I had been a student first at Saint Martin's School of Art in London, where I had spent my childhood and adolescent years, then at the Ecole National Supérieur des Arts Décoratifs in Paris, studying design and interior architecture. Turner, Monet, Matisse, Kandinsky, and Giacometti were my masters, followed later by Rothko, Cy Twombly, Aurélie Nemours, James Turrell, Dan Flavin, and Bill Viola, among others. My eye was tuned to contemporary and experimental art forms, and still is,

stimulated daily by my husband's sensitive minimal work on color, light, and transparency: his oil paintings, pastels, collages, and glass reflections, his landscape installations, over water, among trees.

Traveling slowly, on foot, has further opened my mind, and eyes, to the diversity of human cultural expression and eventually to the understanding that distances, whether temporal or spatial, can be insignificant when it comes to art. Every destination, no matter how far away it is or how ancient or different the associated culture is from ours, offers art forms surprisingly close to those with which I am familiar: in Egypt, the frescoes on the craftsmen's tombs of foliage, birds, and butterflies painted with remarkably modern, bold, spontaneous brushstrokes; in Greece, the pure lines of the Akrotiri frescoes; in India, paintings covering the walls of an off-the-beaten-track Rajasthan palace, displaying greens and blues that have the same luminosity as those of a Matisse painting; the perfect simplicity of Cycladic feminine statuettes, reminiscent of Brancusi's sculpture; the African masks which inspired Picasso; expressive Central American Olmec carvings and Cambodian Buddhas; the polished stone phallic lingas of southern Indian temples; in Mali, the simplicity of two carved and polished breasts emerging from the rough wood of a Dogon "toguna" tree-trunk support; again in Mali, Dogon cone-shaped fetish mounds caked with sacrificial milk and blood mixed with shells, and, far away in India, mounds in the same shape covered with years, centuries even, of conglomerated powdered colors; Australian aboriginal abstract paintings; amazing abstract paintings created by Mbuti and Mangbetu Pygmy populations, exclusively designed by women, of which I have rarely found the equivalent in originality and refinement in contemporary art. Just a few disparate examples, all personally seen and experienced in one way or another, and all somehow mirroring modern art forms.

Curiously, it was only with the revival of abstract and conceptual art in the twentieth century that the vast realm of past nonfigurative expression was "recognized" or came to be of interest once again. The absence of abstraction in the nineteenth century prevented the first archaeologists from seeing, let alone appreciating, the value of nonfigurative art forms, including those of the Paleolithic. Only figurative work was taken into consideration; the rest was ignored, at best pushed to the side and forgotten, at worst thrown away. In fact, it was not until the middle of the twentieth century that

geometric designs, schematic representation verging on abstraction, signs, as well as simple notches, lines, and striations, were studied carefully, but by only a few, including the famous prehistorian André Leroi Gourhan, whose observations are still a reference today. I decided that these designs would be my specialty, despite the evident difficulty of such a choice: how can one approach nonfigurative expression when no one is around to explain it?

A lot more is said and written about cave art. That field is studied by a large majority of paleoarchaeologists, who, like me, are fascinated by the beauty and magic of parietal paintings and of the caves themselves. For 30 years I have been exploring the caves—those in Spain as often as possible and those in the Dordogne over and over again, sometimes even daily at certain times of the year, since sharing the caves with others has become an essential part of my life. There's always something different to discover that I hadn't noticed before: a perfect line, the shape of a rock, a subtle change of color, the expression of an eye, a sign hidden in a corner. It can be a different emotional experience each time as well, depending on one's frame of mind. Even in the middle of a group of tourists, it is easy to find oneself strangely alone. The darkness enhances not only the bright colors of the paintings, like glistening gems in a black velvet jewelry box, but also our most intimate thoughts of the moment. The impact can be one of elation, serenity, sadness, or fear. The senses become acute and are magnified: sight, smell, touch, hearing, even the taste of the air. More mysterious are the unexpected intuitive reactions that can unfold in the powerful environment of a dark cave: sensual, sexual, spiritual, or visionary.

I have never been afraid in a cave, even in the narrowest, most difficult passages. Caves are warm, wet, welcoming places to me—secure places, where I like to meditate, or "cave dream," listening in the pitch dark to the silence, interrupted now and then by the sound of drops of water falling or the muffled echo of distant voices. There is no notion of time. How often have I been surprised to find that night has fallen when I emerge after a long stay underground, coming out from darkness to find darkness outside. It is perhaps, more even than the brilliance of the art, this dissolved sense of time in the caves that brings us so immediately into contact with these ancient people. Perhaps this is one of the reasons why they are celebrated places.

◆

Unlike my scientific articles about portable art, written in French, my university language, I have chosen to write this book in English, my mother tongue, for more freedom of tone, for a more personal touch. No matter how much research is involved, this book cannot pretend to be anything other than subjective, partial descriptions of periods and populations that we modestly have to admit not knowing enough about. I have had to make choices all along, in the brief account of human evolution, the development of tools, the potential dawn of language, and what I find to be significant in each cultural phase. I hope it will be more like a story than anything else, a distillation of years of information, conversations with specialists and amateurs alike, colored by what has left the strongest impressions on me. I am deeply grateful to all the archaeologists and anthropologists who have contributed to what is understood about early mankind, and I hope that the fact that I don't refer specifically to each one's excellent work won't be too much of a surprise, especially where good friends are concerned. If I mention one, I'll have to name everyone, and that would weigh down on the storytelling.

We shall undertake a profound, awe-inspiring journey, through five marvelous Ice Age art sites in the Dordogne: a shelter and four caves. The waters of the past, from the origins of humankind to the end of the Paleolithic, rush by in intervals as we move cautiously from one cave to another.

I've deliberately chosen the five major sites that are still open to the public: Font de Gaume, famous for its polychrome paintings; Combarelles for its hundreds of fine engravings; Cap Blanc shelter for its spectacular sculpted frieze; Rouffignac for its magnificent drawings and engravings, notably of mammoths; and finally Bernifal for reasons too complex to summarize in a few words. All five are of the same Magdalenian cultural period, each is remarkable, each unique with its own specificities, yet also with much in common with the others, as we shall see. Although just about everyone has heard of the famous Lascaux cave, now closed to the public, few have any idea that other treasures lie nearby, those that we are about to discover. Because of the inconvenience of most caves' topography, it is difficult to take photographs of the work, and those that exist give only a partial idea of what constitutes a whole: the figures' interactions and their relation to the mineral environment, for instance, their scale, or the relief and consistency of the wall's surface. This is why I've chosen caves that each reader can actually see and ex-

perience for him- or herself. It's still possible, but for how much longer? We are blessed with this opportunity.

My intention is above all to celebrate the art itself for what we can see, without interpreting or necessarily understanding it. To let the art and the designs, mysterious and magical as they are, ultimately, perhaps, speak for themselves and for their creators.

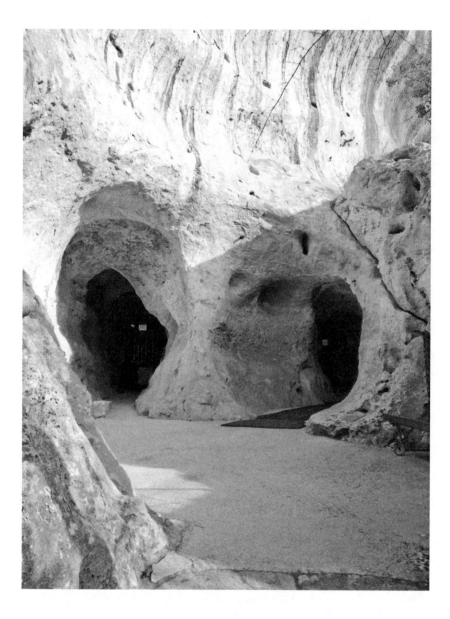

Font de Gaume, cave entrance

Font de Gaume

The steep climb up to the mouth of the cave of Font de Gaume can be experienced as a transition from present to past, a gradual shedding of modern everyday concerns. Bright wildflowers are scattered over the flaky rock surface on the way up. If you're lucky, you might see some wild orchids in the spring, especially the rare "bee" orchids with their delicate mauve flowers lined up along the stem, each centered with what looks just like an intrusive bee. Small, brilliant-blue butterflies, always in the same spot, fly away as we pass. Farther up, wild strawberries carpet some of the shadier spots. Trees have managed to grow despite the scarcity of earth, some even forcing their way through holes and cracks in the cliff: oak, maple, hazel, fig, wild plum, juniper. All the way up, imposing cliffs loom high above, streaked with vertical bands of black and whitish-gray lichen. In July and August it can be unbearably hot, the rock walls baked by the fierce afternoon sun; all the more refreshing is the cool air of the cave entrance.

A spacious shelter welcomes us after the last few steps, framing the original entrance, sculpted first by millions of years of water erosion, then by

wind, drafts, frost. Well protected and west-facing, this sheltered overhang was once used by Upper Paleolithic hunter-gatherers who lived here under wood and animal-skin structures, tents, or lean-to huts against the walls. Never did they live inside the cave itself. A clear distinction therefore must be made between caves, dark and deep, and cliff overhangs, open to daylight. The darkness, the high level of humidity—up to 98 percent in this cave—and the suffocating accumulation of smoke that would issue from campfires would be enough to dissuade anyone from settling in the depths of a cave. Except in a few cases, caves don't yield the heaps of stone and bone fragments or the artifacts commonly discovered on habitation sites, nor do they show traces of everyday activities, food remains, or domestic hearths, all of which are usually found outdoors or under open cliff shelters.

Caves were therefore special places, dedicated exclusively to the expression and possibly the celebration of symbolic imagery, whether mythological, magical, or spiritual. They were cultural sanctuaries of sorts. What their true significance was we don't know; whether they were frequented or not, meant to last or not, we don't know; whether they are illustrations of a momentary event or whether they carry the essence of millennia of tradition, or both at the same time, we don't know. It is the limited, controlled subject matter that was portrayed over thousands of years that reveals the cultural importance of the figures. The absence, or taboo, of certain themes, the codified stylistic transcription of others, the graphic conventions, shared far and wide over such long periods of time, prove that this isn't art for art's sake, an individual's freely inspired creation. We'll see this in the course of our exploration. Undeniable and measurable by all is the quality of the work and the talent and experience of its authors. The necessarily long-term apprenticeship of the artists not only indicates how much value was attached to obtaining a high-quality result but also tells us about the cultural context, rich and complex, sufficiently strong, cohesive, and stable to support and instigate the creation of such wonders. Whatever the meaning, whatever the rituals or beliefs—shamanistic, animistic, totemic, or of a kind we can't even imagine—the quality of the art and the act of performing the art are both events in themselves.

◆

Font de Gaume was "discovered" by Denis Peyrony in September 1901, four days after the nearby Combarelles caves, and was extensively studied by the greatest specialist of the time, the abbot Henri Breuil. The novelty, in fact, was the acknowledgment of the Paleolithic age of the paintings, not the discovery of the cave itself, which had always been open and known by local people. Several caves had already been discovered but not recognized as prehistoric: the famous Altamira cave in Spain as early as 1879, and, in France, Chabot (1878), Pair-non-Pair (1883), and Marsoulas (1883). Indeed, although small art pieces had already been acknowledged as Paleolithic because of their depictions of Ice Age fauna, it seemed inconceivable that "primitive" man could achieve such imposing painted or carved compositions, particularly in the darkness of caves. Not until the 1895 discovery of the nearby cave of La Mouthe (Les Eyzies), with not only paintings and engravings but also an elegantly shaped stone tallow lamp, under which was engraved a graceful ibex, did official specialists finally authenticate the antiquity of these sites. Here was proof at last that it was possible for a Paleolithic artist to venture, and create, underground. (Another such lamp was found much later at Lascaux cave [Fig. 3].) At last, Altamira could be acknowledged, 23 years after its discovery and, sadly, after the owner, Count de Sautuola, had died.

About 125 meters long, Font de Gaume has one main gallery—rectilinear and as high as 12 meters in the heart of the cave—and two right-angled passages. Henri Breuil listed 198 figures during the first decade following the discovery, to which more recent, unpublished studies by Alain Roussot and Denis and Agheda Vialou in the 1980s added at least a third again as many. A good half-dozen bison can be added to Henri Breuil's 80, 10 horses to his 40, a dozen mammoths to his 23, 2 ibexes to his 4, and 1 reindeer to his 17 cervids. Breuil's counts of 8 aurochs, 2 rhinoceroses, and 1 bear have remained unchanged. There are, furthermore, 1 anthropomorphic figure, 4 negative handprints, and multiple geometric signs, including 23 of those known as tectiforms ("tent"-shaped signs). The paintings are reckoned to belong to the Magdalenian period and could be of any age between 17,000 and 13,000 years before the present (BP), or even older.

Since Lascaux (Dordogne) was closed to the general public in 1963 and Altamira a couple of years ago, this is the only cave still accessible to the pub-

lic where polychromatic painting techniques can be observed. These involve the use of mineral colors—a variety of iron oxides and manganese dioxide—prepared beforehand and blended into different shades of yellow, red, and brown before their application. In other caves, the same pigments are used directly as independent colors in their unmodified natural state. Iron oxides were on occasion even fired in order to obtain certain deep shades of red.

Grinding stones have been found at many sites, still encrusted with these fine mineral powders, as well as small stone or shell color-mixing bowls, and even palettes with prepared colors laid out, like the finger-smeared one at La Pasiega (Spain), still lying ready for use on a stone ledge in one of the painted halls, as if time had come to a halt and the artist were going to rematerialize at any moment. The first time I saw it, the emotional impact was so strong that, forgetting the paintings, I felt compelled to return to it time and time again in an attempt to pursue some silent communion I felt I was sharing with the artist.

The pigments were applied in many ways. Sticks of color were made from chunks of the raw minerals, sometimes long and finely tapered with a pointed extremity, sometimes small and modest like the two found here in Font de Gaume. Distinct brushstrokes are still visible on certain paintings: paintbrushes therefore existed, although none have survived; they might have been made of crushed fibers or wood, animal fur, or, for the finer work, even feathers. Colors were also dabbed or sponged onto the walls, with pads of impregnated moss or fur. Fingers smudged the pigments for shading. Even more impressive are the spraying procedures, which consisted of humidifying the porous limestone and, after masking the areas intended to remain free of color, blowing the dry, finely ground pigments either through blowpipes—often hollow birds' bones—or directly from the hand or mouth onto the wet surface. To spray a surface consistently in one pass—for a negative handprint, for instance—two blowpipes could be used, one firmly held vertically with its lower extremity plunged into the color bowl or pouch and the other held horizontally at right angles to the first. In Altamira two pigment-filled tubes have been found to have been made from the same bird bone, and their extremities still match.

The blown or sprayed colors are uniformly absorbed by the damp rock, and carefully masked, color-free areas finely outline eyes, horns, and legs

in perspective and emphasize clear-cut back lines and bellies. Manganese, or deep browns and reds, were afterward added to highlight certain details, such as the voluminous shape of a bison's hump, the curve of a rump, the sharpness of a horse's hoof. These ancient methods are no different from recent fresco techniques, which also consist of applying dry, finely powdered pigments to a wet surface. Establishing that these procedures were used requires ultraviolet or infrared photography, which can also segregate color sequences, giving us precious chronological information. Densitometry is now used to measure the density of color, regular or irregular impregnation of the cave's walls being a good indication of diverse application techniques. But another approach is simply to examine the wall's irregularities and cracks: if a color is applied with a brush, it will be drawn across the surface and build up against the butted side of a fissure, as could also be the case for one sweeping drawn line; but large crayon-colored areas will cake the crack entirely with color, and spraying powdered pigment will cover the surface in a finer, more consistent way.

This is art that demands not only an expert hand but also preparation, planning, and experience. Whether painted, drawn, or engraved, the figures could be neither erased nor washed off, and all corrections therefore remain visible. The figures had to be as perfect as possible, right from the start.

◆

As we pass through the narrow entrance of the cave, an immediate sense of intimacy envelops us, the low winding passages unfolding in gentle curves, at first dark in contrast with the outdoor brightness, gradually becoming lighter. The yellow limestone walls are dry: sculptural, organic, warm. It's like walking through a magical stone landscape which fits snugly around us, protective. Recent studies have revealed that there were once paintings in these first galleries, but the drafts entering freely from the open entrance, as well as from the 21-meter side gallery we pass on our right, slowly eroded the walls and erased them. Only in the deeper sections have paintings survived, once we have passed through two narrow passages, 65 meters from the entrance. Here the circulation of air slows down, the temperature remains stable at approximately 12.5 degrees Celsius, and the humidity is at about 98 percent all year round.

The first tight passage is before us, so small that the Paleolithic artists had

to crawl through on all fours. Before slipping through, we can see engravings high up on the wall, particularly to our left, where there are three fine tectiform motifs, a couple of bison, a horse, and many vertical lines in a row. Even before this, in the first side gallery, a few badly preserved or incomplete engraved animals are to be found.

Beyond the narrow passage lie the paintings at last! A long, spacious hall opens up, a couple of meters wide but 12 meters high, with paintings on four levels, from the ground to about 5 meters above. Some kind of scaffolding must have been built to get up to the higher levels, which are otherwise inaccessible. For this, wood must have been brought in at great effort, proving, if need be, how important the paintings were and how strong the incentive must have been to create them. The high ceiling shows how the cave was initially shaped: unlike those that were sculpted by underground rivers, this one was shaped by water seeping through an open vertical fissure over millions of years, gradually dissolving the limestone on its way.

On the right-hand side, at eye level, is the first series of 12 large bison, 6 of which are lit up for visitors, all but one facing to the right, toward the entrance. They are superbly adapted to the natural shapes of the rock but are somewhat faded, worn down by decades of curious visitors, local people, including adventurous children, feeling their way through. Starting at the far left, we can see that the first bison is the most massive, about 1.35 meters long and predominantly red, its exaggerated humped back line magnified by a protruding stone ridge and strongly outlined in black. The second, in soft shades of brown, is even more closely adjusted to the limestone shapes, in such a way that the back line, belly, hind leg, haunch, and front shoulder are all in natural relief, yet in perfect anatomical correspondence. The third is red and faces the second: they are head to head, not quite touching, standing peacefully, to judge by their lifted heads and lank tails. We'll be seeing two more such pairs of facing animals with different colors: one black or brown, the other all red, whatever this might mean. The sexually defined males happen to be in browns; could the color red have been reserved for females?

Depictions of animals facing one another peacefully are common in the caves, and clearly these "meetings," as I see them, constitute a recurrent, significant theme. The illustration of any form of aggression is exceptional, the rare existing claimed examples being, in my opinion, debatable. In past

interpretations, animals facing one another were defined as "fighting." This corresponded to the popular image of "primitive man." A more scientific approach, taking into account the various animals' morphology and attitudes, such as the tail and horns of the bison here, has since led to a more objective picture. Nevertheless, despite the number of widely recognized errors, biased interpretations of the same order continue.

One of the most spectacular examples, frequently referred to as one of the rare exceptions, is a scene of two "fighting" woolly rhinoceroses in the recently discovered Chauvet cave (France), where the paintings date back to some 32,000 years BP. I, too, intuitively interpreted the scene as such until I met a person who knew African fauna well and offered a completely different version. He had witnessed a boisterous meeting between two rhinoceroses: a female and a very young rhino were grazing quietly until the arrival of another, large adult, whereupon the two adults charged toward each other in a fast, seemingly aggressive way, only to end up excitedly rubbing horn against horn, affectionately nuzzling! "Exactly as depicted in Chauvet," was the witness's comment. Which version are we to believe? I've even recently heard it suggested quite seriously that a mountain lion superimposed on a horse must mean that the first is attacking the second. What, then, should we say about the most common of all combinations: horse on bison and vice versa, or mammoth and bison superimposed? Superimpositions and close associations between different species, so widespread in cave art, are not necessarily consistent with the animals' habits in the natural world, no matter how realistically depicted. All these images are the fruit of complex beliefs of which we have no idea. And the more we explore and compare cave art, the more we are aware of its extraordinary complexity and mystery.

The third red bison, the second of the "meeting" twosome, is facing left. Breuil noted a large, lightly engraved mammoth shadowing it, facing in the same direction, its curved tusks overlapping the head of the bison opposite; I see yet another associated mammoth, facing right (Plate 1). The deeply chiseled contour of its back is superimposed on the bison's, its head is barely visible, and the long curved tusks are suggested by a perfectly suited natural ridge. Mammoths are omnipresent in Font de Gaume, although the visitor won't be shown a single one; they are for the most part very lightly scratched over the bison and among other figures, and they are hard to see. The fourth

bison is a blurred patch of bright colors covered by a layer of calcium carbonate that developed around 9,000 years ago, when the climate warmed. Sealing and protecting the original pigments, it has also masked the contours and anatomic details of the animal. Still, the surviving deep reds and black give an idea of how strong and colorful these polychromatic paintings must have been originally.

The fifth and sixth bison are both large and painted in subtle nuances of browns that shade the body to suggest volume where the wall surface is comparatively flat. These two still have remarkably well-preserved engraved outlines that delineate elegantly shaped hooves and legs seen in perspective, as well as eyes, nostrils, horns, and hairy beards. In Font de Gaume there are engravings everywhere, either closely associated with the polychrome paintings, as in this case, where engraving defined the bodies before the color was applied, or isolated or superimposed on panels, adding further figures.

There is much more in this section: figures we can't see and don't have time to search for, either eroded to near-disappearance, too finely engraved, or hidden in secret corners. For instance, there's a small, deeply engraved mountain lion, about 12 centimeters long, at ground level, facing right, just underneath the fifth bison; and there's a triangular sign with rounded angles and a chimneylike opening, lying at ground level beneath the calcite-coated fourth bison. Two negative handprints, pale against their sprayed cloud of black manganese, are found side by side and out of view under a narrow overhang just below the pair of facing bison. These handprints were made by placing a hand flat against the rock and then applying, or spraying as here, the color over it to leave an outlined handprint, rather than a positive print, which is made by pressing a paint-covered palm against the rock surface. Two more black negative handprints are on the other side of the gallery, at a higher level. It's tempting to presume some connection among the four, especially as, later on, we'll be seeing two pairs of hands mirroring each other in a similar way in Bernifal cave. Other bison continue along toward the narrow passage we just came through. We know they are there, in the dark.

Deeper inside the cave, on the same side, a final bison completes the series. This one is situated at ground level, lower than the others and therefore less deteriorated by early visitors' fumbling hands. Dark brown and black, but with bright red horns and facing to the left, most of the body is

in a concavity, which, when seen in dim or indirect light, appears to be convex. Negative becomes positive with limited light, and the artists played with these optical illusions to obtain dramatic effects.

Lit by the wavering flames of tallow lamps, torches, or small fires, all the animals would spring to life, appearing to move, sway, expand to larger proportions, or momentarily disappear. At times, the interaction of their shadows with other projected rock shapes distorts their proportions, and strange "creatures" appear on the walls, looming impressively over us. This bison's head looks astonishingly like a human profile: the forehead, nose, and chin of a person, the circled eye just where it should be. Could it be a trick of the light? Once seen, it seems so obvious. Ludicrous as it might seem, there is a striking natural resemblance between human and bison profiles, quite visible in photographs of wild bison, as soon as one thinks of it. Could this be one of the reasons why bison were such a common subject during the Paleolithic? In several famous sites, there are composite human-bison figures, such as the renowned "sorcerers" of Le Gabillou (Dordogne) and El Castillo (Spain).

In the shadows above this bison are two large ones facing each other, the left one simply outlined, while the opposite one is suggested mainly by the natural rock, particularly for its back line. Another small bison's head is superimposed on the left-hand one. And there is more, but very difficult to make out.

Opposite these images, on the left side of the main gallery, is another series of bison and many signs. This is in fact a complex panel, with multiple superimpositions of bison, reindeer, horses, engraved mammoths, and geometric signs. Among the latter are the tectiforms, immediately to the left of the narrow passage we initially came through. This particular design, which some have seen as resembling a tent (whence the name, derived from the Latin word *tectum,* roof or shelter), can vary in size and complexity and is also found in four other nearby caves: Combarelles, Rouffignac, Bernifal, and La Mouthe. Those before us show the characteristic roof, a central vertical stem, and a horizontal base; both are remarkable for their fine lines, carefully made up of rows of tiny red dots. Close by, another sign, fitting inside a curved niche, looks somewhat like an igloo: two deeply carved parallel half circles with a "chimney" opening on the top.

Next comes a magnificent 5-meter-long series of painted bison, rein-

deer, and small dark horses, as well as finely engraved mammoths, all inter-
woven, triple-layered for the most part. The brightly colored bison serve as a
background for four finely engraved mammoths, the elegant scratched-out
curves of their huge tusks standing out white against the color; sweeping up
onto the back of the one in front, these curved tusk lines flow gracefully from
one to the other, linking the four mammoths, along with the underlying bi-
son (Plate 2). We won't be seeing any of these mammoths in the course of
the visit, as this section of the panel remains in the dark because of its poor
preservation.

Toward the end of this series, which is not lit up for the public, we are
shown the farthest two bison: they face each other, one red and the other
brown. The huge red bison on the left—about 2 meters long—is defaced by
nineteenth-century graffiti yet easily recognizable because of its adaptation
to the rock surface. It is the largest of all, a mass of brilliant red ocher, and it
seems to be lying down, although its allegedly folded legs are only vaguely sug-
gested. Facing it is a small brown bison, niched in a circular concavity. Three
dark-red tectiforms are traced on the body of the big red bison, and a fourth is
engraved. They're all different: one, for instance, has a horizontal curved sign
on each side of the central stem just above the base, while another has many
oblique lines parallel to the "roof," which give it a "pine tree" effect.

Twenty-three of these signs—possibly more—are in Font de Gaume, all
on the left-hand side of the passage, except for one engraved under a horse
on the right of the next gallery. Their significance remains obscure, and the
theories depend on current fashion: signatures, shamanistic or totemic signs,
or, considering their restricted geographic distribution, tribal identification.
As none of these interpretations can be verified, we must be content with ac-
knowledging their undeniable importance, along with that of the other non-
figurative designs, signs, or symbols. In a variety of shapes, sizes, and degrees
of complexity, they are present in every cave, isolated, clustered on panels, or
associated with figurative themes. In some cases they are far more numerous
than the figurative images. Without a doubt, they constitute an essential as-
pect of cave art.

Farther along on the left, we arrive at the famous reindeer scene, a pair
of animals facing each other (Plate 3). On the left is the larger and more
graceful of the two, in shades of dark brown and black, standing as if on a

downward slope, its head stretched out over the other's. The exaggeratedly long, single-stemmed antlers, boldly painted in black, curve forward in regular arcs. The other reindeer, in deep shades of red, is heavy-bodied, its voluminous rump accentuated by a prominence of the rock. It has smaller red antlers, in smooth curves, flared at their extremities, which fit beautifully under the larger black ones; its hind legs are in standing position, whereas its forelegs are bent, as if it is kneeling, and its head is held low. There is more: the finely engraved head of the black reindeer shows that its mouth is open and it is licking the forehead of the other.

Two details catch the attentive eye: the protruding tongue is in fact on a small natural bump on the wall, and the mouth of the facing red reindeer fits exactly into a natural crack. The two animals are therefore carefully arranged around these two small irregularities of the rock, which become their mouths, a central feature, from which the heads, necks, antlers, and bodies all magnificently fan out. Furthermore, the animals' bodies themselves seem to match the rock surface. The artist's adaptability, talent, and sense of observation, and the ensuing careful planning of this scene, compel our admiration. Apart from the sensibility emanating from the two reindeer, which never fails to move the viewer deeply, the composition is elegant: the interaction, for instance, of the two pairs of antlers, which fill the space between the two animals. I find the aesthetics more moving than the much-discussed significance of the scene itself. The artist's intelligence and sense of beauty are more relevant and more real to me today than any hypothetical interpretation.

Fitting within the red reindeer's body but visible only to an expert eye is a finely engraved mammoth facing right, or possibly two, since there is a double line for the back. A horse is also there, outlined in black.

◆

The gallery opens up onto a spacious central chamber before continuing toward the end of the cave. Another gallery leads perpendicularly to our right. Dominating the open space, high up on the left, are reindeer and bison, strongly painted in black. Other animals are thickly covered with calcium carbonate, but the four before us are spectacular. They interact in such a way as to seem to be more than four, as if there were herds of them crossing and moving in different directions (Plate 4). Paleolithic artists invented many ways of depicting movement and perspective, trompe l'oeil effects not seen

again until the Renaissance. Here are some good examples. On the left is a reindeer outlined in strong black lines and moving toward the left, its legs in perspective, those farthest away deliberately separated from the body by a pale space free of color. No head is featured, but when you see the image from farther inside the cave, the animal seems already to have disappeared around the corner, thus assuming an even greater sense of motion. In the center are two superimposed animals going in opposite directions: a large bison in profile facing left and a deer facing right, the two sharing the same belly line and legs. The superimposition creates a three-dimensional effect: the deer closer, the bison behind. Finally, to the right, there is a small, finely outlined bison. Its head is seen in profile facing right, while the horns are twisted into an almost frontal view. This "twisted perspective" makes the head seem to be turning, especially to a viewer walking by. Imagine what this would look like in flickering candlelight! The most spectacular site at which this technique is found is Lascaux, where all the horned animals are represented in this "cubist" manner, the large bulls being the most memorable: head and body in profile, horns in three-quarter view, ears placed on the neck as if seen from the front, chest frontal as well, and finally the hooves seen from the back.

In this panel, we can see how creative these artists were, using a variety of trompe l'oeil effects in order to obtain the maximum illusion of movement: descriptive perspective by "detaching" the most distant leg; three-dimensional superimposition of two animals, suggesting space as well as movement; and views of the same animal from different angles for animation. As if it were not enough that the animals were easily identifiable, they also had to be moving. They had to be alive.

Opposite these, high on the right, where the perpendicular 50-meter-long side gallery begins, several animals facing left are outlined in black: a stag, or a reindeer, with huge antlers, another one behind, with a lightly outlined horse superimposed on it, followed by yet another horse; and there are red signs, all of which are covered with calcium carbonate of varying density. The famous wolf described by Henri Breuil is purportedly farther up on the wall, although I have never been able to decipher it; I'm not the only archaeologist not to see it there.

Facing these, on the right side of the gallery, are two superb horses thickly outlined in black, one behind the other, both facing right. A large, placid-

looking one stands in front, its hind leg and tail perfectly featured naturally and in high relief provided by a couple of stalactite folds. To complete the horse, the artist simply outlined its back line and forelegs in black; one of its forehooves is lifted in a poised position: the horse is resting. Unfortunately, its head is obscured by calcite. This is another perfect example of how cleverly the artist made use of the natural features of the cave, building the animals around chosen shapes, hollows, cracks. A lot of time was evidently spent on getting to know the mineral qualities of the cave before applying the first touch of color. One cannot help but sense that the cave walls themselves are much more than a protective environment or a durable support. They play an active part in the art.

The horse behind is smaller and, unlike the first, full of vitality, ears pricked forward, forelegs stretched out horizontally, touching the other's rump. Perhaps the two horses form a couple.

Slightly lower down, in the shadows just to the left of these two, are the neck and head of a smaller horse, fully colored in black, as well as many signs: five black dots lined up on a vertical fold next to a parallel branched sign; underneath, a group of eight dots, one above the other repeated four times at the same level on four adjacent folds; the engraved tectiform I've already mentioned; and a small, natural, oval hollow painted in red, typically interpreted as a vulva symbol.

Below the horses, at ground level, are the head and back of a bison facing left, probably lying down, as there is no space for its legs. It looks like a young calf, and no horns are depicted, unless one interprets the back line as being horn and back united in one line, which seems unlikely. The eye is interesting: it's placed exactly where there is a small hole, and the white of the eye, carefully protected when the bright red ocher was applied for the head, remains pale, so that a simple black dot in the center is all that is needed to give it its lively, perky expression. From a certain angle, this profile looks just like a smiling human being. Surprisingly so.

Many animals have human heads and vice versa. Strange anthropomorphic figures are present in most caves, as well as in portable art, as we'll see later, and these may be part animal, part human, humans with mask-like heads, humans in animal posture, or the other way round. And there are also composite creatures, combining several different animal species. A

number of techniques are used to achieve such hybrids: superimposition of two species, although the unknown lapse of time between figures leaves their linkage open to debate; combination of two or more animals' features on one figure; and placement of an animal on a rock shape that resembles another species, in which case it is more or less certain that the artist deliberately created a composite figure. To the right of the horses is a good example of the last technique: a large dark bison is painted on a portion of the rock surface that looks strikingly like a large mammoth facing the other way, its sloping back line, trunk, and even its eye, all in correct proportions.

Not accessible to the public are the remaining 30 meters or so of the gallery, narrowing to some difficult, confined sections that one has to edge through centimeter by centimeter. Hindered by stalagmites and stalactites, the cautious crawler invariably ends up with bruised knees, hips, and elbows and risks getting stuck, as once happened to a fellow archaeologist. The reward is a small circular chamber, thickly covered with calcite, containing some simple black figures among its many folds. There is a rarely represented small bear and two deer, one of which is seen face on, consisting of a few judiciously placed black markings around a vertical fold of calcite to suggest a head: a line for an antler on each side, one dot per eye underneath, and finally a dark smudge for the nose. I remember being impressed by this powerful part of the cave. Was it the effort it took to get there or those eyes peering out at me from the folds? Or was it some mysterious effect inherent to this area, a mineral entity in itself, visually isolated from the rest of the cave yet connected soundwise by its particularly powerful resonance level? Tucked away in an even less accessible spot is a figure that has been interpreted as being a schematic mountain lion.

◆

Back again in the central chamber, we pursue our route along the main gallery to the best-preserved paintings, revealed only when a thin protective layer of hardened clay fell away during careful cleaning of the cave in 1966. A group of bison on the left are lined up along a horizontal ledge, which offers them an imaginary ground level. The first two are facing right, the next is looking toward the left, and the fourth toward the right, all on the same level. Below the third and fourth, a fifth bison faces left.

Most remarkable are the first two bison. The state of their preservation

gives us an opportunity to evaluate—better here than anywhere else in the cave—how fine the Magdalenian engraving and polychrome painting techniques were. Entirely painted in shades of brown, the contours of these animals are sharp. The shapely hind legs are depicted in perspective, and details such as the bisons' pointed horns and browed eyes are perfectly defined and finely outlined by a thin space of the paler natural stone surface, carefully reserved for this effect. A strip of hide might have been used to mask the wall, or some clay or vegetation—or, perhaps, for the animal's body, the artist's own hand shielding the outer space. (We see this in Pech-Merle, France, where the famous dappled horse's neck is lined by a series of negative prints of the flat of someone's hand.) Subtle shading, as well as judicious use of the natural rock, accentuates the shapely rump, thigh, and hump curves. Tufted tails are delicately painted and engraved. The shading also brings out different fur texture and density, on the animals' humped backs, for instance. It might even be possible to define the period of the year in which they are depicted: probably summer, judging by the sleek backs and slender bodies, unencumbered by heavy winter wool. Each bison has a distinct personality: the front one is strong and bold, its expressive eye, ear, and horns deeply engraved, and the head is placed on a protrusion of the rock, making it appear to change angles, watching us as we move along (Plate 5). The bison behind it is quite different: its head hangs low, with finer horns, a smaller eye, and its general appearance bespeaks a rather shy, passive attitude.

It is easy to appreciate how different each animal is. It must have been important to the artist to individualize them, even those of the same species, by their age, sex, character, the seasonal impact on their appearance, or their attitude. Variably applied techniques are a factor, too, as well as the degree of stylization or complexity. Of the more than 80 bison in this cave, no two are the same. There are no repeated, identical stereotypes. Even where stylistic and technical conventions are strong and the figurative subject matter limited to a few selected species, each figure, whether human or animal, is individualized—something that appears to be true also for the nonfigurative designs, which differ in subtle ways even when they belong to the same group. To achieve this, the artist had to be an inspired and creative portraitist, not merely an accomplished craftsman systematically transcribing a conventional image.

The group of bison is followed by a much larger individual, covered with calcium carbonate and facing left, its heavy rump rounding the corner, which leads to a sort of rotunda or alcove.

This intimate circular space, called the small bison chamber, is covered with more than a dozen interwoven painted and engraved figures (Plate 6). It appears that the rock was first scraped, then painted in red before the animals and signs were either engraved or painted in black. Four black bison arranged in a circle in the center are perfectly visible, more stylized than the ones just described and with fewer details. Two of them have distorted proportions, yet they are just as expertly depicted. The top bison, facing right, is fully inscribed within a small circular concavity that gives it the illusion of having a voluminous body when indirectly lit. Below, to both sides, are two others, each facing away from the center. The one on the right is outlined and appears to be a combination of two animals: a bison at the rear and a mammoth at its head and tusks. The bison on the left is entirely colored in black and has an elongated, distorted body that seems to be leaping out toward us. Beneath these two, closing the circle, is the fourth: smaller and well proportioned this time. Its tail is a cleverly planned, delicately painted extension of the tail of the animal above it to the left. Altogether, this is a superb, symmetrically composed group, with flowing lines forming elegant arabesques in black manganese on the red ocher background. Multiple engraved signs and figures are superimposed, including an engraved gridlike sign and several tectiforms, some aurochs—the head and horns of one of which are clearly visible and reminiscent of those in Lascaux—more bison, and what might be a strange three-quarter view of a long-nosed human face. Although it is not always acknowledged, I have seen it clearly. A natural stone prominence at floor level looks strikingly like a large, three-dimensional bison's head. As there is no evidence of man's hand at work here—no trace of paint or engraving, for instance—it cannot reasonably be classified with the other figures. Yet every visitor seems to notice it; could it not have been seen—and taken into consideration—by the artist as well?

This alcoved space somehow radiates harmony, despite the apparently confused superimpositions. Is this because of the flowing lines that link the four central bison so gracefully? Is it the circle they form, or perhaps the circular chamber itself, which connects the viewer to the figures, drawing us

toward the center? Aren't circles always somehow suggestive of magical or mystical practices?

In a tiny narrow passage at ground level to the right, almost underneath the rotunda, are a couple of curved lines representing two schematic bison. So confined is the space that only a very slender person or a child can get far enough inside to see them. Were they ever meant to be seen? Hidden figures in secret nooks and corners such as these exist in most decorated caves, adding to the mystery of the art and to the difficulties of the cave itself. Who, and how many, came into the cave? Or did anyone at all enter the cave once the figures were completed? In confined spaces like these, such questions seem particularly relevant.

Finally, the gallery narrows to a vertical fissure, 12 meters long, 2 to 4 meters high, and the width of a person standing sideways. This section must have been significant, considering the number of drawn or engraved figures: horses, aurochs, a reindeer, a mountain lion, a woolly rhinoceros, and a human. All except one of these are situated on the left of the passage. The most mysterious figure of all is a crudely stylized masklike head and neck outlined in black, with "eyes" (two dots) facing the viewer. Higher up is a large, red, woolly rhinoceros about 70 centimeters long. On the opposite wall is a red stag. Farther along, on the left again, are six superbly engraved horses, all turned to the right. They are small, finely detailed, and cleverly interwoven: one horse's back line is also the belly of a larger one above it, which shares its rump with yet another smaller horse that fits inside it. Facing them on the same panel is a finely engraved mountain lion, difficult to see; finally, at ground level, as though standing on the floor, are some small, exquisitely painted black aurochs similar to those at Lascaux, their slender horns pointing toward the entrance. Their graceful bodies and legs look as though they had been painted with a fine brush.

If we go by stylistic criteria—a generally accepted means of placing the art within a specific cultural epoch—the figures in this section and those in the nearby bison chamber, as well as certain figures in other parts of the cave, are likely to be from a more ancient period, possibly several thousand years older than the polychromatic panels.

At the end, where one can go no farther, seven short red lines fan out diagonally, forming a sign, the last element of what appears to be an unend-

ing parade of magnificent creatures. Such a simple sign, bringing to an end an itinerary filled with complex, sophisticated imagery, is a surprise, until one remembers how often this occurs in other caves. With time, I have come to view such simple signs as a final message. Whatever that message is, the crudeness and simplicity of those lines are truly humbling.

◆

Back out in the blinding daylight, as we gather our thoughts, readjusting to the present century while a jet thunders overhead, questions of all kinds assail us. What did all this mean? Who were the artists? What did these Ice Age people look like? How did they live? What was the environment like? Who was around before them? Where did they come from? Did these people belong to a widespread culture or did they form many distinct ethnic groups? Were the social groups large or small, grouped or scattered, matriarchal or patriarchal? So many questions, only a few of which can be answered, and even then, as we will soon see, incompletely.

But before getting to these questions, let's go back to the paintings. First, the sophistication of the art is enough in itself to convince anyone that this is not the work of "primitive creatures." The Magdalenians had the same capacities that we have today and even used the same techniques as ours for their engravings, sculpture, and paintings. Their sense of design and composition is remarkable. So is their surprisingly modern ability to re-create movement, perspective, and three dimensions, a capacity equaled only recently. The same can be said of the deliberate stylizations, leading to abstraction (there are actually examples in which several representations on the same panel clearly show a gradual progression from figuration to abstraction), and likewise of the economy and simplicity of some of the linear work, which recall the masterpieces of such twentieth-century artists as Picasso and Matisse. These aspects alone are enough to justify the word *art,* for those who are still skeptical.

The fine painting techniques, the subtlety of the color shading, the almost calligraphic linear work, all illustrate the Magdalenians' sophisticated sense of aesthetics and appreciation of quality and, let's not be afraid of the word, beauty. Today, we are deeply moved by the art we've just seen, not only because of our awareness of how old it is nor of the magic of the cave itself— no matter how relevant these aspects are—but because of its beauty. Forget-

ting how old it is, we spontaneously respond to the artists' sensibility. And we intuitively know how close we are to these people. Indeed closer, much closer, if we go by our present-day concept of art, than to more recent historic periods, such as those of the Egyptians or the ancient Greeks, or even, for that matter, the European Middle Ages, when artistic conventions were so different from ours today. Cro-Magnon man's creative faculties were resolutely modern.

Moreover, we are aware of the kind of community or network of communities that supported this work. If art can be considered, as it usually is, to reflect the level of development, complexity, and refinement of a culture or civilization, then here indeed we have advanced cultures. The artists' social and cultural environment must have been propitious for such elaborate, specialized work to have developed. Time and effort were spent in mastering the varied techniques that were needed to obtain such effective and spectacular results, results that were surely valued and encouraged by the entire community.

Once the edge of excitement and curiosity softens, we are aware of how powerfully the experience as a whole has affected us, in a more intimate way. No one comes out quite the same as before. I've noticed over and over again that visitors emerge from the mouth of the cave feeling appeased, enlightened, at times even shedding a tear or two. Is it the soft, rounded shapes of the cave that make it seem so comfortable, so secure? Could it be the delicate details and subtle shading of the animals and their calm attitudes that radiate such peace and quietness? It is with reluctance that we leave.

In the course of our exploration of the next four sites, we'll see how much they have in common and, despite their apparent differences, how complementary they are. Each confirms our present observations, yet simultaneously brings something new. Each will increase our respect and admiration. But before we discover our next cave, let's embark on another kind of journey: let's unravel time, and start with what we think were the beginnings of human evolution.

Millions of Years Ago

This modest and all too short attempt to draw a picture of the evolution of humankind is certainly not exhaustive—several books would be needed for that—and not every famous fossil discovery or eminent paleoanthropologist is mentioned, much to my regret. This is more a personal appreciation of what strikes me—a simple onlooker specialized in the art and not in the biology—as important. Which is why the accent is on fascinating issues such as bipedality, the development of the brain, what to think of Neanderthals, the oldest burials, the first tools, and the potential dawn of language. A vast range, admittedly treated briefly and incompletely, but I hope just enough to put modern man and cave art chronologically into their recent perspective—that is, toward the end of a long string of physical transformations and changing mental aptitude.

Our steps will take us back at least 6 million years, to long before humans existed as we know them today. We must step cautiously, though, because each paleoanthropological discovery is routinely subjected to various interpretations that cause disorder in previously well-established chronological

charts. The picture has become more and more complex over the past 10 years, and neatly designed, reassuring "trees" are being replaced by a rather indigestible tangle of disconnected branches and dotted stems, starred with question marks and codified denominations, all of which are variably distributed, depending on each paleoanthropologist's theoretical approach. This is the price we must pay to get closer to reality, because the truth is that hominid diversity has proven to be far greater than had been imagined, with the development of different species that were frequently contemporaneous or overlapping. Defining a species is, in itself, relatively subjective, based on selected morphological criteria. Depending on what the paleoanthropologist chooses to focus on—the size and shape of the skull or of the teeth, for instance, or any specific cranial or postcranial characteristic, for that matter—the results will differ, and the morphochronological connections may vary accordingly. The fossil data that we rely on are, in most cases, scarce and fragmentary: a jaw bone, skullcap, tooth, and foot bone found on a site aren't necessarily part of the same individual. Adding to the difficulty, each fragment might belong to male or female, to a young person or an adult. It is hard to compare two species when there are only female remains in one case and male in the other. They might be members of the same species.

Until recently, it has generally been accepted that the split between apes and hominids probably occurred around 7 million years ago in Africa. Yet as I write these words, fresh news has come of the discovery in Spain of *Pierolapithecus catalaunicus,* a 13 million–year–old skeleton and the most complete of that age found so far, which might suggest that the separation occurred earlier. Certain paleontologists are convinced of this fossil's affiliation with apes, but the scarcity of ancestral ape fossils and the consequent lack of comparative data on the evolution of apes make this difficult to prove one way or the other. This and other fossils such as *Ouranopithecus* (10 million years, Greece) and *Dryopithecus* (13 million years, Spain) open up the perspective of a possible relationship to apes long before the supposed separation established by DNA molecular specialists.

The early discovery of "Java man," *Pithecanthropus erectus,* by Emile Dubois in 1892 initially identified Asia as the site for the origins of mankind. But southern and then eastern Africa progressively came to the fore, as major discoveries were made of a much older hominid: *Australopithecus.* And in

1924, when Raymond Dart discovered the famous "Taung child" in South Africa, he had the brilliant insight to decipher a mixture of humanlike and apelike characteristics, despite the subject's young age, around four years old. Dart's fossil's teeth had typically human proportions, the skull was slightly larger than an ape's, and the creature showed signs of having stood upright. He called it *Australopithecus africanus,* meaning southern ape of Africa (3.5 million to 2.5 million years). Later, many other specimens were discovered, including, most recently, a whole skeleton found by Ronald Clarke that dates back 3.3 million years or more.

Further discoveries followed of other early hominid species: *Australopithecus afarensis* (3.8 million to 3 million years), of which the best known representative is "Lucy," discovered in 1974 by Donald Johanson (3.2 million years, Ethiopia). Most evocative are the famous footprints found in Laetoli (Tanzania) by Mary Leakey: what indeed could be more moving than those 3.6 million–year–old traces left behind by an adult and maybe a child, walking side by side across muddy ground toward some unknown destination? There's also *Australopithecus anamensis* (4 million years, Kenya) and diverse "robust" forms, of which *Paranthropus robustus* (2 million to 1 million years) and *Paranthropus boisei* (2.3 million to 1.4 million years) are the best known. The essential criterion for distinguishing early hominids from apes is their bipedality, and these early forms moved upright on the ground, while still conveniently maintaining their aptitude for tree climbing.

In the 1990s an older type of putatively erect hominid was found by Timothy White in Ethiopia: *Ardipithecus ramidus* (4.4 million years), followed in 2001 by even earlier specimens discovered in the same region by Yohannes Haile-Selassie and dating to the phenomenal age of 5.2 million to 5.8 million years. These dates were in turn overshadowed in 2002 by a spectacular find in Kenya, where Martin Pickford and Brigitte Senut discovered *Orrorin tugenensis,* 6 million years old, a putatively upright biped. Whether or not *Orrorin* belongs to the hominid family is the subject of heated debate, but its age places it within the exciting time frame during which hominids are believed to have emerged.

Since 1995 western Africa has claimed attention, with two new stars, both found in the same area of Chad by Michel Brunet and his team. First found, in 1995, was "Abel," a jaw of *Australopithecus bahrelghazali* (3.5 mil-

lion years); then, in 2001, the even more amazing find was made of "Tou-mai," *Sahelanthropus tchadensis,* dated to 6 million to 7 million years. Before these finds, it had been thought that the earliest hominids emerged in East Africa, where the rising East African Rift had placed the regions to the east in a rain shadow. This was thought to have favored the development of isolated hominid groups adapted to a more open environment. We now know that this is not the case and that hominids evolved in a variety of biotopes; forests, jungles, tree savannahs, and, particularly, lakeshores and river margins were home to the early hominids, covering a much greater part of Africa than first thought. The Chad sites, 2,500 kilometers west of the Rift Valley, open up vast new perspectives with regard to early human expansion.

Is the recently discovered 6 million– to 7 million–year–old "Toumai" the oldest hominid? This has yet to be established. The discoverers believe that its small canine teeth bring it close to hominids, whereas others argue that it is probably a large ape, most similar to a female gorilla. Whatever the outcome, it's an exciting discovery, the oldest yet that might belong to the hominid line and chronologically the closest to the time when large apes and hominids are believed to have gone their separate ways.

Why was bipedality adopted as a means of hominid locomotion in the first place? Logically, there seem to be more disadvantages than benefits: exposure of vulnerable parts of the body to potential predators for one, less mobility than four-legged animals for another. Being able to stand up to see prey or predators over tall grasses has often been advanced as a good reason, but it's hardly good enough by itself, as numerous animal species can do just that for short or even long spans of time without having become bipeds— apes, bears, mongooses, and squirrels, to name but a few. Perhaps the most significant advantage offered by an erect posture is the faster cooling of the brain and the body. In shadeless environments, heat loss is dangerous, and an upright stance reduces the body area exposed to the sun.

Was it the ability to stand up, walk, and run that broadened the potential lifestyle perspectives of certain hominoids, or was it the other way around, the more adventurous and imaginative adopting bipedality? Did the advan-tage reside with those who had the urge to leave the security of the forests and explore, and adapt to, regions of greater diversity? Did that mobility re-sult from necessity—more varied food resources or social imperatives, for

instance—or simply from curiosity? In any event, this change of posture engendered many consequences: physical, psychological, and cultural. The shapes of the skull, vertebrae, and spine, of the pelvis, legs, and feet, were all affected. Hands were freer for all sorts of activities, such as toolmaking. A vertical spine could balance a larger, heavier braincase, allowing the brain to expand. A larger skull would in turn lead to modification of the size and shape of the female pelvis, possibly a turning point in differentiated male and female activities. Another consequence of the larger brain is a necessarily earlier birth, with postnatal brain expansion, necessitating more care, protection, and learning time for "premature" offspring. Moreover, this shift in position considerably affected cranial as well as facial morphology, entailing new neuropsychological perspectives. All these factors are closely interrelated and interdependent.

◆

The first appearance of the *Homo* genus comes with *Homo habilis*. This species and others like it appeared about 2.5 million years ago and lasted at least 1 million years, as judged from fossils found in Kenya, Ethiopia, Tanzania, and South Africa. *Homo habilis* was named in 1964 by Louis Leakey, Phillip Tobias, and John Napier and was, as the name suggests, considered to be the first "handy man," the earliest hominid to fabricate stone tools, the oldest of which (at Kada Gona) are now known effectively to date back 2.5 million years. These tools, consisting of sharp flakes knocked from pebbles, were often made from "imported" stone—carried from elsewhere—showing foresight on the part of the makers.

Many different hominid species existed at this time in Africa: the archaic bipeds *Australopithecus africanus, Paranthropus robustus,* and *Paranthropus boisei,* as well as others of the *Homo* genus: *Homo rudolfensis* (average brain capacity, 740 cubic centimeters [cc]), *Homo habilis* (640 cc), and *Homo ergaster* (582–840 cc). It isn't always easy to distinguish among them, and the details are debated.

At the moment, it is not clear who fathered *Homo habilis* or other early *Homo* species, the legendary "missing link" turning out to be not singular but plural, omnipresent at virtually every stage of human evolution.

Why is this particular fossil, and not those formerly described, called *Homo*? What are the decisive criteria that justify the turning point, the switch

to "human" as a definition? The answer no doubt lies in a variety of factors, physical but also cultural, which include the obviously larger and more complex brain, the hand and foot bones, and the first flaked tools.

More evolved are both *Homo erectus* (1.7 million to 27,000 years) and *Homo ergaster* (1.9 million to 1.4 million years). These, in Asia (Java, Indonesia) and in Africa (Kenya and South Africa), respectively, were taller than their predecessors, in some cases even as tall as modern humans, and they had a cranial capacity that could range from 750 cc to as much as 1250 cc. Varied indeed were hominids at that time, probably even more so than we are aware today. Take, for example, the famous tall, slender Nariokotome boy (*Homo ergaster*, 1.6 million years, Kenya), who, when he died at about eight years of age, was already 1.60 meters tall. Had he grown up, he might have been as tall as a present-day Masai. His remarkably modern postcranial skeleton is, however, combined with a relatively small 880-cc brain.

The species *Homo ergaster* is considered to be the first hominid to have moved out of Africa, to spread in all directions. Although its brain was not, on average, vastly larger than those of the early bipeds, *Homo ergaster* had notable postcranial distinctions, being the first hominid of essentially modern body form. By this stage, the hominid skeleton, with its former twofold faculties of tree climbing and bipedality, had resolutely opted for the latter means of locomotion. The physical changes led to a locomotion that was relatively slow but that could be sustained for long periods of time. And this laid the groundwork for all that was to follow. Certainly, this modern posture would have been a determining factor that affected the rest of the skeleton in many ways, including stature, body mass, and brain size, all of which contribute to what we are today.

Homo erectus was first found in Java by Emile Dubois in 1891. It was originally called *Anthropopithecus erectus* before being renamed *Pithecanthropus erectus,* "ape man." The skullcap Dubois described is now known to be 700,000 years old, and remains in other sites are about 1.7 million to 27,000 years of age, an extraordinarily long span. Later, between 1929 and 1937, Asian hominid fossil discoveries were made in China; these initially were called *Sinanthropus pekinensis* (800,000 to 200,000 years). For both finds, the name *Homo erectus* is now more commonly used. There are, however, considerable differences in brain size among *Homo erectus* remains, so

much so that we may be faced with two or three distinct species instead of one, especially in view of the long period of time they cover.

While we're in Asia, what about the recent, truly amazing Indonesian discovery: *Homo floresiensis* (74,000 to 12,000 years) described in 2003 by Peter Brown? Are its particularities—its small size (1.05 meters tall), a brain volume of about 400 cc, and its marked propensity for tree climbing, for instance—the result of hundreds of thousands of years of isolation on the island of Flores? The remains were first compared with those of *Australopithecus,* before being attributed to the *Homo* genus, although not *Homo sapiens,* as there are too many differences between the two. With this discovery, we learn that, as recently as 12,000 years ago, another species was still around. We weren't alone.

◆

There must have been serious reasons for the gradual migration of these human groups, who chose to leave Africa and spread in all directions approximately 2 million years ago. This was a particularly eventful, adaptive period, leading inevitably to the development of more advanced species with local peculiarities, such as, much later on, Neanderthals in Europe and modern humans in Africa. At this point, it is important to note that for about a million years in Africa, between 2.5 million and 1.5 million years ago, when bifaces first made their appearance, there was no truly remarkable change in stone technology. Tools remained surprisingly similar, even as the brain showed notable changes in size and presumed complexity. In comparison with the present day, when technology is significantly valued, at the dawn of our evolution there was not necessarily a simultaneous cause-and-effect correlation between a larger brain and technological improvement. It could be that, as in certain populations today, human intelligence was focusing on other priorities, of a more social and cultural order, which leave no archaeological record. It might even be that the intellectual efforts made toward the development of a more complex society are what led to a more complex brain in the first place. The question is always the same: which came first, the chicken or the egg?

Another major discovery, in 1999, has completely changed what was thought to be true of the first arrivals on the European continent. At a site called Dmanisi (Georgia), five hominid skulls and three mandibles have

been found alongside chopping tools; these are now dated at 1.8 million to 1.7 million years old. *Homo georgicus* is half a million years older than any other known European hominid fossil! One need not be an expert to observe striking discrepancies between the fossils, indicating that they might constitute more than one human type. They are rather short-statured and have a relatively small cranial capacity, an average of 650 cc. It's too soon to tell how they fit into the general picture. Their discoverers regard them as a kind of *Homo erectus*, but they are closer—physically and chronologically—to *Homo ergaster*. There is also the interesting possibility that they are not all of the same species, or that they belong to species that are so far unknown.

At the moment, there is quite a gap between these early hominids on the fringe of eastern Europe and *Homo antecessor* (800,000 years, Spain) and *Homo heidelbergensis* (700,000 to 150,000 years in Europe and 600,000 years in Africa). As the former are represented mostly by immature subjects and the latter by adult males, it is unclear whether they are in any way related. In view of its brain volume (which averages 1274 cc), *Homo heidelbergensis* might well be the Neanderthal ancestor.

These *Homo heidelbergensis* were probably the builders of one of the oldest known types of constructed habitations found so far, at a site called Terra Amata in southern France. Several large, oval structures, 7 to 15 meters long and 4 to 6 meters wide, date back 380,000 years. Although the structures themselves have long since disappeared, post holes and stones lining defined areas are still visible. There are hearths as well. The domestication of fire was by that time a regular part of the hominid repertoire. The social implications of these home bases and hearths are obviously considerable: attracted to the security of shelter and domesticated fire, with advantages such as light, heat, and cooking facilities, groups would form and bond, and this would probably have led to internal organization and communication of a more complex order, as well as to all sorts of sociocultural activities that had not existed before.

In the same southern area of France, another site, discovered in 1821 and called the Lazaret cave, offers a vivid picture of its inhabitants' brief stay there. The levels date back to about 160,000 years BP, which corresponds to a short, warm interstadial period within the 300,000 to 120,000 years of the Riss glacial period. Game was in abundance in the lush environment of the

French Mediterranean coastal areas, which is why a group of hunters traveled there from their home base some 60 kilometers away to hunt and to dry the meat before carrying it back. How can we be sure of this? The tools found there were fashioned not only out of flint from 15 kilometers away but also out of black quartz from the Italian Ligurian region, 60 kilometers away, which is presumably where the travelers came from. There is also flint from the French Menton area, halfway in between. Large quantities of game were hunted, to judge by the bony remains of 23 stags, 6 mountain goats, and 6 aurochs, representing about 3,800 kilograms of meat. Of particular interest is what the contents of the hearth have to tell: small marine gastropods and other shells were discovered in the residue, indicating that seaweed was used for fuel. As seaweed is efficient in giving off neither heat nor light but produces a lot of smoke, the hearth was probably used to dry and smoke the meat. Furthermore, the red deer bones make it possible to determine the exact season of the hunt: the calves' teeth show them to be either 6 or 18 months old, so the hunt would have taken place between the end of October and the beginning of December. It is not known what *Homo* lineage these particular hunters belonged to, but one can imagine from the time frame that they were an early form of Neanderthal.

Neanderthals are our next topic. But before moving on, there's one other aspect of this site that vividly brings its seasonal inhabitants to life: the deliberately crushed bones lying around make it easy to imagine the feast of marrow that the hunters must have joyfully shared, before returning to their home base, laden with skins and dried meat.

Neanderthals and Homo sapiens

The first fossil ever to be found of a human different from ourselves was that of a Neanderthal. The first bones of a Neanderthal were found in Belgium by Philippe-Charles Schmerling in 1829. These were of a child less than two years old and were not then recognized as being of a distinct species. Part of a skull and fragments of a skeleton, discovered in 1856 in a quarry in the Neander Valley (Germany), were first interpreted as belonging to a distinct human "race," and not until 1863 were the fossils identified as being those of a new species: *Homo neanderthalensis.* Later on, their distinct morphology was incorrectly diagnosed as a case of modern pathological degeneration. It was not until 30 years later, at the site of Spy (Belgium), that Marcel De Puydt, Max Lohest, and Julien Fraipont found three Neanderthal skeletons and two skulls, this time within archaeological layers and, alongside, undeniably Paleolithic fauna and stone tools. Other discoveries soon followed, mainly in France, including the first Neanderthal burial, found in 1908 by Amédée and Jean Bouyssonie at Chapelle-aux-Saints

(Corrèze); this well-described skeleton served as a reference for Neanderthal fossils to come.

Named *Homo neanderthalensis* by most anthropologists, but *Homo sapiens neanderthalensis* by others, Neanderthals had evolved in Europe by at least 200,000 years ago as the last manifestation of an endemic European lineage, with roots going back at least half a million years. They spread over the European continent in all directions, from the Atlantic Ocean to as far east as Uzbekistan, and also south, as we know from sites around the Mediterranean, particularly in the Levant. The earliest reliably dated Neanderthal site with skeletal remains and stone tools is 175,000 years old (Biache-Saint-Vaast, France), but the majority of known sites are at least 50,000 years younger. Little is known about the initial stages of Neanderthal evolution, whereas hundreds of sites from 120,000 years BP onward have been found, some of them famous for their burials and well-preserved skeletons. This is the first extinct hominid that we can picture and discuss on the basis of abundant data. These Neanderthals must have had to adapt to considerable temperature variations: Riss glacial peaks first, then temperate to very hot climatic conditions during the interglacial period, before once again adjusting to the last, and coldest, Wurm Ice Age, which began some 80,000 years ago. Our most prolific and significant Neanderthal excavation sites belong to this period onward to about 30,000 years ago, a few thousand years before the species totally disappeared. The most recent evidence of Neanderthals comes from Iberian sites less than 30,000 years old.

Meanwhile, *Homo sapiens,* the species we all belong to today, arose in Africa. The oldest fossils of *Homo sapiens* found so far go back at least 200,000 years. Discovered in Herto (Ethiopia) in 1997, two skulls, of an adult and a six- to seven-year-old child, have been dated to 160,000 to 154,000 years ago and are clearly *Homo sapiens,* although not identical to any population living today. It appears, moreover, that these skulls were handled after death: skinned, scraped, and polished, as though in some postmortem mortuary practice, in which case this would be the oldest existing trace of ritualistic behavior by *Homo sapiens.*

Because of the 1868 discovery, in Les Eyzies (Dordogne), of the famous Cro-Magnon skeletons, it was long thought that *Homo sapiens* first developed

in Europe. Under a small shelter—called a cro in the local Oc language—
belonging to a certain Monsieur Magnon, modern human fossils were dis-
covered in association with the remains of Ice Age animals. The Cro-Magnon
"race" was established a few years later, in 1874. There were five skeletons:
three men, a woman, and a child, now attributed to the early Gravettian
period (around 28,000 years BP), as indicated by recently dated adjacent
Litorrina shells at the site. This is one of the oldest known Upper Paleolithic
burials.

Earlier *Homo sapiens* fossils were found later, in Africa, and also in the
Levant, the oldest of the latter about 95,000 years of age, from Jebel Qafzeh
and Skhul (Israel). Near Skhul is another site, called Tabun, where a Nean-
derthal was buried perhaps a little earlier, some 120,000 years ago. The last
known Neanderthal from the Levant is about 45,000 years old. There seems
to be evidence, therefore, that these two human groups lived at close quar-
ters in the Levant, before modern humans made their way to Europe around
40,000 years ago.

Should Neanderthals be considered a subspecies of *Homo sapiens* (*Homo
sapiens neanderthalensis*), or a different species altogether, *Homo neander-
thalensis*? If Neanderthals were a subspecies, they could have interbred with
Cro-Magnons (*Homo sapiens sapiens*), but no convincing skeletal evidence
of such mixing has been discovered. Today the majority of paleoanthropolo-
gists prefer to separate the two human types into distinct species, on the basis
of their DNA and numerous morphologic characteristics. Among those spe-
cific to Neanderthals are a large braincase, less high-vaulted than ours but
more voluminous behind, forming a kind of low "bun"; a continuous, pro-
tuberant brow; receding cheekbones, unlike our broad ones; a lower jaw that
lacks a prominent chin; and a generally heavier build.

Some specialists argue that the 1200- to 1740-cc cranial capacity of Ne-
anderthals—larger than ours on average—is good enough reason by itself to
justify attribution of these hominids to *Homo sapiens*. Cultural aspects, such
as burials and evidence of humane caring and healing, provide further argu-
ment. Many Neanderthal burials have been found, some of which have been
interpreted as ritualized. This is particularly true of some burials in France
(such as at La Chapelle-aux-Saints, Le Moustier, La Ferrassie, and Le Roc de

Marsal), where skeletons were found in dugout pits, arranged in fetal posi-
tion, and occasionally even protected by large stone slabs, with tools, traces
of red ocher, and animal bones that might have been meat offerings.

At La Ferrassie (Dordogne), seven individuals were discovered by Denis
Peyrony between 1909 and 1921. Two were adults, preserved in remarkable
condition: a man and a woman lying in fetal position 50 centimeters apart.
A ten-year-old child was found in one pit, two newborns in another, and a
three-year-old in yet another, covered this time by a stone slab decorated with
carved-out cupules. A fetus was also found in one of nine small mounds. A
two-year-old was discovered in the course of more recent excavations (1973),
along with a well-preserved elderly male skeleton that shows evidence of a
chronic bone disease, which must have handicapped him for years.

At the Roc de Marsal, practically on my doorstep, a four-year-old child
was unearthed in 1961 by Jean Lafille; in excellent condition, it is the finest
known example of a Neanderthal child. When admiring it at the Musée Na-
tional de Préhistoire in Les Eyzies (Dordogne), one can't help but notice how
similar the delicate skull bones are to ours, with, for instance, a flat forehead
and no prominent brow ridge. To our surprise, we learn that not until a Ne-
anderthal was eight or nine years of age did the brow assume its distinctive
protuberance.

Another striking example of possible Neanderthal burials is in Shanidar
(Iraq), where as many as nine Neanderthals were interred some 60,000 to
44,000 years ago. One of them has been romantically described as lying on a
bed of flowers, as suggested by the pollen found at the site, although we now
know that the pollen was probably introduced more recently.

Of the many Neanderthal burials, the Kebara grave in Israel deserves
special mention, because its relatively recent (1983) discovery allowed far
better recording—and understanding—of burial conditions than did older
finds. This 60,000-year-old male adult skeleton is in excellent condition, the
sturdy bones fresh-looking and shiny, as though they had just been buried.
He was laid on his back in a 25-centimeter-deep, deliberately dug pit, his right
hand resting on his left scapula and the left hand on his stomach. From his
cervical vertebrae and the mandible, one can see that his head was propped
against the wall, slightly higher than the body. The cranium is missing. There

is no sign that it was cut off while fresh. Careful study, in fact, reveals that the body was first placed in the pit, which was not filled with earth (perhaps covered with a stone to protect it from predators) until the flesh and tendons had disappeared. After this, the cranium was carefully removed, and the rest of the skeleton was left in the pit and covered with earth. With these expert observations, we have an unusual example of a complex burial in two phases (ritual, symbolic?). This is an exceptional case, but who knows what might have been found at the other famous burial sites had the same care and expertise been available at the time? We will never know what was on Neanderthal minds, but this example seems to illustrate unsuspected cultural complexity.

Proving which remains were intentionally buried, and which of these—if any—show evidence of ritual, is a difficult task, but an important one, considering that our cultural picture of Neanderthals depends largely on evaluations of this sort. More conjectural is the burial at the Roc de Marsal, where a child was found lying in a pit exactly in the center of the vault-shaped shelter. The central position of the skeleton appears not to be random but rather the result of careful planning. But there is no way of proving this. Once again, many major sites were discovered too soon, at a time when the finds were poorly recorded and precious information about the related archaeological context, as well as the burials themselves, was overlooked.

What else can be said about Neanderthal behavior? Bone chemistry and tooth wear provide information about diet, showing without question that they were meat eaters. Difficult times can be detected from stress indicators in the bones or on the enamel of their teeth during growth. Cases have been found of diseased or disabled people who not only survived their predicaments but either healed or continued living for years with their handicaps. A broken leg, severe arthritis, or partial paralysis would surely have meant death for someone on the move, had others not cared for and fed those unable to fend for themselves. This presupposes the development of a social environment, whether a group or a family, that was sufficiently organized and cohesive to support such a burden and handle the situation.

Items of personal adornment, in the form of perforated pendants and beads, notably at Arcy-sur-Cure (Yonne), constitute further evidence of sym-

bolic thinking. These are, however, "postcontact," dating from after the arrival of the first Cro-Magnons. Varied collected exotic objects, a few simple engraved nonfigurative designs on large stones, and some color sticks, consisting of chunks of red ocher and manganese dioxide shaped into a point, survive, although nothing is left to show us how these were used. Not much to go by, but neither has much evidence of symbolic expression been left behind by the contemporaneous African *Homo sapiens*. It is only when the first *Homo sapiens* made their way into Europe, around 40,000 years ago, that the earliest manifestations of elaborate art show up. One cannot help but be surprised that, culturally, there is nothing until then to distinguish early modern humans substantially from Neanderthals, not even in their technology. Nothing shows a superior intelligence on the part of *Homo sapiens* before the Cro-Magnons.

Just how important are the differences between Neanderthals and modern humans?

Couldn't certain physical specificities of Neanderthals be due to adaptation to rigorous continental climatic conditions? Their heavy build and slightly shorter legs, for instance, are similar to the morphology of present-day Arctic populations. As for their intellectual capacity, their minds: do we know enough today about how the brain functions to be able to extrapolate how the large Neanderthal brain worked? We do know something about these hominids' intelligence from their tools, which show remarkable efficiency and adaptability. From the burials, one can imagine the existence of beliefs or metaphysical preoccupations of some sort, and subsequently the use of complex communication forms in order to share them among members of groups. Why not?

Did they have language? In the absence of writing, there is no way of knowing with certainty. Of all the major issues in early cultural evolution, the most sensitive, the one most likely to inspire fiery debate, is language. We *Homo sapiens*—we modern humans—like to think that language is exclusive to us. But nothing would have prevented Neanderthals from forming articulate language. The higher position of their larynx would have made it difficult or impossible for them to utter certain sounds and may have given their voices a higher pitch, but the range of available vocal expression certainly

remained broad. Look at how strange some present-day populations' vocalizations seem to our Western ears: the San Bushmen's clicks, for example, or the high-pitched modulations of certain Asian languages. Around 2 million years ago, *Homo ergaster* may have had vocal possibilities broader than those of their predecessors, and *Homo heidelbergensis,* several hundred thousand years before Neanderthals, already had a skull base flexed like that of modern humans, suggesting a lower larynx and a wider vocal range.

Of course, the existence of vocal potential doesn't automatically mean that language existed. In order to form an opinion about this, we first need to explore the available cultural data, to try to evaluate, for each period, the level of intellectual development. This leads us back to tools. Tools are all we have before body adornment and artistic expression appeared. Paleolithic technology is our only chance of measuring how the mind worked, and how rational and creative early man could have been.

◆

Lower Paleolithic tools (from approximately 2.5 million to 300,000 years BP) basically consisted of what is sometimes known as pebble culture, consisting of stone pebbles and their hammered-off flakes. They are often called choppers when flaked at one end on one side only, chopping tools when flaked at one end on both sides, forming a cutting edge, and bifaces when they are worked more extensively on both sides. More often than not, the detached flakes were the tools, sharp and multifunctional.

The Acheulean epoch, starting about 1.5 million years ago in Africa and 500,000 years ago in Europe, is characterized by predominantly biface technology, usually with flint: the stone core itself is presumably the main tool, the flake residue secondary. This is obvious on bifaces with finely designed symmetric shapes, but the cruder ones that are abundant, especially in their initial stages, can be interpreted differently: it is possible that these are in fact what remained of flint cores after the artisans had helped themselves to as many flake tools as required. In this case, the biface is not a tool itself but a potential tool kit ready for use when needed, a reserve of flint tools.

Only when the Levallois technique was invented, some 250,000 years ago, did flakes dominate the scene again. Acheulean bifaces, made in Africa much earlier than in Europe, evolved from thick, rather crude hand axes into

finer bifaces with more regular, at times perfectly symmetric, proportions. The latter appear to have carefully designed shapes, which vary from small to large and heavy, thin to thick, slender to broad, oval, triangular, almond-shaped, or pointed, so that it becomes obvious that they were designed to serve predetermined functions. The purely technical term *biface* (flaked on both sides) thus seems more appropriate than the more popular *hand axe*, given that these tools could have been used as scrapers, for foraging roots, for crushing bones to extract marrow, for grinding seeds or other types of vegetation, as butchering knives, as hunting weapons, or for any other function one can think of. *Biface* is a more neutral term, and better accommodates the versatility of these tools.

During the Middle Paleolithic (300,000 years to about 40,000 years BP), Mousterian tool assemblage is generally associated with Neanderthals in Europe, yet, as is clear from the dates, these tools were in use long before the Neanderthals (unless these hominids prove to be older than currently thought). The Mousterian technocomplex is remarkably varied and adaptable over the whole continent. It is generally characterized by a heavy predominance of scrapers. At first, Denis Peyrony described two categories of tools: points and scrapers. Then, in the 1950s, François Bordes defined five or six Mousterian assemblages. His classification was based on two factors: the predominance of certain types of tool over others and the use of different debitage (stone-knapping) techniques, Quina, Levallois, or bifacial. Classification by type of tool relies on the relative quantities of thick Quina scrapers and of finer ones, for instance, or of denticulated and notched tools, or, more rarely, on the presence of bifaces. For the classification by debitage technique, Quina-type debitage (named after the La Quina site in Charente) produces thick, asymmetrical flakes; the Levallois technique results in fine, layered flakes; and, in bifacial debitage, the core and not the flake becomes the tool, as described above. Some researchers relate these categories to different cultural traditions, while others consider them, more simply, as technological options affected by the scarcity — or abundance — of flint. Different sorts of tools might also reflect different activities, depending on the season or the duration of settlement or occupation: whether the occupants hunted or fished, for instance.

Establishing such categories implies that every tool has been found exactly as it was initially planned, and that each tool is both intact and characteristic. Much as we archaeologists would like this to be the case, the probability of discovering tools in their initial condition is slender. An excavation site is more like a heap of leftovers than a museum. Should we not therefore see a tool as probably being at the end of its life, after multiple repairs and transformations, perhaps even after being discarded—or, as in some cases, put aside in heaps for potential future use? This approach would give us another picture, perhaps closer to reality. If this is the correct perspective, we should concentrate on the manufacturing techniques alone (Quina or Levallois, for instance) and consider variations in shape and size as cases of improvisation. By this view, the Neanderthals seem to have been more adaptable even than modern humans, who appear to be limited by more rigorous technological conventions.

Le Moustier (Dordogne), situated on the Vézère River, is the reference site for the eponymous industry. Discovered in 1860 by Edouard Lartet and Henry Christy, it was extensively excavated and reported by Denis Peyrony in 1930. It covers about 20,000 years of the Mousterian, from 56,000 to 35,000 years, and it yielded not only a remarkable abundance of tools but also two Neanderthal skeletons. The first, an adult, was unearthed and reburied several times just for effect by the Swiss antiques dealer Otto Hauser before being sold to the Berlin Museum, where only the badly reconstructed skull survived the Second World War. The second is a remarkable skeleton, in excellent condition: a Neanderthal newborn, now exhibited at the Musée National de Préhistoire in Les Eyzies.

To have spread so consistently over vast areas, throughout Europe and as far away as Mongolia, it is highly probable that the fine Mousterian flint technology was shared and communicated. Moreover, the complexity of certain fabrication techniques seems certain to have involved the use of language. A good example is the Levallois technique, in which the flint core is prepared first, shaped like a tortoise shell with a peripheral ridge that serves as the striking edge for a succession of flakes struck toward the center. The resulting production is a series of predetermined flake tools that demand minimal, if any, further transformation. With this method, much more useable cutting

surface is obtained from a core than would result from random improvisation. We're witnessing abstract conception here: a series of as many as 15 tools are "visualized" within a stone core, and each flake tool is detached, one after the other, in layers, each conditioned by the one before and influencing the shape of the one to follow. The main advantage of this brilliant innovation, more than 250,000 years old, first observed at the cave of Vaufrey in the Dordogne, is economy of resources, good quality flint being rare, except in some localities. Rational use of this precious raw material obviously enabled populations to move farther away from the flint source when necessary and become territorially more independent.

Could this controlled technique have been shared and spread without articulate language? How else would it have been possible to convey to others how not only to envisage the series at the start but also to deal with the inevitable disparities in density, texture, and structure of the stone itself? Surely a complex form of oral communication was involved. I find it hard to imagine that this sophisticated technology could have been invented without the long preexistence of language.

There is consensus that, as soon as figurative and nonfigurative art forms appeared, during the Upper Paleolithic (about 40,000 to 12,000 years BP) with the arrival of modern humans in Europe, the people obviously had language. Yet there was no art to speak of in Africa before—apart from a few engraved lines (at the 75,000-year-old site of Blombos Cave, South Africa) that are no more impressive than those left behind by Neanderthals in Europe. If art is the sole criterion, would that imply that during the more than 100,000 years that modern humans spent in Africa, before moving north, they didn't have language? It seems logical that, in order to spread the ideas, myths, or beliefs underlying the accomplished art that we have been admiring in the caves—in order, even, to develop them in the first place—complex language must have been elaborated long before the art as we know it.

There is no trace of any intermediate artistic phase between the few simple lines found in Africa and the exquisitely carved objects found in central Europe as early as 38,000 years ago. With time, many ways of expressing symbolic thought simply disappear into thin air: codified gestures, dance, music, perishable personal adornment, tattoos or scarification, objects made

of wood, hides, and feathers, and an infinite variety of rituals, few of which, apart from the burials, leave any trace. Yet all necessarily involve the use of oral communication.

The question of the existence of spoken language among species with the requisite vocal capacity that predated modern humans thus depends on our subjective appreciation of the limited yet eloquent surviving data left behind by hominids now extinct. Similarly, the question of whether Neanderthals are a *Homo sapiens* subspecies or, more likely, a totally independent species is influenced by the interpretation and hierarchy of a number of selected anatomic characteristics, coupled with each paleoanthropologist's intimate convictions on the subject.

◆

Another imponderable question is "What caused the disappearance of Neanderthals?" At the moment, there is no certain answer, but there are several theories. We know that *Homo sapiens,* who arose at least 200,000 years ago on the African continent, almost certainly met Neanderthals, not only in Europe but also in the eastern Mediterranean region. These modern humans produced Mousterian tools just like their Neanderthal neighbors; in fact, little differentiates the two culturally, from what we can infer from the archaeological data furnished by the Levantine sites. Around 40,000 years ago, modern humans moved toward Europe, logically overland through eastern and central Europe, where most of the oldest Upper Paleolithic sites have been found. However, a few equally ancient discoveries in Spain have made the initial itinerary less clear. Neanderthals all over Europe were evidently gradually confronted with these new neighbors. Whether they lived side by side or avoided each other, collaborated or competed during the approximately 13,000 years they coincided, we can't tell. What we do know is that the latest Neanderthal sites are in Iberia, and are just under 30,000 years old.

Naturally, the most popular explanation for the disappearance of Neanderthals is influenced by historical and present-day models: modern humans wiped Neanderthals from the face of the Earth. As human nature is commonly thought of as essentially belligerent, this appears to be the most likely scenario. Scientifically speaking, though, there is no evidence of human ag-

gression—of inflicted wounds, for instance—such as those found much later during the Neolithic, when conflict did exist and left abundant evidence. There are no scenes depicting human aggression in any form of Upper Paleolithic art, either. Evidence of cannibalism has been found, but this should not necessarily be confused with belligerence; on the contrary, it might, as in the funerary rituals of certain populations, represent a manifestation of respect and affection on the part of the group or of close relatives.

Most likely, the answer lies elsewhere. The theory that modern humans and Neanderthals interbred is still popular but seems improbable: first, they would have to have belonged to the same species, which is doubtful; second, if they interbred, why would the more specialized Neanderthal characteristics have disappeared? Other theories suggest that diseases previously unknown in Europe were introduced by the newcomers. Another scenario, which I favor, is that as modern humans encroached on their territory, Neanderthals moved away toward less familiar ground and more difficult living conditions, as suggested by traces of nutritional deficiency in the remains of some late fossils. Reduced to isolated pockets, their populations would have slowly and naturally dwindled before disappearing altogether.

None of this need have anything to do with intelligence, or its lack, on the part of the Neanderthals. Dispersion and isolation have led to the disappearance of cultural groups all over the world, and continue to do so. A more aggressive group (more belligerent or more culturally imposing, for instance) has the advantage over more passive people, but should the latter automatically be considered less intelligent? Were the Mayans less intelligent than the Spanish? Are the Tibetans less intelligent than the Chinese today? There is an all too common tendency to equate the term *successful* (for culture, race, development, or expansion, for example) with superior adaptability and intelligence. As we can see from these and many other examples, that is not necessarily true. Perfectly adapted indigenous groups, populations that are socially and culturally strongly structured and well established, may easily give way to more "powerful," or ruthless, newcomers.

The period during which Neanderthals and modern humans shared Europe is one of the most fascinating in prehistory, probably because we are modern humans ourselves and because so much remains to be understood.

Before tackling the rich, complex Upper Paleolithic period, which is marked by the worldwide supremacy of modern humans, another cave experience awaits us. Bringing us back to the Dordogne and drawing us into a dark, calm haven once more: Combarelles cave, a mineral cocoon webbed with finely interwoven engravings.

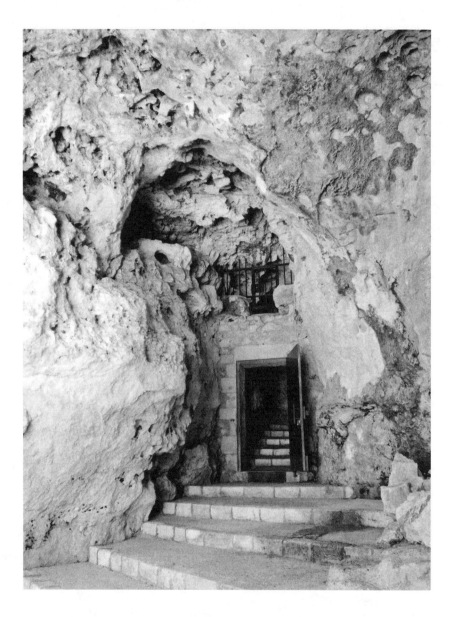

Combarelles, cave entrance

Combarelles

The engravings of Combarelles cave, 2 kilometers from Font de Gaume cave, were discovered by the owner, a Monsieur Berniche, and his son-in-law in 1901. The two caves are in the same valley, where the Petite Beune stream runs by before joining the Vézère River a couple of kilometers farther on. Unlike Font de Gaume, which is situated high in the cliffs, Combarelles is at valley level, in a small dell encased in humid woodland and carpeted with thick green moss and ferns. It's a secretive spot, the entrance hidden from the nearby road—or, rather, entrances: there are two caves side by side, Combarelles 1 and 2, plus a third cavity close to the road. Combarelles 2, which is not open to the public, is about 115 meters long and has about 50 engravings in poorer condition than those we are about to discover, among which is a representation of a saiga antelope, rare enough to merit special mention. The open shelter that houses both entrances was, like Font de Gaume, lived in, and the thousands of artifacts found here cover a couple of thousand years of the Magdalenian period, between about 14,000

and 12,000 years BP. This time frame coincides with the presumed age of the images we are about to see.

We will be discovering engraved art here, more than 600 figures, which makes this site one of the most spectacular for both the variety of species and the precision of engraving techniques. In the 1980s studies of the figures by Claude Barrière and Claude and Monique Archambeau revealed at least 200 more figures than the 300 announced by Henri Breuil, Louis Capitan, and Denis Peyrony in 1924. Barrière noted 141 horses, the predominant species by far, followed by 38 bison, 24 mammoths, 11 reindeer, 10 deer, 9 ibexes, 7 bears, 4 aurochs, 3 mountain lions, and 1 woolly rhinoceros. Many unpublished figures have been found since (for instance, one, or possibly two, of the rarely represented wild donkey). Furthermore, numerous geometric designs have yet to be deciphered. Anthropomorphic images are also exceptionally numerous in this cave: more than 50 are known today.

New figures are discovered every year, which is why the 284 figures first painstakingly identified and listed by Breuil after years of intensive study have now virtually doubled in number. Some are so fine, or so well hidden in the rock shapes, that they can appear in an instant, only to disappear as soon as the light shifts, remaining lost for years until, by chance, they are found again. Paintings once existed as well, but few have survived. When the cold began to give way to a more temperate climate, around 10,000 years BP, the melting ice and snow and the rising rivers caused some caves, especially those at valley level like Combarelles, to become active again, and water exuded through the porous limestone walls as a result. This saturation ultimately washed away most of the paintings, but it also accelerated the formation of calcium carbonate, which turned out to be a blessing for the engravings, which were thus coated by this hard protective veil. How much of the surface was painted is not clear, but numerous traces are still discernible, enough to know that the figures were made in various ways: painting on its own, painting associated with engraving, and engravings with no color whatsoever.

The nonfigurative designs vary considerably, from the simplest to the more complex and composite: there are dots, rectangles, meandering lines, squares, grids, triangles, circles with lines, crosses, zigzags, barbed signs, series of oblique lines crossed off in the center, tectiforms, and more. They are omnipresent, fascinating.

One can't help but marvel at how much there is to see in this cave. Beyond the incomparable diversity of animal species represented on the walls and the range of nonfigurative motifs, Combarelles is a paleoarchaeologist's paradise for human depictions. The 50 or so anthropomorphic figures compare with one or two in a typical cave. Images of humans in Paleolithic art are invariably schematic, stylized, or, when realistic, either incomplete, disproportioned, or part animal. They are frequently crude, caricatured, and technically clumsy (deliberately so, in contrast to the precisely depicted animals). They can consist of simple masks, barely identifiable outlined body contours, isolated vulva and penis figures, headless bodies, heads without bodies . . . all of which are found in this cave. How is it that these remarkable artists, capable of representing any wild animal perfectly, chose to distort humans in this way? During 25,000 years of figurative art, there is not one full picture of a human, realistic from head to toe, with a facial expression and detailed clothing. This lacuna can be explained only by strong cultural codes or taboos that restricted the subject matter and illustrates how significant the art in the caves must have been.

The absence of certain figures and themes tells us as much as the subject matter that is treated: both convey the symbolic content of the art and reveal its sociocultural implications.

◆

The entrance was originally not high enough to stand in. The full extent of the cave consists of a single 237-meter-long gallery, formed originally by an underground river. At the end, the gallery, dry now, narrows and slopes down toward a stream still running a couple of meters beneath our feet. The space in the cave was so confined that, for most of the way, the Cro-Magnon artists came in stooping or crawling on their hands and knees. Large reunions in the cave, for ritualized or ceremonial practices, for instance, were clearly impossible. Few people could enter at a time, which makes one wonder whether the art was ever meant to be seen once completed.

After the 1901 discovery of the cave, the ground was lowered considerably in order to allow visitors to enter more comfortably, so today we have no idea what the original surface looked like, except along the sides, where the calcified ground level is still visible in some areas. It wasn't regular or smooth, and some passages were encumbered by loose rocks, stalagmites,

and sharp, vertical, water-retaining calcified ridges, which made the going even more difficult. The alterations destroyed not only the ground but also whatever was lying on it: artifacts, tools, colors, or lamps, as well as traces left by the occupants, such as foot- or handprints in the wet clay. It's surprising, though, that so little damage was done to the engraved walls themselves, considering the volume of rock knocked away and evacuated in the rudimentary conditions of the time.

◆

Darkness surrounds us as soon as we pass the first few meters. Darkness and quiet. The walls are glossy with calcite, possibly wet. We mustn't touch them to find out, much as we are tempted to, as each trace of dust, pollen, bacteria, or microorganism of any kind offers substance for the proliferation of destructive algal or fungal growths. This is indeed a wet cave, still active, with glistening drops already tipping some short stalactites not far from the entrance. Unlike the graceful folds of Font de Gaume, the walls and ceilings are tortuous here, irregular, riddled with cracks, holes, and eroded stone formations of all shapes, or laced with ruffles of glistening crystallized concretions. This was an underground river millions of years ago; the water's pressure and fanciful turbulences fashioned the cave as we see it now.

The air changes after the first few meters. Cool on the face, damp, tasting like a fresh mountain brook. The transition is immediate; a different world imposes itself so suddenly, before we are ready, perhaps a little too quickly. Jagged outcroppings protruding from the ceiling slow our pace as the passage narrows, despite our cautiously lowered heads. Our eyes are not yet adjusted to the dark.

Fine traces of engraving are found close to the entrance, but they are few and far between; there might have been more, possibly eroded by air circulation, drafts, or temperature variations, but it is more likely that there were few figures at first, becoming more and more numerous the deeper we go. After about 70 meters, a few easily distinguishable figures are found scattered on the walls; these are individual, isolated cases, unlike those profusely superimposed farther inside. One of them is a strange anthropomorphic image: a stylized human head and torso in front view, an arm bent at the elbow, and a "trunk" or ribbonlike extension curving out from the head, downward, then upward; it has been called the "mammoth man," but who's to say whether

those lines are flowing out from the head or going toward it? Perhaps they are illustrating something more symbolic, such as emanations of the mind, words, or dreams?

The low, sinuous passage occasionally widens into a slightly more spacious chamber, fashioned by whirling waters trapped at a turn. This is what we will find all along the way: a single confined gallery, interrupted regularly by small chambers where we can stretch a little, as one can imagine the Cro-Magnons doing at the time. The cave's atmosphere, the darkness, the humid mineral odor, and the silence impregnate our minds, gradually eclipsing the outdoor modern world. As the entrance disappears in the dark behind us, the past awaits us and slowly takes form.

A sharp hairpin bend announces the section where the hundreds of engravings begin to appear, about 160 meters from the entrance. Unlike paintings, these are not easy to see: the light has to come from the proper angle to put the delicate lines into relief. Originally, these engravings were the creamy white color of the natural limestone. Every chiseled line was like a white line drawn on the dark, weathered surface of the rock, and this was even used as a supplementary color on painted surfaces, to highlight certain details. Farther inside, for instance, is an ibex outlined in black manganese with a finely carved white line added to give volume to its body and horns, a technique that reminds us of today's black-and-white pastels on grey paper. All these lines were therefore easy to see at the time, like white drawings, until the calcite mixed with dust impregnated them and eventually sealed and darkened them.

From here onward are 200 meters of uninterrupted imagery.

◆

The first animals that we see are horses, lots of them. Like concentrated herds, moving toward the depths of the cave on the left-hand wall, mostly coming out on the right-hand side, one behind the other or overlapping, nudging each other forward. The passageway is low and narrow. The walls are relatively smooth along a broad horizontal band, which is framed below by a prominent ledge and above by the coarse, irregular ceiling. The meandering lower ledge offers a convenient base for the animals, like an imaginary ground level, and the cave becomes a sort of landscape for them. Other figures share the left of the gallery with the horses. A crude masklike head, for

instance, consists of two eyes inside a broad pumpkinlike contour of a face, and signs abound, such as those superimposed on a large horse: a striated grid carved on its belly and a V shape on its rump.

So numerous are the engravings, in such a tangled maze, that it's impossible to describe them all. Deciphering the more obvious is hard enough. Most of the hundreds of lines are still a mystery to us; they could be surviving parts of animals, humans, or signs, the rest having been eroded or, if painted, washed away. They could have been deliberately designed to be incomplete or unrecognizable, perhaps to obscure their meaning from the uninitiated. The multiple superimpositions could be a deliberate ruse to confuse the viewer. I suspect that this is often the case.

The horses on the left-hand wall, facing the right toward the depths of the cave, are overrun by a series of similarly organized signs: several parallel oblique lines crossed by a thicker one in their center. Going in the same direction, a smaller horse, about 85 centimeters long, is adapted to the natural shapes of the cave: natural holes fit both the eye and the nostril, and its backline and mane follow a ridge; the body and head are outlined by fine engraving. Farther along, this time facing left, is a smaller horse's contour, deeply carved with sharp, bold lines, its haunch, its belly, and especially its head fitting within the rock shapes; a fossil outlines the lower jaw. It seems to be striding through grassland, the lower section of its legs hidden by the natural horizontal ridge. Perfectly detailed are its muscular legs, knee joints, flowing tail, and bristling mane. There is motion here.

Just beneath the horse, a trained eye can detect the double mark of two Cro-Magnon fingers running along the wall, which was once coated with silt. The fingerprints appear to be alive, dancing along the irregular surface, tracing an imaginary ground level for the horses. Are they those of the artist's hand, or someone else's? Whoever they belonged to, these finger markings leave a strong impression on us: we're in contact with a person who was there at the time, someone who suddenly becomes real and alive, surprisingly tangible, surprisingly close to us in the intimacy of the cave.

On the opposite wall, along with other animals, there are again many horses, most facing right, like herds going back toward the entrance. Among these is the most realistic of the cave, as well as one of the largest—1.10

meters long—which explains why it was the first to be "recognized." This is reputed to be the figure that led to the discovery of the cave art. Its head is remarkable, with a shapely jowl, detailed lips, nostril, forehead, eye complete with eyelids, two ears in perspective, with some hair between them, and a thickly crested mane. The cheekbone corresponds perfectly with a convexity in the rock, as do the rump and hindquarters. Its belly is voluminous, but it's visibly a male. Usually, in the drawings, horses are indistinguishably male or female, and large bellies have frequently been interpreted as belonging to gravid mares, but in this case a penis tells us otherwise. Round bellies are characteristic of Przewalski horses, a species that still exists. The thick extra fur that they must have had during the climatic conditions of the Ice Age would have made them heavier looking. A line is traced between the jaw and ears, which might look like a bridle, but it isn't: this breed does not yield to domestication. Rather, the line is that of another horse's head, facing left; with the other horse's body and bristly mane, this second head is turned back, eye and nose at shoulder level. This horse has two heads!

Above its rump is the head of another horse, following closely. Its eye is a large natural hole; its nostrils, lips, and mane are delicately engraved, but the bristling hairs of the mane are strongly accentuated by thick black manganese brushstrokes, regularly spaced among the finely chiseled lines. This is a good example of painting and engraving combined.

After horses, the predominant representations are of anthropomorphic figures. Most caves have one or several star features among the restricted conventional range of subject matter. In Font de Gaume, bison are the most numerous, followed by horses, and there's an omnipresent combination of bison and mammoths; in Lascaux, the horse predominates, frequently associated with either bison or aurochs; in Rouffignac, the mammoth is by far most frequently represented, followed by bison and horses. The fact that the dominant theme can vary from one cave to another doesn't obviate the aspects they have in common: recurrent associations between certain types of animals and between certain figures and signs; similar limitations in subject matter; and the vast realm of themes that are totally absent, probably taboo. The thematic consistency does not seem fortuitious. It can be explained only by thousands of years of a common understanding of beliefs and practices.

◆

The narrow passage now widens into a slightly more open circular space, where several mammoths are grouped. Bending down, we can admire two mammoths facing each other, one small, the other large, each fitting perfectly into its respective concave space. Both have exaggeratedly long trunks curled back against their bodies, their sensitive, double-finger extremities well defined. The mammoths' anatomy is accurately portrayed, with a sloping backline, a characteristic V-shaped dip where the back and head meet, and a hairy belly, body, and legs. The smaller one, on the left, is easier to see and is full of details, whereas the one opposite is masked by a thick layer of calcite; both are standing at the cave's original floor level, engraved therefore by an artist who was crouched on the ground in the most uncomfortable of positions. Yet the lines are sure and precise. Just above our heads is another, much smaller mammoth hidden among the many knobbly, water-eroded stone protrusions of the ceiling: the whole animal is in fact conveyed by the rock shapes, and only a few finely engraved lines add a final touch here or there. If you didn't know it was there, you wouldn't see it. There is always an incongruous mixture of obvious, clearly discernible figures next to others that are hidden either in nooks and corners or underneath other lines or are too small or too fine to see.

◆

More and more engravings cover the walls. The deeper we go, the more densely interwoven they are. The winding, confined passage now becomes an uninterrupted sequence of superimposed figures—no, rather, a tangled maze, which we shall attempt to unravel as best we can. A couple of meters away, on the left-hand side, is a panel with a group of interesting human depictions: three stylized, headless feminine profiles facing left, slightly bent forward, one behind the other (Fig. 4). Each illustrates a different stage of abstraction: the one on the right is simple but well proportioned, with a curvaceous back line, a breast, a slim waist, a small stomach, a thigh, and a leg; the central figure is a simplified version of the previous one, with the same back line but no breast and an exaggerated stomach and thigh; finally, the disproportioned thigh of the one to the left becomes a large, triangular vulva, with the curved back line still there, but less obvious. This composed series of closely interactive figures is a good example of progressive, deliberate ab-

straction. Sequences such as these, drawn either in the caves or on bone, make it possible to measure the intellectual elaboration of abstract concepts, to understand that the simplification of a figure is willed and not random or due to clumsiness.

There is more on the panel: the trio is completed by another vulva, to the right (symmetric to the vulva on the left?), and, on each side, pointing toward this female group, is an erect penis approximately the same size as each female. A large triangle links the penis and vulva on the right. This is not a triangle scratched haphazardly on top of the two sexual symbols; in fact it cleverly encompasses them: the horizontal base and left angle carefully frame the vulva, the top angle is central, and the right-hand side of the triangle joins the penis but, instead of cutting through it, bypasses it, before forming the third angle with the base just underneath.

These grouped figures are virtually at ground level. A portion of the original floor is still intact, and we can see that water was retained in several tiny pools by sharply ribbed, calcified ridges. Imagine this composition just above these mini-retainers filled with water, glistening in the flickering light of tallow lamps. Was there water there at the time? Did the water reflect the images? Was there some special meaning in the connected presence of water and these female and male figures? We will never know, of course, but we can sense that this particular spot was carefully chosen. Two more finely outlined feminine profiles, and maybe more, lie hidden in the cave's intimate folds, closer to the ceiling. Reduced to the strictest minimum, these very discreet figures would not be identifiable if it weren't for the more obvious ones nearby.

◆

On our left, where the passageway turns at right angles to the right, more anthropomorphic figures are concentrated in a more spacious, alcoved area: these are either simplified or grotesque, with big bellies, disproportionate or distorted heads, and attitudes that are more animal-like than human. Two large representations are bent over, one behind the other, toward the left; if it weren't for the hand of the one in front and the human leg of the other, they could easily be taken for animals. They are described as being a female in front of a male; this is clear for the latter, who is endowed with an erect penis, but nothing indicates that the figure in front is female. The male's leg and thigh lines are used for the back of a third figure, much smaller and

turned to the right, sexually undefined, headless, and apparently walking. Many other engravings cover this intimate corner—animals and signs as well—but the anthropomorphic images are the most intriguing. One more figure, just to the right of the alcove, is worth mentioning: it's a vulva on its own and, for once, realistically depicted, with detailed anatomical features, unlike the simple triangular, stylized versions.

On the right-hand wall, more or less opposite the group of feminine figures described above and just before the turn, are many figures, including a superb superimposition of three small animals. First is a small bovine head facing right, so beautifully carved that it appears to be modeled in relief. This head could also be a donkey's, depending on which of the two back lines you choose for it: the neck and back of the bovine are typically at the same level as the head, and a tail, detailed hind legs, and a belly complete the picture; whereas the wild donkey—probably not a horse because there is no horse's mane—has a sloping neckline and lower back, and its belly is suggested by a ridge farther down. The third animal is a cleverly superimposed mammoth, which shares the back of the bovine but faces in the opposite direction and has a head and trunk added to the bovine's rump and a front leg corresponding to the bovine's hind legs. These three animals are exquisitely interwoven and engraved, again practically at ground level, which wouldn't have been an easy task.

Were they carved simultaneously by the same artist or by different artists? It is impossible to know, although I see only one hand at work. The three together take up no more than a 20-centimeter-long space, the mammoth being only about 10 centimeters high, whereas just around the corner is a large horse, more than a meter high, its front leg touching the small mammoth's head. In fact, it has three forelegs, as though in motion; this is not the only horse in the cave with more than two front legs.

The disparity in the sizes of neighboring animals that we observe everywhere in this cave, but also in other caves, remains unexplained. At the moment, there seems to be no logical pattern to these discrepancies, which are often interpreted as adaptations to the natural rock. I imagine, however, that there is more meaning to them than that.

The ceiling is higher around the corner, and there's more room, so the artist could actually have stood up here. To our right is the abovementioned

three-front-legged horse facing right: massive, taking up all the available space, with its long bushy tail, its belly, and its back well defined, and its head somewhere on the worn-down rock protrusion jutting out from the hairpin bend; a few finely engraved lines are all that is left of its crested mane. Another horse follows, its hind legs part of a large profile view of a human, who is pictured in a seated position, facing left. From the waist down, the body is realistic and well proportioned, with a clearly defined leg and foot, whereas the rest of the body is crudely suggested by straight lines for the torso—the same lines as those of the horse's tail, a short line for each forearm, and only a half circle with no added features for the disproportionately small head. The contrast between the accuracy of the lower part of the body and the clumsy, rigid aspect of the upper half is surprising. Some have interpreted this disparity as evidence of the work of different artists on the same figure or completion of the figure at a later date, which comes to the same; I believe this to be another example of the common deliberate distortion of human representations. Incidentally, this is not the only place where a horse and a human are interconnected; there are several other examples in this cave.

Many other figures are nearby, more difficult to see, two of them particularly delicate: a barely visible geometric sign, consisting of a fine circle with parallel lines running through it, and, even finer, another of those small feminine figures in profile, with a back line, thigh, and stomach that together form a perfectly harmonious design. The breast might be there as well: a small bump on the wall. If it weren't for the characteristic curvaceous back line that we can now recognize at a glance, we wouldn't know that it's a woman and would take it for an elaborate abstract sign instead.

Opposite this panel, on a smooth space where the clay-covered, reddish wall is exceptionally devoid of calcium carbonate, is a mammoth. For once, the fine engraving appears white against the red, practically as clear as when it was created. Its trunk is turned back, like those already described; the tusks are long, the back consists of a series of fine lines that give the body volume, and its four legs, in perspective, are lined with short curved hairs, down to the soles of their feet. I particularly like these hairy, pudgy feet! To me, they're comical, and I invariably smile when I go by that familiar mammoth, usually in the dark during the visit. Close by, to its left, is another detailed vulva, finely engraved.

◆

Another right-angle turn rounds the corner toward the right. This turn and the previous one form a broad U-turn — the seated human and the mammoth on opposite sides of the section corresponding to the flat of the U. Whirling waters, trapped in a small conduit within the solid rock, formed a smooth pothole here, discovered when the ground level was lowered for the second time; two finger bones and a human canine, coming from who knows where, were found inside the bowl-shaped cavity.

Just around the turn, a group of 10 small bison are arranged on the left-hand wall, all of approximately the same size, between 20 and 30 centimeters, and all facing left. They are standing on two natural, parallel ridges, as if on two hillsides, one behind the other. Most of them are only partly visible, but one is remarkably detailed: its horns are in perspective, with a tuft of hair between them; its eye, ear, furry beard and chest are all engraved, as are the sleek belly, penis, tufted tail, and legs; and the humped back closely follows the curve of the rock. Superimposed on its belly are two very small figures: a finely outlined ibex neck and head facing right, with exaggeratedly long antlers elegantly curved backward, and one of those simple tectiform signs.

We saw the same in Font de Gaume: tectiforms on a bison.

Higher up is a large doe, with probably the most graceful head and neck I've ever seen. The ears fit two crevices, the back follows a natural ridge, the tail is a bump on the wall, and, when we get to the long, graceful hind legs, we find the same sensitive engraving as for the head. The contour of the forehead and muzzle is so precisely that of a doe that there is no mistaking it for a reindeer or a stag. In fact, there are two reindeer close by, and it's easy to see the differences, not only in their antlers but in the shape of their muzzles: square and thick for the reindeer, finer and more pointed for the deer. This doe is perfect.

The two reindeer are just a bit farther, facing each other on the same side. The left-hand one is probably a female, with its slender neck and shorter antlers, whereas the right-hand one is definitely a male, characterized by a prominent chest lined with thickly protruding fur and a huge antler, the palm of which gets lost high up in the confusion of the ceiling above. The female has a magnificent head with a tear-shaped eye, and the back line and hind leg are outlined, the back being exactly adapted to the cave's stone ridge and the

hind leg to a thighlike prominence; the male's back follows the same ridge, and its head is adapted to a rock protrusion, but its hindquarters, belly, forelegs, and chest are deeply carved, almost sculpted, with sharp, vigorous incisions.

Neatly fitting into the space between their heads is the rear half of an aurochs. To my mind, it was probably added by a different hand and at a later date, because, unlike the expert, sensitive engraving used for the reindeer, the lines for the aurochs are crude; moreover, they don't have the same patina, they look fresher. The two reindeer remind me of the reindeer scene we saw in Font de Gaume. The composition is not quite the same, of course—one is not licking the other—but they are also facing each other and appear to be a male and a female. For their interrelation, another factor, the cave itself, must be taken into account: each figure, or group of figures, is adapted to the rock shapes and closely integrated within the available space. Reminiscent of Font de Gaume as well is the artistic quality of line and the gentleness of their manner.

◆

So many figures cover the walls everywhere, every centimeter now, that we can't possibly stop to see them all. The nearby large mammoth with its thick-looking, wrinkled skin, and huge tusks, for instance, its eye sunken in the wall's folds: of all the mammoths in the cave, I admire this old creature most, old and gnarled like the bark of an ancient oak tree. Another marvelous reindeer is nearby. We are obliged to make choices each step we take. Days and weeks would be necessary to see as much as possible, and even then much would escape us, because so many of the identified images are intimately interwoven with lines that are not understood. The deeper we go, the denser the network. The ceiling is low and treacherous, which adds to the difficulty, yet we are far more comfortable than the Paleolithic artists, who had to crawl on their hands and knees. A relatively large ibex can be seen at ground level on the right: just its head, neck, and back, as it's too low for any legs. It has an unusual eye, with closed eyelids, and its mouth is open; its forehead is "colored" inside by a broad band of rock surface that was carefully scraped off to look white at the time. This is a good example of how engraving was used for whiter shading effects.

After ducking into a particularly low passage, we come to where the

most complex panels are grouped, in the deepest areas of the cave. Just before these, though, on our left, there is a tiny deer figure, only a few centimeters long, at ground level and facing left; it is one of the many relatively recent discoveries. On the left-hand wall of this confined passage, we find a tangled maze of horses, aurochs, deer, donkeys, and rhinoceroses, as well as a mountain lion.

First, there's a remarkable donkey's head facing left: there's no question that it's a donkey, with its thick lips, broad jaw, slit of an eye, and big ear. It looks as though it's laughing! It is part of a complex superimposition that includes a large aurochs, a horse going in the opposite direction, and another horse that can be recognized by its mane. Many animals are incomplete, but enough of each is there to identify the species, even when the animal is reduced to a minimum: a mane or a simple back line, for instance.

A step farther, and there's the woolly rhinoceros. Small and simply outlined, its head is low, with an eye, a large ear, and its double horn pointed left; we also see the voluminous humped back that characterizes this type of rhinoceros, adapted to the cold. Its body is on a vertical doe's head, which is lifted up, mouth open, as if calling or eating leaves from a tree. The two animals are carefully superimposed and are connected in a way that I feel was planned, and therefore contemporaneous. A superimposed triangle linking the two animals could be further confirmation of this intention.

And just above, at last, the famous mountain lion! More likely a lioness. It faces right, and only the front half is visible, about 70 centimeters long (Fig. 5). It looks so real, pacing along with long muscular forelegs, head stretched forward and intent, prolonging the typically feline back line. The head and jaw muscles are bulging, the nose line is perfect, and the mouth and protruding lower lip are delicately outlined around a patch of white crystallized calcite that looks like frosty breath or dripping saliva; the effect appears to be deliberate because the engraved lines are on top of the calcite. The eye is engraved just above a misleading bit of plaster that masks a hole made by a visitor: the eye is in fact small and circular, with a long tear pit running parallel to the nose.

It is so alive, tense, intently moving forward!

Another lion is immediately in front, going in the same direction; but only part of it is still visible. Its long tail is gracefully curved beneath the

former's head; the hind leg and thigh are there, and a belly thickening with hair toward the chest, like a mane, indicates that it is probably a male. A pair of lions, the female following the male.

The narrow passage now opens into a small circular chamber, but just before, on the right-hand side of the wall and opposite the lioness, is a small bear, among numerous other figures. This animal is another that is relatively rarely depicted. It has a well-defined head facing left, a slightly lifted, pointed muzzle, and a plump body suggestively fitting into the natural rock shapes.

We are now in a more comfortable space, although originally it was not quite high enough to stand in. To our right is a concave space filled with engravings, among which we can discern a human and many magnificent animals. One of these is the famous "drinking" reindeer (Fig. 6). Despite its small size, only about 40 centimeters long, it is one of the liveliest of all the animals, perhaps because of its perfect proportions and natural posture. It stands to the right of a vertical crevice that broadens into a small pool-like depression at ground level, its neck and head stretched toward the dark hole as if it were drinking from a pool of water. One can actually see its tongue protruding. The hindquarters are slightly higher, which accentuates the forward stooping motion; exaggerated antlers and the tuft of hair on its chest indicate that it's a male. The impression this image invariably leaves on the onlooker is one of a peaceful hillside scene.

To the left of the crevice, a larger ibex appears to be climbing out, its back emerging from the vertical crack, its straight front legs at a higher level and its head in a typically proud, goatlike posture—exactly as an ibex would look in its mountainous surroundings, rounding a corner and looking far into the distance. Although on a different scale, the ibex being much larger than the reindeer, both seem to be part of a natural scene. The rock wall becomes a landscape, with hills and possibly an imaginary waterfall, for these two animals. The other animals on the same panel appear to have no such consistent grounding. They seem to be floating.

Numerous animals are cleverly interwoven here: the chest of the ibex, and possibly its foreleg, are also the chest and foreleg of a horse facing it, and the same lines serve for the right side of a standing human. The same lines therefore contribute to three different figures: ibex, horse, and human. The human consists of a body contour, front or back view, with two legs but

no head or arms. It is topped by the ibex's head. The horse, facing right, is large and well proportioned. We are again witnessing the combination of horse and human, a recurrent theme. Superimposed on the horse is a graceful, prancing ibex, facing left. And just above, another ibex faces right; this is the one already mentioned because of its color, which is still intact: the painted manganese contour is outlined by a finely engraved line, resulting in a black-and-white contrasted effect, which gives shape to the animal. A small bison, approximately 15 centimeters long, lies hidden in the ceiling's tormented rock formations directly above our heads, part natural, part engraved; the head and hump are the natural edge of a jagged rock protrusion, and a fine line cleverly completes the hindquarters and belly, with just a light touch here and there.

At ground level once more, back to where most of the animals are concentrated, we see a second bear to the left of another large horse. This one is much bigger than the first, and fully engraved this time. This is to me the finest bear in all Paleolithic art. Heavy bodied, depicted standing at the original ground level of the cave, its head is low, as if it were sniffing the earth; both front and back legs are in perspective, plodding along, and its back line is characteristically rounded. It couldn't be more bearlike! The tips of some of the front claws are shown, making them seem to be scratching the soil, and there are other small details, such as a stumpy tail, a slit eye, an ear, and a protruding shoulder blade, which adds to the bear's lumbering motion. Curiously, a natural shape looking just like a bear's head is near the engraved one, like a shadow. Could it be that there are two heads for the one body, one of which is clearly defined and the other hidden in the rock? I wouldn't be surprised; we've seen it before.

Pursuing our search for images around the circular chamber from right to left, we come across a confused, vigorously carved network of superimpositions on a relatively smooth panel to the left of the bear. About 10 figures have been identified among the hundreds of lines: a horse's hindleg, a mammoth, a deer with an arched back and the head lifted up as if calling, another remarkable bear with a round eye, ear, and mouth all deeply incised and jaws that seem to be tightly gripping something the size of a coin. More finely engraved are two more horses, which are incomplete, and a distorted anthropomorphic profile consisting of a round head complete with nose, mouth,

and chin, hardly any neck, and a short, squat torso. It is very strange, and looks almost like a curled-up fetus. This is at ground level, where, alongside, many deeply carved vertical and oblique lines are arranged in such a way as to form grounded triangular designs or a graphic system of some sort, with alternating short and long lines.

◆

This small chamber is in fact at a bend after the narrow "lion gallery," an area where whirling waters eroded and widened the space before continuing perpendicularly to the left, toward the end of the cave. It's a strategic spot, a small chamber linking one narrow gallery to an even more confined one. As might be expected, and as is so often the case, graphic signs announce this difficult passage, barely 30 centimeters high, which one can squeeze through only with great effort: in this chamber are two tectiforms facing one another. One is the simplest tent-shaped version, engraved, lopsided, in a concave space that is diagonally opposite the coming passage, on the right; the other is a few centimeters away from the passage, on the left: this one is a complex version, with extra lines and arcs inside, all finely and carefully carved. I'm certain that it is not a coincidence that these signs face each other, in this particular spot. We will see a similar disposition of tectiforms, also in a narrow passage, in the Bernifal cave.

Just as significant, if not more so, is another figure, directly above the tight passage: a small negative handprint, a child's, which just fits into a small concavity among the jagged shapes of the ceiling. So confined is the space that one wonders how it was possible to apply, or spray, the black manganese around the hand. It must have been important, because it certainly wasn't easy. Even more difficult to get at is a red spot facing the hand and completely hidden from view. Are these symbols—the tectiforms, the hand, and the red spot—somehow connected with the forbidding passage lying ahead and the art beyond? Are they an encouragement to pursue our exploration to the depths, despite the physical effort involved? Or are they a sort of symbolic punctuation within a global statement, related to the other figures, those before and those to come?

Dozens of engravings line the narrow, meandering 30 or so meters ahead, including many horses, many anthropomorphic figures—particularly caricatured profiles—many signs, and animals of diverse species. This section

is not open to the public, of course, but I have had the privilege of seeing it, and I shall never forget the experience. Edging my way along, centimeter by centimeter, so close to these beautiful, fragile engravings, made me realize, in a powerful way, how extraordinarily significant the cave, and all it holds, must have been. It brought to light, forcefully, the unfathomable mystery of its imagery.

•

On our way back toward the entrance, the distance seems longer and the progression through the cave's narrow passages even more difficult. The Cro-Magnon artists crawled, or crouched at best, along nearly the full 237 meters, holding a stone grease lamp, carrying colors and chisels for engraving, and perhaps some extra fat for the lamp, just in case, to mention only the bare essentials. This is certainly not the most convenient of places to perform art of any kind, and it becomes clear that the cultural motivation and implications must have been strong for such an achievement. In the impressive, majestic, cathedral-like Font de Gaume cave, it's easy to let one's imagination go and visualize rituals, ceremonial events, important social gatherings, but in Combarelles this was obviously not the case. There is a sense of intimacy, of solitude in these secretive meandering passages that seem never to end. It's a completely different journey altogether, which perhaps only a few privileged people at a time could have experienced, on rare occasions.

The striking disparity in the size and topology of the caves chosen by Cro-Magnons contrasts with the relatively homogeneous artistic codes and thematic limitations that lasted thousands of years. I often wonder "Why this cave and not the one next door?" There are thousands of caves in this limestone country to choose from, and nothing logical, from what we can understand, seems to link the selected sites. Their entrances face in all directions, their altitude, height, depth, length, and spatial distribution vary. They can be wet or dry, with or without stalactite formations, and the rock surface itself varies from soft chalk to hard calcite, from rough to smooth. Yet some reason must have guided each choice. Perhaps the chosen site was part of a legend or myth. Perhaps a major event, or some magic, took place there. Perhaps a spiritual leader or a wise man once lived nearby. It could also have to do with the shape of the rock formations, evoking animals, landscapes, spirits, the

passage from one world to another. Or it might have been the physical effects that certain minerals had on people, effects that we are not aware of today.

The selection might also have had something to do with sound. Sound resonance flowing along the narrow passages, from one chamber to another, echoing on its way. In unaltered caves, it has been observed that there are punctate signs or important art panels where the resonance is greatest. As we no longer have the original floor level here, we can never know exactly how the cave sounded at the time.

◆

The two caves we've explored so far are very different in size and shape, which is one of the reasons they might seem to be, at first glance, graphically distinct. This impression is reinforced by differences in the media chosen: polychrome paintings for one, engravings for the other. But we should recall that in Font de Gaume, alongside the polychromatic work, engravings as well as monochrome figures abound, and that there were paintings in Combarelles that have not survived. Need we be reminded further of the adaptability of these artists to rock surfaces and spatial imperatives, which influenced their artistic techniques? If one were to concentrate on the depictions themselves, one could not help but notice how much the caves have in common, such as similar subject matter and thematic combinations: the prevailing horse/ bison/mammoth figures, for instance, and the tectiform signs, specific to only five caves in close proximity. The remarkable sophistication and technical quality of the art at both sites is yet another aspect that links them.

◆

Finally emerging into daylight and turning around for a last glance at the impressively dark, narrow entrance, one cannot help admiring the determination and courage of the artists who went so deep inside to create such wonders. But above all, once again, it's the beauty of what we have just seen that stays in our minds. So lively are the animals that the celebration of life itself could be one of the purposes of the art. Sensitively portrayed, each individualized by its particular animated manner and expression, the animals are depicted not only with talent but with respect, admiration, possibly reverence. Yet at the same time, they cannot be seen as interacting in a purely naturalistic manner, as many of these species would not normally be

found side by side. They have more to them than meets the eye. Indeed, they no doubt illustrate concepts of a far more obscure, symbolic order.

In contrast to the larger caves, with their spectacular assemblages, the lack of space here confers an intimacy with the figures that draws us into the stone among them, forcing us to participate, sharpening our attention as well, as we attempt to decipher details among the tangled lines. Here's a whirl of interwoven imagery, where the secrecy and complexity of the message are even more palpable, more acute than anywhere else. The intricacy and abundance of figures are such that any search for logical explanations appears to be vain, even irrelevant. The usual aesthetic approach is gradually overcome by the experience itself, the mystical slowly penetrating our minds. I have noticed over and over again how each viewer emerges from the visit deep in thought, each with a quietly chosen figure in mind, a favorite, one in particular that he or she will carry away, and remember.

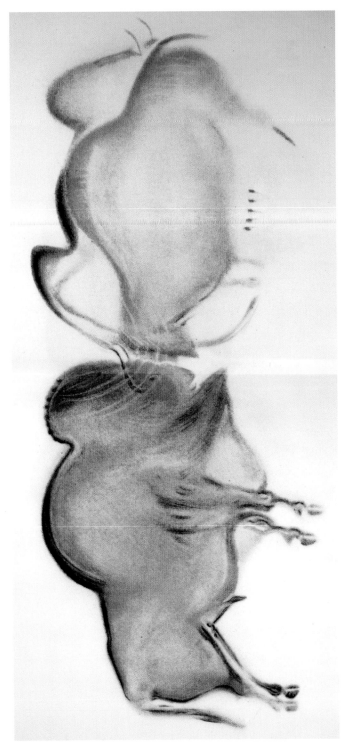

Plate 1. Font de Gaume. Two bison head to head, with superimposed mammoth(s), as drawn by Henri Breuil (Photo Philippe Jugie)

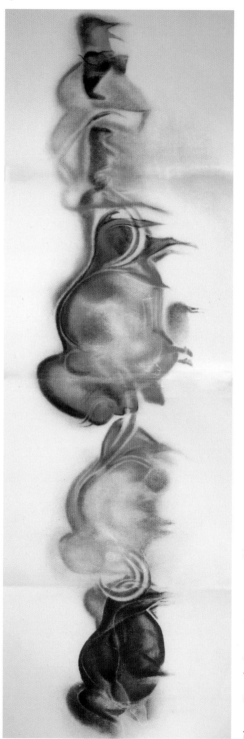

Plate 2. Font de Gaume. Superimposed bison, mammoths, reindeer, and horses as drawn by Henri Breuil (Photo Philippe Jugie)

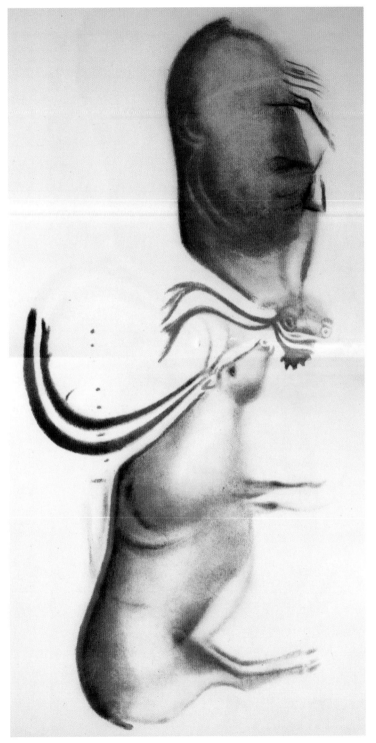

Plate 3. Font de Gaume. The "licking reindeer" as drawn by Henri Breuil (Photo Philippe Jugie)

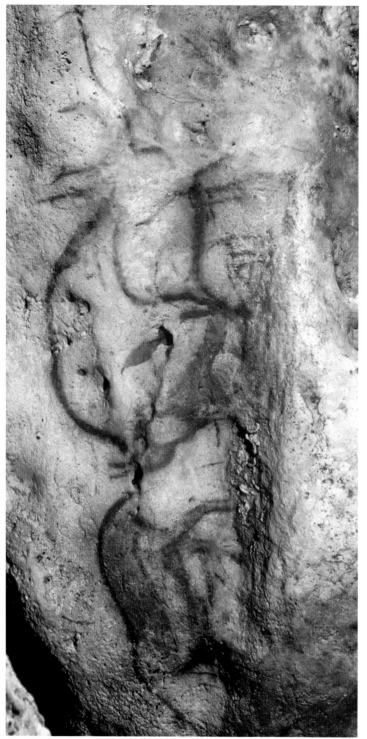

Plate 4. Font de Gaume. The "black frieze": a bison and a deer in the center are superimposed and facing opposite directions for a three-dimensional effect; another deer is to the left, drawn in bold and masterly lines, and part of a bison can be seen at right. Note the "cubist" effect on the central deer: its head is in profile view, and yet the horns are practically face on. In the flickering light of grease lamps, the head would seem to be turning. (© N. Aujoulat-CNP-MCC)

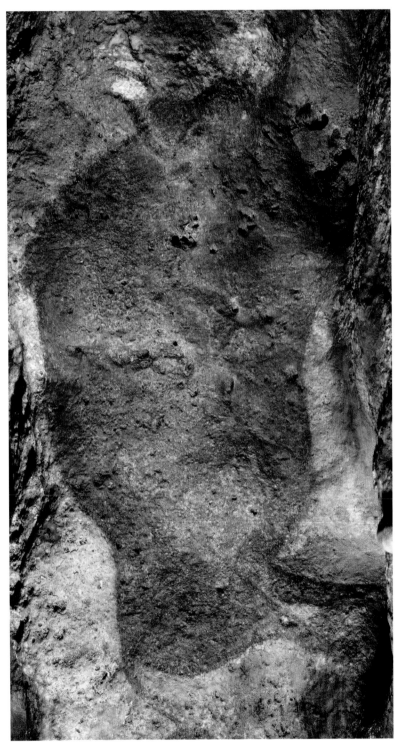

Plate 5. Font de Gaume. One of the finest polychromatic bison, in the last gallery. The subtle variations of browns, the details of the animal's anatomy and fur texture, and of its expression, make this painting one of the most remarkable examples of cave art. (© N. Aujoulat-CNP-MCC)

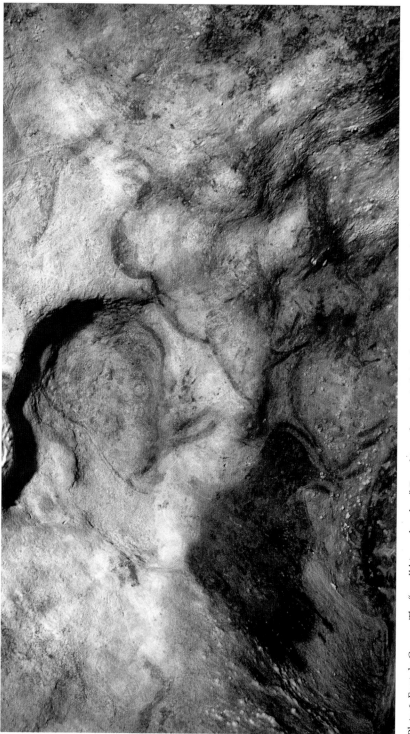

Plate 6. Font de Gaume. The "small bison chamber." Four bison form a circle in the center of the rotunda. The animal to the right is half bison (the rear), half mammoth (note the tusks). The left-hand black bison's tail flows elegantly down to form the lower bison's. This alcoved space contains many other animals and signs. (© N. Aujoulat-CNP-MCC)

Plate 7. Rouffignac. Detail of the "ten mammoths" frieze. Two groups of mammoths meet on a slightly protruding section of the wall, fitting in a horizontal "landscape" between the lower ridge and the band of flint nodules above. Note the striking effect of perspective, and how the backlines and certain details vary for each animal to give a naturalistic effect. (Courtesy of Marie-Odile and Jean Plassard)

Plate 8. Cap Blanc. The left-hand section of the 12-meter-long sculpted frieze, including the magnificent life-size central horse (© N. Aujoulat-CNP-MCC)

Venus Figures, Blades, Beads, and Bone

O ur Cro-Magnon ancestors become more real with every site we visit. Of course, the dates are impressive: art that goes back 12,000 to 17,000 years or more in the caves we've just seen. And these are more recent than other cave sites, such as Chauvet, which extends back 32,000 years. Yet these people, through their art, have become surprisingly familiar. We are aware of the fact that they are modern humans just like ourselves, with not only the same physical appearance but also the same mental capacity. These are our brothers and sisters.

Homo sapiens emerged in Africa at least 200,000 years ago, as we have seen. They migrated to the European continent approximately 40,000 years ago, on their way encountering widely scattered indigenous Neanderthal populations. The contemporaneous presence of the two in Europe lasted for about 13,000 years, until the disappearance of the Neanderthals, but there is no evidence that they actually lived together. During the Upper Paleolithic period, cultural changes appear to have occurred in both human groups. A logical explanation could be that differentiated cultural identity became a ne-

cessity as competition between the two groups developed. It is interesting to note, though, that until then, in the Levantine, where both human types were present, little distinguishes them culturally: they shared the same stone technology and had in common the same apparent absence of elaborate forms of artistic or symbolic expression. In Europe, it's a different story.

The Neanderthals had, alongside the familiar Mousterian technology, a new tool assemblage called the Chatelperronian, which is mainly characterized by the production of flint blades, including the Chatelperronian point. The oldest engraved designs made their appearance in Europe at the end of the Mousterian and during the Chatelperronian, consisting of a simple arrangement of parallel incisions found in Temnata cave (Bulgaria) and geometric patterns engraved on sandstone at Cosnac (France), approximately 50,000 and 35,000 years old, respectively. As for *Homo sapiens,* the first cultural period associated with their arrival is called the Aurignacian, which is also characterized by the development of blade-flaking techniques, but even more so by a major novelty: the unprecedented use of antler, bone, and ivory for the fabrication of tools and spear points. These and all the various other types of objects made out of this material are grouped in a category of artifacts called the bone industry. Highlighting this period is the dawn of elaborate artistic expression, in the form of statuettes, decorated pendants, beads, designs on diverse loose material, and, of course, the earliest appearance of cave art.

◆

The Chatelperronian period was one of climate change, a more temperate, damp interglacial phase, from which few archaeological data survive. This is why we know so little about this transitional period. Furthermore, it is difficult to date with precision what has been found, as carbon-14 dating methods are less accurate when we approach the 37,000-year limit of their applicability. Named after the Grotte des Fées at Chatelperron (Allier, France), this period is geographically restricted to northern Spain and France (for instance, Arcy-sur-Cure, La Ferrassie, Combe-Capelle, and Saint Cézaire), but its technology is comparable to other contemporaneous European industries, such as the Uluzzian in Italy. In 1979, at La Roche à Pierrot, Saint Cézaire (Charente-Maritime), it was understood that the inventor of this

technology was Neanderthal and not *Homo sapiens,* as previously thought. François Lévêque discovered the remains of a Neanderthal skeleton buried in a circular pit, 70 centimeters in diameter, unquestionably associated with Chatelperronian strata.

Considered by some to extend to as late as 32,000 years BP, the Chatelperronian industry is characterized by the introduction of flint blade-knapping techniques that led to the production of proportionally longer implements, shaped into typical Chatelperron points, backed knives, burins, or scrapers. Chatelperronian scrapers differ from the Mousterian side scrapers in length and shape: whereas the latter technology involved retouching the side of a broad flake to make a scraping edge, in the former it is the blade's extremity that is finely chipped into a scraper. As would be expected, the prevailing prejudice against Neanderthals' intellectual capacity led to the idea that this new technology was first invented by modern humans and then copied by Neanderthals. However, there is no chronological evidence to support this. On the contrary, there is evidence that the technology was elaborated long before *Homo sapiens* arrived in Europe. Is it a mere coincidence, though, that the earliest Upper Paleolithic modern humans in Europe, the Aurignacians, produced blades that were similar in the initial stages to those of the Chatelperronian? Could the warmer climate somehow have been the instigator, the resulting change in living conditions engendering new activities and new hunting imperatives, which consequently affected their tool kit and weapons? Or was it the necessity to make more efficient use of raw material in areas where flint was scarce?

Blade technology accomplishes just that. It consists of first giving the raw flint nodule a conelike or vaguely cylindrical shape, with a broad, flat surface at one end that offers an efficient starting point from which long blades can be knapped or pressured off. The next stage involves chipping off a narrow longitudinal band of short perpendicular flakes along the side, in order to define the width and length of the first longitudinal blade, after which a successive series of blades can be knocked off, the point of impact on the flat surface determining each one's size and shape. These long flakes were detached one after the other longitudinally, the point of impact of their percussed base circling the flat extremity of the block of flint, progressively

reducing the latter's size. Little was wasted, and the potential cutting edge was multiplied considerably over that of the Levallois technique practiced until this time, and abandoned thereafter.

◆

The Upper Paleolithic period, from approximately 40,000 to 11,000 years BP in Europe, is divided into five major periods, some of which have "early," "middle," and "late" chronological subdivisions, each characterized by specific artifacts. These five cultural periods are named after the French sites at which they were first discovered: Chatelperronian, Aurignacian, Gravettian, Solutrean, and Magdalenian.

The Chatelperronian overlaps the enduring Mousterian as well as the coming Aurignacian epochs, and has elements of both. The next four periods are all attributed to *Homo sapiens,* and each has distinctive, sometimes even exclusive, typological characteristics that become models for their differentiated classification, thus establishing chronological phases that we archaeologists find contentious in relation to time.

I wonder, however, how artificial these subdivisions are when serving to justify cultural separations. Would we consider subdividing our Judeo-Christian era into Sword Culture, Bicycle Culture, Tap-water Culture, Zipper Culture, and Computer Culture? Much as I bless the day that zippers were invented—my three daughters wore jeans throughout their childhood—and despite the considerable changes in our lifestyle brought on by technological innovations and scientific progress over the past 2,000 years, our Judeo-Christian heritage continues to underlie the Western way of thinking, influencing educational, philosophical, and ethical principles all over the world. And the imagery and symbols of our religious art have remained unchanged in substance, although periodically colored by fluctuating artistic conventions. Similarly, throughout the Upper Paleolithic, with about 25,000 years of cave art, it seems to me that there is remarkable continuity in the subject matter of the art: even though the distribution and combinations of the figures vary, they are limited to a restricted range of species, and certain themes are consistently absent or taboo, whatever the period. The invention, every few thousand years or so, of a differently shaped point or chisel, or, more rarely, of a new hunting weapon, does not appear to have had any effect on the more symbolic art forms.

Some might argue that, without writing, the same beliefs could not have prevailed over such a long period of time, but in reality, oral traditions are far more faithfully passed on than the written word. A written account can be open to multiple interpretations, distortions, and transformations, depending on the time and the situation, economic imperatives, or the whims of political or religious leaders. Orally transmitted traditions, in contrast, must be rigorously and accurately passed on in order to survive in all their subtlety and in the smallest of details. Furthermore, the written word, thought to be the surer and safer means of communication, is not only less reliable but also more permeable to outside aggression than are the more secret codes of an oral system. During the time of the Roman Empire, for instance, the fact that the Celts were still "prehistoric"—meaning that they hadn't recorded their history, ways, and beliefs—made it much harder for the conquering Romans to devise an appropriate strategy to subjugate them.

One of the most representative novelties of the Upper Paleolithic period is, as mentioned, the "bone industry." For the first time, bone, ivory, and, above all, reindeer antlers were chosen as raw material for tools and hunting weapons. Previously, in certain flint-knapping techniques, "soft" percussors made of bone and antler had been used, their function being to obtain finer flint chips than would "hard" stone percussors, which were used for heavier work. Bone and antler tools therefore existed before, but only as flint-knapping instruments, tools for making other tools. With the onset of the bone industry, a variety of objects began to be made, mostly of reindeer antler but also occasionally of bone and ivory: spear points, chisels, wedges, spatulas, awls, drills, needles, perforated antlers used as shaft straighteners, and, later on, harpoons and spear propellers. Rarely decorated in the early stages of the Upper Paleolithic, these functional artifacts later bore designs of all sorts, from the simplest to the most elaborate, figurative and nonfigurative. With or without embellishment, whenever a carved piece of antler turns up on an excavation site, one can be certain, without further investigation, that it is from the Upper Paleolithic epoch.

Personal adornment existed only modestly before, during the Mousterian, in the form of perforated shells, fossils and bones, and a few simple canine tooth pendants. From the Aurignacian epoch onward, beads abounded, as well as bracelets, necklaces, headbands, and headdresses; delicately carved

pendants were made as well, of ivory, bone, antler, shells, animal teeth, fish vertebrae, marine fossils, and various types of stone.

When decorated, functional bone objects and these elements of adornment make up part of what is called portable art—art on loose material, in contrast to "parietal art," on stone walls. Portable art also includes statuettes of all kinds, from those consisting of carefully selected bone or stone material that naturally evokes a figure, to which are added only a few lightly engraved lines, to fully sculpted, three-dimensional pieces in ivory, bone, tooth, antler, or stone. Finely or deeply incised engravings on freestanding stones of various sizes are also found, from huge blocks of limestone measuring more than a meter to small pebbles or broken slabs of stone only a few centimeters across. Similarly, there is a surprising abundance of decoration on pieces of broken bone and antler, at times possibly selected for their shapes; many are finely engraved with designs and figures that are more often than not of remarkable quality, despite the fragmentary, ordinary aspect of the material used.

◆

The western European Aurignacian period ranged from about 35,000 years to possibly as late as 22,000 years BP in France (Aurignac, Brassempouy, Pair-non-Pair, Vachons, La Quina, Les Cottés, Isturitz, Canecaude, and other locations, plus those of the Dordogne mentioned below), Belgium (in the Meuse Valley), Italy (Grimaldi and elsewhere), Spain (Cueva Morin, El Pendo, and elsewhere), Germany (Lommersum, Vogelherd, and elsewhere), and Austria (Willendorf, Krems, and elsewhere). In central Europe, there are sites from about 38,000 to 26,000 years BP, particularly in Moravia, and possibly as early as 43,000 years BP farther east (Bacho Kiro, Bulgaria).

The Aurignacians occasionally produced flake tools, including denticulated tools and "raclettes" (fine round scrapers with an abruptly chipped retouch), but their flint technology is characteristically recognizable by long, centrally narrowed blades and relatively thick, heavy blades, the tips of which are often retouched in order to make scrapers or various types of burins. The differentiated typology of these burins illustrates several distinct chronological phases. Another feature of Aurignacian technology is the production of bladelets. There is evidence that these were inserted and glued into carved grooves on bone spears, making this hunting weapon far more effective, combining suppleness (the bone or antler) and sharpness (the flint). In

western France and northern Spain, bladelets evolved over time: from long and straight to short and curved, then twisted, then smaller, before lengthening once more.

First defined in 1906, the Aurignacian epoch was initially subdivided into five phases on the basis of differently shaped bone spear points. Only two kinds were finally found to be chronologically significant: those with a split base and those with a flatter section and a lozenge-shaped base. Both were elaborated during the early phase of the period. The flint technology finally served as reference for the various phases: how Cro-Magnons went about making their end scrapers and burins, how abundant these were in relation to one another (which was probably related to attested changes of climate rather than to cultural differences), and how accomplished they were in mastering the blade technology. Of the many sites all over Europe, the Dordogne (France) houses some of the most famous, these being the first of the period to be discovered and studied, including some that are reference sites: La Ferrassie, Laugerie-Haute, Abri Cro-Magnon, Abri Cellier, Abri Pataud, Abri du Facteur, Abri du Flageolet, Abri Lartet, Abri du Poisson, Abri Blanchard, and Abri Castanet, for example.

The last two sites are situated in a string of shelters known as Castelmerle (Sergeac). Grouped in the Vézère Valley, they cover the duration of the Upper Paleolithic. These are among the oldest Aurignacian shelter dwellings in western Europe, about 35,000 years old. They contain stone blocks with carved stone links that may have served as rings for tying ropes or tent skins. One such stone, found in Abri Castanet, has a perforated link circled by an unusual design featuring a combined vulva and penis. Portable art is well represented here: large limestone blocks with deeply engraved animals and stylized vulvas, others with nonfigurative designs, such as meandering lines or hollowed-out cupules, sometimes arranged in a semicircle, looking like a bear's paw mark. There are engraved plaquettes (slabs of stone) and decorated bonework, including a particularly well-known piece found in Abri Blanchard: a fine 9.7-centimeter slice of ivory with carefully incised small notches along the sides and a centrally composed, meandering pattern of punctations. Similar incisions and punctations are engraved on a piece of ivory of the same shape and size in the Abri Lartet site, near Les Eyzies.

There is even wall art here, testified by a fallen fragment of the shelter's

ceiling, still brightly decorated with a painted bison. This piece was found face down under Aurignacian strata, making it the oldest known painting. The quantity of beads of all kinds found here is so exceptional that it is possible that the occupants specialized in their fabrication. Perhaps this was *the* place to come for necklaces, pendants, ivory headbands, and beads made out of the teeth of animals (including fox, reindeer, stag, bear, and lion), mammoth ivory, different types of stone, fish vertebrae, and varied shells by the hundreds. Some are decorated with carved parallel lines or disseminated dots, some are colored with red iron oxide, commonly used to polish ivory beads. We can actually see every stage of the production of ivory beads: raw mammoth tusks were split into slender rods, which were in turn truncated into small cylinders, one end of which was carefully thinned in order to drill a hole while the other was given a round basketlike shape, ready to receive a final polish. Some beads are so tiny that only children's small fingers could have shaped and polished them.

The exotic artifacts found on these sites—shells from the Mediterranean Sea or the Atlantic Ocean, exotic colored stones, and ivory carried from distant mammoth-populated central and eastern Europe—show how valued and culturally significant adornment was. The same is true in regions toward the east; thousands of shells found their way through central Europe onto the Russian steppes. Was this a means of displaying a group's specificity or an individual's position within a group depending on ancestry, age, social function, or personal experience as a hunter, craftsman, or storyteller, or an indication of whether a person was free to marry, for instance? Were these exotic materials prized for their rarity, beauty, shape, texture, or color? Or for their symbolic value? Could materials from far away represent ancient traditions, passed down from generations that had once lived in distant regions, people who had traveled from east to west in the case of the mammoth ivory carvings, for instance? Most people today interpret the nonindigenous materials as proof of trade, but they could have been gifts, territorial tolls, tokens of peaceful cohabitation, or matrimonial settlements; they might even be materializations of ritual initiation ventures—all of which could justify long travels and cultural exchanges between distant populations, exchanges that are further testified by certain widespread stylistic conventions, particularly during the following Gravettian cultural period.

Among the other shelters in the Dordogne are two that are well endowed with early Aurignacian material, including portable art similar to that of the Abri Castanet and Abri Blanchard: Abri Cellier and La Ferrassie, which has already been described for its Neanderthal burials but which was also occupied by Cro-Magnons. Both have stone blocks engraved with hollowed-out cupules, vulvas, and animals, depicted separately or combined; both have numerous beads, and, among the adornment, there is Abri Cellier's famous ivory headband.

Three sites in Germany must be mentioned for their particularly remarkable statuettes. Geissenklosterle (34,000 to 30,000 years BP) had an anthropomorphic figure (3.8 centimeters high), a bison (2.6 centimeters), a mammoth (6.7 centimeters), and a bear standing on its hind legs (5 centimeters), with similar geometric signs on each animal's body.

An anthropomorphic figure was discovered in Hohlenstein-Stadel (32,000 years BP) in 200 fragments by Otto Völzing in 1939. Reconstituted by Joachim Hahn, it turned out to be a human body with a feline head, exceptional in size (28 centimeters high, 6.5 centimeters wide, and 6 centimeters thick). This is the famous ivory "lion man." In fact, it is more likely to be a lion woman, because, although the chest section is incomplete, there is a horizontal line just under the belly forming a vulvalike triangle, and there is no mane.

In Vogelherd (32,000 to 28,000 years BP), among many statuettes, an exquisite ivory horse was found: only 4.8 centimeters long and 2.5 centimeters high, it is so beautiful that, of all the Paleolithic objects, this is my favorite. Its polished sheen, perfect proportions, shapely body, and arched neck line make it seem alive. How accomplished the artists were already, that early on! Somewhere along the line, techniques were clearly developed and mastered, long before this level of sophistication was reached. We have nothing to show of the first graphic attempts, the first hesitations; we don't know where it all began, or how long it took to master these techniques. Their "sketches" and first attempts were probably done on perishable supports. Here, in this 32,000-year-old horse, we have an undeniable masterpiece. At the same site and belonging to the same period are two lions (6.8 and 8.8 centimeters long) and a mammoth (5 centimeters long), also made out of ivory and equally superb. All have simple geometric signs engraved on them, similar to those at Geissenklosterle.

The only cave with paintings known with certainty to belong to the Aurignacian is Chauvet (Ardèche, France). After its discovery, in 1994, the photographs of its amazing paintings made front-page news in international newspapers. The animals are lively and expressive; they exhibit elaborate transcriptions of perspective and decomposed movement; they incorporate sophisticated shading techniques, and realism as well as virtually abstract simplification. It's already all there! There is a "before and after Chauvet" phenomenon: the days of well-established chronological stylistic phases are now over. If the 32,000- and 30,000-year dates were not irrevocably certified, one would be convinced that these paintings belonged, for the most part, to the Magdalenian phase, some 15,000 years later. They illustrate so many aspects until then considered to be typically Magdalenian that the dates given to some other Magdalenian caves are now being questioned. Could the estimated dates, most of which were based until now on stylistic criteria, be wrong? Could it be that some of our "Magdalenian" sites are, in reality, much older?

◆

The Gravettian period, approximately 29,000 to 22,000 years BP, is the most geographically widespread of cultural periods, ranging over almost the entire European continent, from France, Spain, England, Italy, and Belgium to central Europe, Poland, the Czech Republic, Austria, and Germany, and across the Russian plains as far as Siberia. Over such vast territories, regional entities can be distinguished. In central Europe, two regional denominations are commonly used: Pavlovian, after the Czech site of Pavlov, and Willendorfian, after the Austrian site of Willendorf. In eastern Europe, the term Kostienkian is used, after the Russian site of Kostienki. In France, the Gravettian period was initially called the Perigordian. It comes after the Chatelperronian and the Aurignacian epochs in certain regions but is contemporaneous with the Aurignacian in others. Technologically, it is possible to see at a glance how the Gravettian differs from the Aurignacian period: the blades are finer and longer in proportion to the width, and certain points and burins are very small. There are characteristic types of tools, such as backed Gravette points with their triangular section, pedunculated Font Robert points, and small, narrow, truncated Noailles burins, all named after French sites. The finely flaked Kostienki knives and bifacial and pedunculated points are

typical in the east. On the whole, though, there is a technological consistency that is remarkable, considering the distances involved.

Of the many Gravettian sites in the Dordogne, I have already mentioned one: the famous Abri Cro Magnon, in Les Eyzies, where the skeletons of five individuals were discovered in 1868. Too modern-looking and too tall to be considered prehistoric at the time of the find—after all, Darwin's book on the evolution of species had come out only 10 years earlier, and to most people, his theories couldn't possibly apply to humans—it was only in 1874 that the site's name was given to this new "race," the earliest of those otherwise known as *Homo sapiens* to have been found. The site has now been dated to about 28,000 years BP. The destructive excavation methods of those days have left us with little information about these supposed graves. Perforated shells—possibly part of a necklace—and a fine ivory pendant were found there, along with other artifacts.

The most characteristic portable art form of this period is illustrated by the feminine statuettes commonly called Venus figures. Here again, we can only marvel at how homogeneous a theme this is across the continent, from east to west. These are stylized, three-dimensional figures made of ivory, stone, or baked clay. Typically with large breasts, belly and hips, some are even clearly pregnant, which has led to their being interpreted as fertility symbols or mother figures. However, since a variety of versions exists, from slender to very fat, from juvenile to mature, and even figures of elderly women, they might have had several meanings. What they have in common is their systematic stylization: a stereotypic lozenge shape, relatively small arms and legs, the latter ending more often than not in a point, and a general lack of personified facial expression. The widespread absence of any fully realistic version suggests not only a shared understanding of the symbolic significance of these statuettes but also a manifest respect for the codified manner in which they *had* to be represented throughout Europe.

In the central European regions where the earliest stages of the Gravettian technology were developed, the statuettes, as well as other art forms, are renowned for their refinement. The most significant sites are Dolni Vestonice, Pavlov, Predmosti, Brno, Moravany, and Petrkovice (all in the Czech Republic) and Willendorf (Austria). The stone Venus of Willendorf is a little

more realistic than most and is the most famous example of feminine figures of the time. The breasts, belly, and hips are those of a very fat woman, her big thighs converging to shortened legs, her disproportionately small arms resting on large breasts, and her round head festooned with rows of prominent bumps, like a beaded headdress, which covers the face as well. Generally speaking, eastern and central European statuettes are more realistic than those of the West, where peaks of stylization, verging on abstraction, are common.

The Dolni Vestonice, Pavlov, and Predmosti sites are worth special attention because of their size and the abundance of discoveries made in them. The first consists of five independent camps from relatively close periods in time, ranging from as early as 29,000 to about 26,000 years BP. Particularly impressive are its large structures, notably one that is 14 by 9 meters in size. Another one, a round habitation circled by picket holes for the roof support, has a central hearth that contains numerous fragments of baked-clay statuettes as well as finger-marked lumps of clay. This is probably one of the oldest clay ovens, 27,000 years old. There are graves, too, one of which is of a woman in a fetal position, covered by two mammoth shoulder bones. Numerous bone tools of different types are present, including long, spoon-shaped mammoth bone tools covered with delicate geometric designs. Among the more usual types of adornment—predominantly fox canines and perforated shells—there are eight remarkable pendants (2.7 centimeters on average) symbolizing women in a most minimal way: a vertical cone shape with two breasts hanging down, transversally perforated behind. These are similar to some highly stylized statuettes found on the site, which consist of a long rod with two breasts hanging close to the center and decorative striations. A forked figure (8.6 centimeters)—represented simply by two arched, pointed legs, a deeply incised vertical line in between (a vulva?), and a stick torso with a perforated hole at the top—could also be a female pendant figure.

These are extreme stylizations, but more realistic representations were also found on this site: large-breasted female statuettes made of baked clay, incomplete as usual, despite their excellent proportions; an isolated mask-like face; and the most famous of all, a three-dimensional (4.8 centimeters) representation of a man's or woman's head, carved in ivory. The long, slen-

der face has delicate features, a slender nose, and expressive eyes, deep-set under the brow. The mouth is suggested but remains undefined. The face is topped with either hair drawn up in a bun or a bonnet of some sort. Exceptionally, this is a true-to-life portrait of a person, someone we can relate to for once, and not just a symbol. This is a unique piece. There is no body; could this and the absence of a detailed mouth possibly be a way of complying with the same codified "incompleteness" that is otherwise consistent for the statuettes?

Pavlov (about 26,500 to 24,500 years BP) is 500 meters from Dolni Vestonice. It has yielded about 100,000 artifacts, including tens of thousands of tools made mainly of stone but also of ivory, reindeer antler, and mammoth bone for the large, characteristic "shovels," for instance. Among the various types of ivory adornment are refined pendants and flat diadems delicately engraved with geometric designs. Most uncommon are some circular finger rings, like those we might wear today. There are statuettes similar to those already described, but also unusual, flat pieces with barely any relief, representing animals—mammoths and lions—and anthropomorphic figures; these might illustrate a transition between sculpture and figurative engravings. What I'm most attracted to in the art of Pavlov are the geometric designs finely engraved on a number of pieces. One can't help but be impressed by their delicate simplicity and their balanced distribution. I have always found these abstract art forms particularly beautiful, and intriguing.

Tens of thousands of tools have also been found at Predmosti (around 26,500 years BP), also famous for its portable art, which includes eight feminine statuettes, a stylized face, and a unique engraving on ivory of a woman composed in a geometric fashion with an abstract, masklike face, a piece that reminds me of African art. Beads and pendants also abound, made of stone, ivory, teeth, and perforated shells, as well as large, flat, leaf-shaped pendants decorated with delicate geometric designs. Predmosti is outstanding for another major discovery: a grouped burial of 20 individuals (8 adults and 12 children and adolescents) in a space of about 4 by 2.5 meters, covered by stone blocks that separate it from the archaeological levels.

Yet another site, Brno 2, is known for a unique ivory male figure made in separate articulated parts, just like a puppet. The fragmentary trunk (13.5

centimeters) and head (6.7 centimeters) are longitudinally perforated, and the surviving arm (9.8 centimeters) seems to have had a tenon at the shoulder. Six hundred *Dentalia* shells were found on this site, far from their usual habitat, as well as other adornments such as flat stone finger rings, like those at Predmost, and 14 small, finely shaped disks.

◆

As we head toward eastern Europe, the Russian steppes and Siberia, there are many remarkable sites, including Kostienki, Avdeevo, and Sungir.

Kostienki (Russia) comprises a vast group of sites with numerous habitations, some of which are huge. In Kostenki-Borscevo (24,000 to 21,300 years BP), for instance, are four complex structures, one of which is particularly impressive, with a surface area of 36 by 18 meters, nine hearths lined along the center, and, on the side, four large pits of about 3.5 by 2 meters that have been interpreted as having been winter homes, with roofs supported by mammoth tusks and bones. Kostienki 4 has a 17-by-5.5-meter structure separated into three sections by two banks and multiple small pits with traces of ashes, which could have been hearths. Judging by the number of hares' paw bones found there, tanning hides may have been a communal activity. Mammoth tusks and bones were used not only for structures and as fuel but, stacked in layers up to 50 centimeters thick, also to isolate and consolidate the ground people lived on. This is the case in Kostienki 2, which is also known for the grave of a man more than 50 years of age, who was buried sitting up, with his legs and arms bent tightly against his chest.

As there is virtually no archaeological evidence that mammoths were hunted, it is more likely that the bones and tusks were scavenged. The legendary "mammoth hunt" is a fantasy, indeed one of the most popular, yet a look at the thickness of a mammoth's layer of fat, added to its skin and fur, is enough to convince anyone of the improbability of it being taken in a hunt. Among the artifacts found at these sites, special notice should be given to some large mammoth-bone, shovel-like tools decorated with geometric designs, as well as ivory female figures, which often have decorative lines around the breasts and hips, looking like beaded straps.

Avdeevo (Russia, about 22,500 years BP), also has large structures: one is an oval space measuring 20 by 15 meters, bordered by seven pit habita-

tions built with mammoth tusks; another structure covers a surface of 350 square meters, with pits and living spaces surrounding a line of three large, equidistant hearths. Twenty thousand stone artifacts were found at the site, along with many objects made of bone; there were beads and pendants with geometric designs, five ivory feminine statuettes, one of which is similar to Western European versions, a clay mammoth, an ivory horse, and many fragments of clay statuettes and pendants.

Sungir (Russia, around 23,000 years BP), is famous for two graves containing more than 17,000 beads, approximately 4,500 of which are of mammoth ivory. The first grave is that of a tall, 55- to 65-year-old man lying on his back, arms and hands crossed, covered with ocher. As many as 3,500 ivory beads were arranged in rows around the head, no doubt for a headdress, across the body, down the arms and legs, and around the ankles, sewn in lines on his clothing, along with fox canines and a decorative, perforated slab of schist. He had ivory bracelets and necklaces too. The second tomb is that of two children lying on their backs in a straight line, the tops of their heads touching. The body thought to be that of a girl was 10 years old and that of the boy was 12 or 13 years old when they were buried; they were both covered in deep red ocher. They, too, had hundreds of beads on their clothes, about 1,000 of them in ivory, as well as fox canines in abundance—240 on the boy's belt alone. Each child had a bone pin on the chest, and ivory bracelets and rings as well. Most extraordinary are the 16 ivory lances, daggers, and points by their sides, particularly two amazing pieces, 2.42 and 1.66 meters long. Technically, it would have been a remarkable feat to straighten a piece of ivory of such length. Even today, it is hard to imagine how it could have been done. There are also ivory disks and a small cut-out horse with carved dots in two lines along its body. Close to the man's grave, another, in poorer condition, was discovered, of a woman lying on her back with dozens of beads and perforated fox teeth, as well as bone pendants, tools, and a large shell.

The size of the habitations and structures suggests semisedentary living conditions, a change of lifestyle probably due to a more clement climate. The steppes and tundra in central and eastern Europe were turning into rich grassland, and the ensuing abundance of game offered ideal conditions for the development of more stable, larger communities.

The presence of similar rare objects and specific stylizations, found sometimes more than 1,000 kilometers apart, indicates that distant groups were in contact. To give but a few examples, the same stereotyped feminine figures, with large breasts, a flat backside, and disproportionately small arms, were found in Kostienki and in Moravany; the same Venus figures in Gagarino and in Willendorf; the same spoon-shaped bone objects, with four perforated holes in the flat of the "spoon," in Kostienki and in Avdeevo.

◆

Fewer statuettes have been found in western Europe than in the east, but those that have been found are considered to be masterpieces, each as outstanding as the Venus de Milo. In Italy, we have the statuettes of Grimaldi and Savignano; in France, those of Lespugue (Haute-Garonne), Brassempouy (Landes), and Sireuil and Tursac (Dordogne). Equally famous are the bas-relief carvings of women discovered at two other Dordogne sites: Laussel and Abri Pataud.

The Venus figures of France and Italy, along with the abovementioned Willendorf Venus, are considered to be the most characteristic of the type. The only well-dated sites are Lespugue (Haute Garonne), Tursac, and Abri Pataud (Dordogne), but the stylistic conventions of the statuettes found in these and the other sites are sufficiently coherent for us to presume that the others belong to the same period, especially when the same aesthetic criteria are also found in other well-dated sites in central and eastern Europe.

The Lespugue Venus (14.7 centimeters), made of ivory, has the most exaggerated proportions: huge round breasts hanging down to waist level, with small forearms resting on them, a round belly protruding underneath, large buttocks that overlap the hips, smooth, rounded thighs, footless legs joined in a point, and a stylized head with lines that could be hair, as well as a gridlike design covering the face. It is a magnificently balanced piece of sculpture from whatever angle you look at it. Face on, it's a vertically elongated lozenge, the hips at their broadest exactly at midheight and the sides narrowing in symmetrical arcs to the top and the bottom: arms and head mirroring the thighs and lower legs. From the side, the elegance and flowing simplicity of the curved lines remind me of a Brancusi sculpture. Behind, the legs are replaced by a series of tight vertical lines, which cannot be inter-

preted as clothing, as they are underneath the buttocks. Could this be a way of emphasizing the voluminous backside? Some think that the pointed leg extremity might have made it possible to drive the statuette upright into the ground, in which case the lines might have been a decorative presentation element.

When turned upside down and seen from behind, the statuette looks like another woman. In this case, the longitudinal lines at leg level become long hair hanging down to the waist, and the centrally composed buttocks serve both figures convincingly.

In Italy, the series of caves and sites called the Grimaldi complex is known above all for its numerous burials, with a total of 17 skeletons in variable condition. The best-documented site is the "children's cave" (Balzi Rossi), where an adolescent and an elderly woman were buried together in the fetal position, their heads protected by stonework. They may belong to an older Aurignacian level. The adolescent had four rows of *Nassa neritea* shells around the head, and the woman had two bracelets of the same shells. An adult man 1.78 meters tall was buried in another place, with a headdress of the same perforated shells and stags' canines, as well as a shell necklace. This tall stature is the average size of all but two of the skeletons, the same as that of the first Cro-Magnon finds in Les Eyzies. Another double grave, of two children lying on their backs, has yielded more than 1,000 perforated *Nassa* shells, which were arranged around the pelvis and the thighs, possibly decorating loincloths. The age of the skeletal remains is uncertain, as the excavations began as early as 1874, but the collected data convincingly point to the Gravettian period, except for the first two, which probably date to the earlier Aurignacian epoch.

Grimaldi is also famous for its feminine stone statuettes. Several of these have a lot in common with the Lespugue Venus: large breasts, belly, and hips, heads with no facial expression, considerably reduced arms, and footless legs converging to a point. On one of them (6.4 centimeters), the back of the skull is shaped into an oblique point, which mirrors the pointed leg extremity, symmetrically equidistant from the protruding belly. Unlike these mature-looking figures, other statuettes represent young women, such as the obviously pregnant one (6.9 centimeters) found at this site, with small juve-

nile breasts and a perforated hole just above the neck (a pendant?). Another one (4.7 centimeters), carved in translucent yellow steatite, is perhaps the most famous because of its perfect proportions; for once, this is not a caricature, the feminine shapes being realistic and agreeably plump, with balanced, simple volumes, beautifully enhanced by a smooth polished finish. A piece that reminds me of modern sculpture.

Still in Italy, an unusually large statuette (22 centimeters) was found accidentally in Savignano, far from any archaeological context. It has the same conventional shape, with the extremities even more pointed than usual, the abstract "head" no longer recognizably headlike but transformed into an elongated vertical cone.

◆

In France, stylized to the extreme, is the Tursac Venus. From the Abri du Facteur, at Tursac (Dordogne) on the Vézère River, made of amber-colored calcite and 8.1 centimeters high, it is one of the rare statuettes found in its archaeological context and associated with artifacts dating back about 23,000 years (Fig. 7). The trunk is cone-shaped with no breasts, no arms, and no head; it has a protruding, low belly and, at a slightly higher level behind, an equally protruding backside, with two dwarfed, bent legs curling behind, between which a reversed cone is carved, either for aesthetic reasons— mirroring the trunk—or to prop the figure upright. Had there not been other, similar, highly stylized representations, with an added anatomical detail here or there to justify a feminine attribution, we wouldn't know how to interpret this one. Thanks to the curved small of the back and the high protruding buttocks that so often characterize these feminine figures, we can recognize this as one of them.

The Venus of Sireuil (Dordogne), 9 centimeters high, is also sculpted out of amber-colored calcite (Fig. 8). It is in many ways similar to the Tursac Venus: the same curvaceous small of the back and pronounced buttocks, the same curled, reduced lower legs, the same low belly; but this time small, youthful breasts complete the figure, with two dwarfed arms folded immediately underneath, hands apparently joined—although one is broken. The head was no doubt broken at the time of its discovery in 1900, but a sculpted relief between the shoulders might be part of a hair arrangement. The legs are curled around the back into a loop, circling a vertical hole that might have

served to hold the statue up, with a peg, for instance. The smooth, polished surface and perfectly designed curves of the body make this piece one of the most attractive, a good example of the artistic talent and sensibility of those times and of the care put into the fabrication of these statuettes.

The Venus statuettes described above are all world famous, but the greatest treasure of all, the emblematic figure of the Gravettian period, is the Dame de Brassempouy, a small head, only 3.65 centimeters high, carved out of mammoth ivory (Fig. 9). It was discovered in 1894 by Edouard Piette—probably the most enlightened pioneer of all in the wake of early prehistoric discoveries—at a site called La Grotte du Pape, only a few kilometers from Brassempouy (Landes). The archaeological levels of the site cover a long period, from the Mousterian to the Magdalenian, and the statuette was found in a Gravettian layer.

The head is probably that of a young woman or a girl. It is truly exquisite: the polished oval-shaped face has high cheek-bones and penetrating, almond-shaped eyes in the shadow of a pronounced brow; a fine nose surmounts a pointed, prominent chin. The head is covered by a sort of veil, hanging loosely in folds and incised with a gridlike design; whether this is a sophisticated headdress or braided hair is hard to tell. The long, graceful neck gives the figure a proud allure and an elegance one would not suspect for those times. No mouth is depicted, despite the realism and detail of the other features. This is surely deliberate and significant, possibly dictated by the graphic codes of the Gravettian period, similar to those applied to the incomplete Venus figures. She reminds me of another figurine: the head figure from distant Dolni Vistonice (Czech Republic), described above. They are contemporaneous, and are equally moving, because we are given a rare opportunity to visualize a real person behind each.

Now that Piette's fabulous collection is open to visitors at last, I encourage everyone to go to see it. It is in the Musée des Antiquités Nationales, in Saint Germain-en-Laye, near Paris. The Dame de Brassempouy is there, a princess among hundreds of other treasures.

◆

In western Europe are limestone bas-relief carvings of women that conform to the same stylistic conventions as those of the statuettes. The Abri Pataud and Laussel in the Dordogne have good examples of these.

The Abri Pataud is a vast shelter site in Les Eyzies, with a well-dated archaeological sequence that covers about 14,000 years, from the early Aurignacian (around 34,000 years BP) to the Proto-Magdalenian (around 20,000 years BP). In an extension of the site just the other side of the village road, called Le Vigaud, Mousterian artifacts were found. Neanderthals were therefore also here, much earlier. The massive 40-meter cliffs bordering the Vézère River, facing the south and towering over the valley, offered ideal living quarters for Paleolithic hunter-gatherers—particularly the Abri Pataud, with its huge, protective overhang. A 10-meter-high vertical cut in the excavation site reveals that the massive rock roof eroded with time and eventually collapsed; fallen limestone, ranging in size from fine stone deposits to blocks weighing tons, gradually filled the shelter and covered successive archaeological layers, preserving the story of this shelter habitation. The thickness of these deposits furthermore gives us an idea of the duration and harshness of the corresponding climatic conditions: the colder the weather, the greater the effect of erosion on the more porous, more water-absorbent rock strata. This explains the initial formation of the shelters themselves, shaped and weathered over millions of years. Eventually, the erosion is such that an insufficiently supported roof collapses, as it did here.

The section excavated by Hallam Movius Jr. between 1958 and 1964 is mainly limited to a 6-by-14-meter trench, 9.25 meters deep, framed by massive rock-fall blocks weighing down on the rich, compressed Aurignacian and Gravettian levels. Solutrean and Proto-Magdalanian levels lie above, so close to what remained of the shallow roof that one could no longer stand upright. These layers were also explored over a surface of about 200 square meters. Carbon-14 dating was used here for the first time in the valley, an event that brought considerable changes to the world of archaeology. Thirty-four samples were dated at the time, and these have since been corroborated by sixteen more datings, this time with mass spectrometry methods.

Not only is this site a geology lesson in itself, as we have seen, but it is also the perfect place to understand something about archaeological excavations, because layers with and without Paleolithic remains are clearly distinguished. The 14 archaeological layers are darker and gray with ashes from campfires, dirt, and various decomposed organic elements—food, animal

fat, hides, wooden structures, vegetal elements, and pollen—whereas those devoid of archaeological content remain a light-yellow ocher. The first vary in extent and content, depending on how long or how regularly the site was lived in. In strata briefly occupied, by a passing group of hunters, for instance, barely a sliver of the finer ash-gray deposit is visible; in those inhabited for a longer stretch of time—semisedentary occupation, regular seasonal stays, or frequent short visits, for example—the layer is a more or less dense conglomeration of stone, ashes, and soil and of bone and flint material, which we can see protruding through the cut. The Gravettian is the period best illustrated, with such a concentration of finds that exploring a surface measuring 50 centimeters square, at a depth of 20 to 30 centimeters, can take a couple of weeks, as I found out when I was excavating there. More than 15,000 artifacts have been found from the Gravettian period alone, with 150 bone and antler objects and a dozen made out of ivory.

At a glance, one can see tools protruding from the compact Gravettian strata, but far more abundant are flint residues of all sizes and tiny splinters of antler and bone, reminding us, if need be, that we are exploring what was left behind by hunter-gatherers: refuse from making tools and weapons, beads and objects made out of bone and antler, crushed shells, abandoned hearths and structures, and, of course, food remains—mainly reindeer, including bones with the marrow extracted. Artifacts are more often found broken than intact: those that were discarded, remodeled, or sharpened to the extreme limit, those that might have been forgotten or lost in the heaps of flint chips and flakes scattered on the ground. Flint points are not often found intact in excavation sites, unless they were freshly made; they were destined to be taken away on the hunt, and it is easy to imagine their getting lost or broken far from the home site. Several hearths lie undisturbed, circled by reddened pebbles and stones. Some areas are bright red from ocher, commonly used for its abrasive or preserving qualities—for tanning hides, making glue, and polishing beads, for instance—or simply for its color. A grinding stone, still encrusted with powdered red ocher, is exhibited in the small nearby museum, along with hundreds of stone tools, fragments of local fauna, and personal adornment, including perforated shells and animal teeth, polished stone pendants, and beads. Some of those made

of bone are most unusual: tiny and delicate, square and flat, with a perforated central hole.

The bones of nine individuals—four adults and five children—were discovered on the site, one within the Gravettian layers and the others all Proto-Magdalenian. Among the latter is a fifteen-to-sixteen-year-old girl, buried with a newly born baby. Her skull was found 4 meters from the rest of the skeleton, carefully protected by an arrangement of stones. Could this be an example of a complex burial ritual involving two phases: a first burial, followed later by another, modifying the original position of the bones? This practice still exists today in certain populations.

As for the art, portable forms are sparse in the Abri Pataud, as the strata don't cover the prolific Magdalenian period. The multitude of small fragments of painted rock on the ground, however, indicate that the shelter walls were once decorated. On the shelter's ceiling where the small museum is today, a well-proportioned mountain goat is engraved in relief, horns twisted into a three-quarter view. Stylistic criteria indicate that it's about 18,000 years old, from the end of the Solutrean period.

Back to the Gravettian, the most famous art piece in the Abri Pataud is a bas-relief Venus engraved in the center of a small block of limestone; fine and delicate, it is more realistic than most of the abovementioned statuettes, yet still in conformity with the typical Venus lozenge-shaped design, the legs ending in a point (with no functional justification this time, as this is not a free-standing three-dimensional statue), barely visible arms, and a featureless face.

Laussel, close to Marquay, is another famous outdoor site in the Dordogne, and one of the largest in France. The shelter, along the Grande Beune Valley, is 80 meters long and 15 to 20 meters wide. The 9 meters of archaeological strata incorporate 11 layers that cover periods from the Mousterian to the late Solutrean. On this site, excavated by Emile Rivière as early as 1894, Jean Gaston Lalanne discovered, in 1911, four separate blocks, each with a remarkable bas-relief carving of a woman. A fifth block was found with either a male or a female figure. All four women have large, heavy breasts, and round bellies; three of them have clearly defined navels, plump hips, arms that are more or less of a normal size, and heads with no features. They therefore

have a lot in common, yet each has its own particularities. The most famous is the "Vénus à la corne," 42 centimeters high, on a block of limestone cut off from its original massive 4-cubic-meter block of rock (Fig. 10). In its original position, the carving was facing toward the inside of the shelter. The woman is holding a horn in her right hand at shoulder level and seems to be looking at it, because, although her face is not defined, the shape of her head is sufficiently clear, and she has what could be long hair or a headdress sweeping over her left shoulder. The body is superbly modeled, polished, and carefully outlined, and the left hand is resting lightly on her belly. In contrast, her head seems to be unfinished and is of a rough, natural texture. Traces of red pigment are still visible on the body, and there is a small forked sign on the right hip. The horn is said to be that of a bison, but the engraved transversal striations more closely resemble those of a male ibex. Is it a coincidence that this feminine representation is associated with a horn, which we could today compare with the "horn of plenty"? The idea is amusing. Cro-Magnons evidently saw symbolic meaning — even if we have no idea what kind — because every calculated detail of these conventional feminine figures points to some kind of shared, codified significance.

Another bas-relief, 38 centimeters high, is similar, except that it's less complete and faces the other way, this time with the left arm bent and seemingly holding an unidentifiable object. The head is completely engraved with a fine gridlike design that reminds me of other figures, such as the Venus of Willendorf. A third carving resembles the first even more closely, holding a horn on the same side; it was sold to a private collector and has disappeared. The fourth is a unique piece: composed on a 45-centimeter limestone slab, two women are joined opposite each other at the waist, like a playing card or a reflection in the water; together, they form a symmetrical design 20 centimeters high. Although they are two distinct women, the end result looks just like some of the statuettes, with their rounded shapes — head, breasts, belly, hips, and thighs — symmetrically distributed so as to form an oval or vertically stretched lozenge. Finally, one bas-relief is completely different: an elegant, slender figure in profile, with what looks like a lifted arm. It has no apparent feminine characteristics, which is why it's interpreted as being a man — more precisely a hunter — despite the absence of male attributes or of

any weapons. It could just as well be a young girl or boy. The slim body and graceful lines give it a unique aspect, fleetingly reminding me of the elegant, juvenile, male athletes and fishermen of the Akrotiri frescoes in Santorini, Greece. The carved women clearly belong to the Gravettian period, but this last bas-relief, found on top of the strata—therefore out of context—might not be of the same period.

Unique in the realm of Paleolithic art is the famous male salmon engraved on the ceiling of the Abri du Poisson (Les Eyzies, Dordogne). Although the shelter was explored in 1892 by Paul Girod, the carving was found only in 1912, by Jean Marsan. It is considered to be late Gravettian because of the archaeological context; stylistic comparisons cannot be used as criteria, this being the one and only fish representation of this size and quality. Thin limestone flakes fell from the ceiling during the Gravettian period; as the fish shows no such sign of erosion, it is therefore bound to have been carved afterward, either toward the end of the Gravettian or later. Along with some earlier Aurignacian tools, there is abundant Gravettian technology in this shelter, giving us another good reason to associate the carving with this period. The 1.05-meter salmon is superb, the body well proportioned and the beaklike jaw characteristic of a mature male, with traces of red ocher still visible on the body. The incised frame surrounding it shows how close it was to being cut out and sold, as was all too frequently the case in the early 1900s. This one was saved just in time. Other figures nearby, deteriorated and barely visible, include a faded negative handprint.

Not many caves clearly date back to the Gravettian period, but those that do are spectacular. The major sites in France are Pech-Merle (Lot), Cougnac (Lot), Gargas (Hautes-Pyrénées), Pair-non-Pair (Gironde), Cosquer (Bouches-du-Rhone), La Mouthe (Dordogne), and, recently discovered, the amazing Cussac cave (Dordogne). The first four are open to the public, and I encourage everyone to go and see them while it's still possible. Other caves that might belong to this period are cautiously defined as "pre-Magdalenian," as it is unclear whether they are Gravettian, Aurignacian (earlier), or Solutrean (later).

Speaking of caves again, the moment has come for a third Dordogne cave experience before pursuing our journey in time and exploring the Solu-

trean and Magdalenian cultural periods. Another fabulous venture awaits us, in a mineral world completely different from that of the two previous caves. And in comfortable conditions too this time, as a small electrical train takes the visitor through it.

This is the largest and one of the most impressive caves of all: Rouffignac.

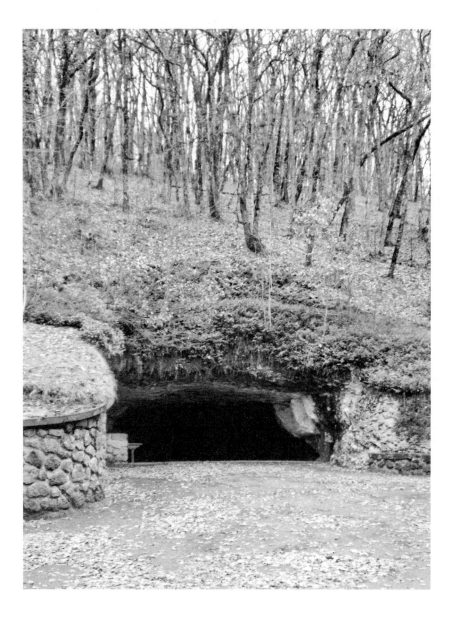

Rouffignac, cave entrance

Rouffignac

Rouffignac, also known as the "hundred mammoths cave," is huge: about 10 kilometers of galleries spread out on three superimposed levels. The top level is about 6 kilometers long and the other two—the second consisting of dry galleries and the third of an underground stream—cover the remaining area. The art, thought to be about 14,000 years old, extends over a distance of more than 2 kilometers on the upper level only, with the exception of a few figures down in a pit. For millions of years, this was an underground river. It is important to remember that the whole region was originally covered with water and that limestone is a sea deposit consisting of heterogeneous and more or less compact horizontal strata. About 70 million years ago, tectonic shifts led to the formation of reliefs and mountains, and the sinking seawater found its way through cracks and holes in the limestone, actively dissolving the rock, particularly where it was more porous, eventually shaping out valleys, shelters, and caves. While the Font de Gaume cave owes its existence to slow, gentle infiltration of water

through a narrow fissure, both Combarelles and Rouffignac were caused by underground river erosion.

At Rouffignac the water penetrated through an opening in the hillside and worked its way in two directions: out toward the present entrance, and deeper inside along meandering passages before descending a shaft to the second level and then to a third, where water still flows. In the initial stages, there must have been tremendous pressure, the water being confined to narrow spaces, forcing its way through, tightly hugging the ceiling, leaving it velvety smooth, and, whenever it was trapped in small concavities, whirling around in larger and larger circles, creating the huge overturned potholes that we can admire above our heads today. The flow slowed as the passages became more spacious, with peaks of mechanical erosion and dissolution leaving horizontal terraced ledges lining the walls as the water level fell in stages, until it finally left the two upper galleries dry sometime between 1 million and 2 million years ago. After that, the cave remained unchanged, ready for the Magdalenian drawings.

Unlike most caves, this one has hardly any stalagmites or stalactites, because the limestone is largely composed of waterproof clay, which prevents water seepage from above. The size of the galleries themselves makes them remarkable, with mysterious side passages and shafts, dramatic domes decorating the high ceilings, and myriads of protruding flint nodules glistening along the damp walls. These resisted water erosion longer than the softer limestone that they're still encased in, which is why they still protrude. They are there by the millions throughout the cave and become more decorative the deeper we go, as their layered distribution becomes more distinct and their porous outer cortex is reddened by the iron oxide–saturated waters.

The original entrance is still wide open today. It was a popular place to explore, particularly in the eighteenth, nineteenth, and twentieth centuries, as we can see from the numerous inscriptions on the walls. There are names and dates that cover four centuries. No one in those days knew about the existence of Paleolithic culture, so it is understandable that the art was ignored, even though some drawings were quite visible. In fact, as early as 1575, François de Belle-Forest wrote about the wonders of this cave and mentioned the "paintings," adding that he thought the place to be one of idolatry, possibly with sacrificial rituals dedicated to Venus or some other "infernal"

pagan deity. His interesting manuscript provides supplementary evidence for authentication of the art. Indeed, as prehistoric art was unheard of until the mid-1800s at the very earliest, no fake "prehistoric" depictions could have been done before then, certainly not in 1575.

It was not until 1956 that the art in Rouffignac was officially "discovered" by Romain Robert and Louis-René Nougier and recognized as prehistoric by the most eminent specialist of the time, Henri Breuil. Why not before, as major caves, including Lascaux, had already been acknowledged and studied? Earlier visitors had seen the drawings, as mentioned above, but the omnipresent graffiti, frequently superimposed on the drawings—in some cases even covering and nearly obliterating them—were considered to be contemporaneous with the inscriptions. Stories and superstitions about the cave had grown over the centuries, including a suspicion that the "extraordinary" animals—mammoths, woolly rhinoceroses, and even bison were unknown to the local people—had been drawn on the walls by pagan sects. These beliefs are testified by the Christian symbols traced on the animals, to exorcise these "diabolical" creatures. It is not surprising, therefore, that no one looked at them with a different eye. Those who would have been able to acknowledge their prehistoric value—Breuil, for instance, who actually visited the cave in 1915—didn't go far enough inside to see the drawings.

The battle to authenticate the work was ferocious. There are still a few detractors today, although I don't understand their skepticism. The first, decisive step was identification of the black pigment used for the drawings as manganese, unlike the black graffiti, which had been traced by means of the smoke of lamps. It was common knowledge that Paleolithic artists used manganese, and it was therefore obvious that the two were not contemporaneous. Another essential observation concerned the engravings: their patina proves their age. We saw in Combarelles how difficult it can be to see engravings, because, with time, the lines age and become as gray as the natural rock, whereas when freshly carved they looked like white drawings. The same phenomenon occurred here: an engraved mammoth remains invisible to the eye when it is lit from the front, whereas it suddenly appears, sharp and clear, when lit from the side. The centuries-old names and inscriptions traced on the walls and ceiling with sticks or fingers, in contrast, remain light-colored to this day.

We have already seen in both Font de Gaume and Combarelles how the growth of calcite over paintings or engravings helps to authenticate them. The lower half of a long frieze of mammoths here is encased in a horizontal band of calcite. Although the calcium carbonate hasn't been dated, it is unlikely to have formed during the 50 years between the earliest recognition of cave art and the discovery of these representations. Another convincing argument is the detail with which these prehistoric animals are depicted. The Przewalski horses on the "Great Ceiling" are even more detailed than those at Combarelles. The mammoths have certain anatomic characteristics that only someone who had seen them could have known about, such as a flap of skin that protects the anus from the cold. The extinct woolly rhinoceros also displays telling anatomic correctness, with its characteristic boxlike nasal appendix, which warmed the air it breathed. These and other equally precise anatomic details are all clearly portrayed in the drawings in Rouffignac.

◆

The cave is owned by the Plassard family, who couldn't be more dedicated to preservation of the site. They know better than anyone else the delicate balance of temperature, air constituents, and humidity, which must remain stable all year long, and how to achieve this by regulating visits. Taking visitors in by train was a brilliant idea: the numbers are limited, people are kept in a tight group and are thus more easily supervised, and less pollution is trodden into the cave floor (pollen, vegetation, and microorganisms of all sorts brought in from outdoors). Most important, there is no wiring for light in the cave; the passage of the electric train on the rails releases the lighting for each section, then leaves the figures in pitch darkness a moment later, once the train has passed. Thus each panel is lighted for only a few minutes per hour. The art has survived for so long in part because it has remained in the dark. The owners have furthermore decided to close the cave completely for four consecutive months of the year, and they allow no exceptions.

◆

Jean and Frédéric Plassard identified 258 animals, all of which appear to have been drawn over a relatively short period, by fewer than four artists, perhaps only two. Approximately 500 square meters of meandering abstract line designs illustrate another aspect of the art. Among the animals, there are 159 mammoths, which represent nearly half the number of mammoth figures in

all known European caves together. Although the number is exceptional for one cave, the fact that one species was chosen to be represented more than any other is not exceptional in itself. We have seen that in the Font de Gaume the "star" is the bison and that in Combarelles it's the horse. Here, it's the mammoth. The recently discovered Chauvet cave is rightly famous for the remarkable quality of its paintings, thought to date back 32,000 years, but it surprises me that so much fuss is being made about the unusual numbers of woolly rhinoceroses, bears, and mountain lions represented, when we know that predominant emblematic figures exist at so many other sites. True, these species are rarely depicted elsewhere—unlike horses and bison, which are omnipresent—but Rouffignac is in that case equally remarkable for its mammoths and Combarelles for its exceptionally numerous anthropomorphic figures. After the 159 mammoths, next in importance come the bison: 29 of them. There are 16 horses, 12 ibexes, 11 rhinoceroses, 1 bear, 4 humans, 4 undetermined figures, and 16 tectiforms. Again, as in Font de Gaume and Combarelles, we have the trio of horse, bison, and mammoth, as well as tectiforms.

◆

The cave's shelter entrance is wide open, a huge open mouth on the hillside, drawing the intrigued visitor inside, to be instantly swallowed by an impressive underground environment of a size unsuspected from outdoors. Unlike the two caves we have just been through—where we were at close quarters with the walls and which have something welcoming and intimate about them, something of a human dimension—this one's main upper gallery is awesome. Overwhelming. The ceilings here are 8 to 13 meters high, and the width is between 7 and 8 meters. Dead-end side passages slope down, where water stagnated, before spreading out in a multitude of smaller terminal branches, some of which are impenetrable. Now dry, such corridors have lower ceilings and are generally broader, about 10 meters wide, with walls and ceilings that are appropriately smooth for the art found in a few of them. These secret passages are difficult to get to and, of course, inaccessible to the public.

The walls are chalky, and their consistency varies considerably from one area of the cave to another. Techniques were adapted accordingly: where the surface is soft, lines were traced with fingers or possibly with a stick of some sort; where the rock is harder, lines were engraved by means of a flint chisel

or a piece of bone or ivory; and when it was even harder, it was possible to do
the black manganese drawings. Applying color to a soft surface is ineffective:
try drawing on sand or on earth, and you'll end up with an engraving.

Our first stop is about 700 meters from the entrance: on the left-hand
side of the broad main gallery, a couple of mammoths face each other. These
were the first to be discovered. The two mammoths together form a 1.70-
meter-long panel, and are finger-drawn at hand level on soft, powdery lime-
stone that is still as fragile as it was then. The left-hand one consists of only
three lines: one uninterrupted line for the back, head, and trunk and one long
curve for each tusk. The opposite mammoth is larger and more detailed, with
woolly legs and belly; the eye is a natural flint nodule protruding just where
it should. This is not fortuitous, the figure is composed around the flint "eye."
The tusks of the two are cradled one above the other in the same parallel
curves. It is remarkable how simple, yet effective, those lines are. I wonder
how many years of experience would have been necessary to get them just
right, with such economy of means. Many visitors, even archaeologists and
art historians, tend to be disappointed by Rouffignac, because they expect
paintings and colors instead of linear work, either engraved or in black. I, on
the contrary, marvel at the ingenuity of such simplicity, which is in no way
detrimental to a perfect transcription of the animals' correct proportions,
and I admire the calligraphic sensitivity of the lines themselves, infinitely
more difficult to achieve than some of the more laborious paintings. With
one outline, the animal is there.

Long vertical lines seem to cover the right-hand mammoth, looking at
first glance like wool; in fact, they are underneath the animal's contours and
spread out far beyond it, in a thick, decorative band along the wall to the
right. They are drawn on the soft wall with the tips of fingers in twos and
threes, and they no doubt constitute a sort of sign language, the meaning of
which is unknown. They are important, there is no question about that, as
they are found throughout the cave, covering a total surface of more than 500
square meters, forming huge meandering abstract designs and mazes on cer-
tain panels. Among the multitude of possible interpretations, it is reasonable
to imagine that they are closely linked to whatever the animals meant sym-
bolically and mysteriously. For although they usually are separated from the
figurative art, in some panels they are found under, over, or around the ani-

mal depictions as part of a global conception, and therefore most probably traced by the same artist's hand. But the digital signs could also illustrate the active contributions of one or several elected Paleolithic participants, deliberate traces left behind by representatives of the community, for instance, which would explain those made by small children.

◆

At a junction about 100 meters farther on, two galleries fork away: to the right is the Henri Breuil gallery and, to the left, the passage that will lead us to the Great Ceiling. The next panel consists of a 3.50-meter group of three woolly rhinoceroses, each measuring about 90 centimeters, drawn on the right side of the Breuil gallery (Fig. 11). Fitting into a long, horizontal, concave space, which looks a bit like a natural landscape between a ledge below and a horizontal layer of flint nodules above, they are turned to the right, one behind the other. They are spectacular, the finest known, along with those in the Chauvet cave. Each one is different. Although they all have characteristic woolly bellies, massive humped backs, and double horns, the central and left-hand figures are more detailed, each with an expressive eye and eyebrow, each with its legs in perspective, yet each with an individual touch: a well-defined ear for the one on the left and the typical nasal appendix for the one in the center. All three appear to be further individualized by differently shaped upper horns: that of the animal on the left seems to be broken, perhaps in the course of a fight; that of the central rhinoceros is long and twisted forward, which would be typical of an elderly animal; and the one on the right has a short upper horn pointed upward like that of a young adult. I wonder what the story is. A peaceful trio, judging by their lankly hanging tails. The raised eyebrow and liveliness of the two on the left give them a happy expression.

Again, I can't help noticing the accuracy of the single line used for their backs, drawn in one sure gesture: perfect. The lines are outlined in certain areas by engraving. The perspective of the most distant leg is simply suggested by a blank space between it and the body: as it is not quite attached to the body, the leg looks as though it were farther back. Each animal is individualized. These depictions have more detail than the previous finger engravings, but they are nonetheless line drawings, with no color inside the body. Even the more elaborate mammoth figures in the cave, whether drawn

or engraved, have the same single continuous line for the back, in contrast to the multiplicity of small lines for the belly and chest wool. To the left of the rhinoceroses is an engraved mammoth—a simple line contour—and two more are close by.

Directly above the rhinoceros farthest to the left, hidden within the shapes of a large knobby flint nodule, is the profile of a horse's head, drawn in black. It is looking straight at us, eye wide open, with a round nose and shaggy lower jaw, and it fits ideally around the natural shapes of the rock. This figure is rarely shown for lack of time, but I know it's there, and every time I'm in the cave I feel its presence, like that of an old friend watching us go by in the dark. A nearly identical head appears on the Great Ceiling, but on a fully drawn horse. They're so similar that I'm certain the same artist drew both.

◆

Opposite the rhinoceros panel, on the left-hand side of the gallery, two mammoths face each other. Mammoth meetings appear to be a recurrent theme in this cave, repeated 11 times. Again, one is larger and much more detailed than the other. Just as in the first pair, the left-hand mammoth is the simpler, with a single line for the back, head, and trunk and one more for each tusk. These figures are not finger drawn but engraved by means of a sharp tool, probably a flint chisel. The facing mammoth, 1.22 meters long, is the most famous of the cave, the most detailed and expressive of all, and is known as the patriarch. Different techniques were used to convey texture, without derogating the seemingly tacit decision only to outline the animal and not to apply any shading: the back and top of the head are one sure, sharp line, and the rest, instead of being outlined, is "modeled" by a series of short lines representing the wool around its voluminous head, bulging forehead, cheek, and ear, and around its trunk, legs, and belly. The eye is a deeply incised triangle with a pyramid-shaped eyeball in the centre; it is topped by a pronounced brow. The artist changed tools for the tusks: in order to suggest their size and weight in a single line, the engraver chose a broader chisel, made of a piece of bone, antler, or flint. This is an old animal, with its long tusks and thick wool, a venerable and imposing creature, a worthy patriarch.

To the left of these two mammoths, another animal comes into the pic-

ture: a horse facing right. Its mane, chest, and beard consist of a series of lines representing the hair, whereas the back, forehead, and muzzle are sharply outlined with a single stroke. There is no eye, which is unusual, and the ear is suggested by a small rock protrusion. With only a few lines, this horse is right there before us.

Other engravings complicate the "patriarch" mammoth: a dozen gouged markings are grouped above a small flint in the center of the body. These are deep and crude, something we'll see on other mammoths. And beneath the back line are two huge horns, those of a large rhinoceros.

An exceptional figure lies a bit farther to the left: a finely engraved bear, considered to be the only one in the cave.

The two opposite panels seem to be quite different thematically and technically: the main figures on the left-hand side are mammoths, and they are engraved, whereas those on the right are drawings of rhinoceroses. But if we look closely, we find that on both panels is the same combination of mammoth, rhinoceros, and horse. We might add a bear to each group. Officially, only one bear is represented in the cave, the one on the same side as the patriarch, but another may be on the opposite wall, on the shapely flint nodule with the drawn horse's head, above the rhinoceros. This protruding flint nodule is partially broken to the right of the horse, but a few black lines that have nothing to do with the horse are visible, and the natural rock shapes look to me like a bear's rounded body. I saw it at once in a flash, even though it is far from obvious. Years of experience lead to this kind of spontaneous, immediate recognition. Only afterward did I learn about the finely engraved bear on the opposite panel, thus reinforcing the probability that the fragmentary "nodule bear" is real.

Farther along the same gallery, a fork to the right leads to a dead end. On the right-hand wall is one of the largest composed group of animals known in Paleolithic art: a 9-meter-long scene of two groups of mammoths meeting, six on the right facing four on the left, all drawn in black manganese (Plate 7). They are inscribed within a long, smooth, horizontal, concave space framed by a ridge below and a row of flint nodules above, but the two central figures are head to head, their tusks overlapping, on a convex curve of the wall, setting the others slightly behind in perspective. Each group consists of mammoths in close contact or overlapping, except for one at the end of each line,

which is placed at a certain distance from the others; either it's a coincidence or a well-observed habit, because this is how I've seen modern elephants act: one often remains at a certain distance to watch over the others, which are otherwise closely grouped. This is the panel that is partly veiled by a horizontal band of calcium carbonate. Beneath the white calcite, one can see here and there part of a leg, foot, or tusk. The drawing is simple and effective, and each outlined animal is individualized by the presence or absence of an ear or an eye and by their differently shaped tusks and back lines. The heads and tusks are low, and the tails hang down limply, an indication that the "encounter" is peaceful. They seem to be moving forward gently, their voluminous backs rolling along. I imagine how real and alive they must have looked in the flickering glow of fat lamps or wooden torches. Wonderful!

Such a carefully planned composition has to be considered a "scene"—a meaningful scene, perhaps telling a story, illustrating some legend or myth, bringing the cave walls to life. It is often said that narrative scenes in prehistoric art are exceptional, and the example of the licking reindeer in the Font de Gaume is cited as one of the rare few, but do animals have to be licking each other, copulating, or fighting to be recognized as being in relation to one another? I am convinced that an isolated panel composed of only two animals facing each other, let alone two groups, is conveying a relationship of some sort, just as there would be communication between two people who are face to face, looking at each other, without touching or saying a word. Something is happening. Some sort of exchange is taking place.

The Henri Breuil gallery continues, but without us. Several hundred meters farther along, there are a few exceptional figures, including six tectiforms—those tent-shaped signs already noted in both Font de Gaume and Combarelles—and three humans. Toward the end of one of the branches, three equidistant tectiforms line the smooth ceiling, near two caricatured human heads engraved in profile and facing each other; both are much larger than life, and they are commonly nicknamed Adam and Eve, although there is no indication of gender. The head on the right is 65 centimeters high, and the left-hand one is 86 centimeters high, with a strange oblong eye and an upturned nose; each has a smiling, if not laughing, mouth. There is something comical about these two characters, who seem to be leaning toward each other, sharing a joke, their foreheads nearly touching. This is not un-

usual, as faces or human profiles are more often than not caricatured and at times even funny. They can be grotesque, with snouts, looking more like monkeys than humans. They can have big round eyes, upturned noses, no chin at all, long thin necks, or humpbacks. Realistic portraits of individuals with normal human proportions and expressions are indeed rare, as we have seen. In yet another terminal branch is a third anthropomorphic figure, next to a small shaft that he, or she, seems to be crawling away from. Much more stylized than the others, this figure isn't typically human, but it's not animal either, so it is considered anthropomorphic. Beyond it is a mammoth, drawn in a confined area in which one has to crouch. At this point, the figures are 1 kilometer from the entrance.

◆

The train moves back to the junction, taking the left fork this time, the one leading to the Great Ceiling. Just at the fork, on the ceiling above the protruding, pillarlike junction wall, is a large rhinoceros, magnificently engraved but inconveniently situated and therefore not shown to the public. But it is important to know that it's there, in such an obviously strategic position in the cave. Another is next to it, crude and clumsy in comparison. Were these depicted by different artists or were they deliberately differentiated, like the mammoth "couples" seen so far?

As soon as we make our way along the main gallery again, we see that the compacted clay floor is riddled with large circular pits—up to 2 meters wide and 1 meter deep—that were dug out by a much older inhabitant of the cave: the ancient cave bear. These huge bears came in to hibernate, leaving their lairs by the hundreds—and leaving millions of claw marks throughout the cave—until their extinction about 23,000 years ago. For the Paleolithic artists, these pits made their venture even more difficult, as they do for those of us exploring areas off the beaten track today.

The ceiling is lower, the space becomes more confined, and very soon the artists would have had to crawl. A trench has been dug for the train to pass and to ensure the preservation of the drawings and engravings, now out of reach, which is why visitors are allowed to come this far. I'm particularly fond of a group of mammoths on the right, which I've secretly named the "family of five": two adults on the right face two on the left, and in between is a young mammoth, perhaps a baby. In this group the left-hand figures are

the most detailed, especially the one closest to the central "baby." This adult is engraved with an elegant, flowing line for the back, tusks, and trunk, the tip of which is curled; the rest of the body is shaped by abundant hair lines. The wall surface is soft here. A continuous, meandering four-finger digital sign crosses this mammoth diagonally from the top of the head down to beyond the belly and is prolonged by another one flowing around the top of the head down to the curve of the tusks; it may be the same sign continued. The mammoth's back line is crossed by more of these finger markings. The animal and the signs were probably accomplished simultaneously, as the latter are both on top of and underneath the animal. Furthermore, the mammoths on the left have several deeply gouged markings grouped in the centers of their bodies, just like those on the "patriarch."

The mammoths on the right are badly damaged, but one can still see that they were initially less detailed. They even look more clumsily done than the others. I have no doubt, though, that they were engraved by the same artist, as the group forms a balanced composition of five figures. There must have been some meaning behind the fact that one side is more finely finished than the other, a distinction we have seen on two other panels. The central figure, slightly lower, is a funny-looking young creature, with a lumpy head, no tusks, and a hairy trunk. It is snugly niched between the adults' curved tusks. It seems to be surrounded protectively by the four adult mammoths.

Above our heads, a maze of digital lines covers the ceiling, leaving hardly any space free. These are long and curved or straight, even forming geometric designs such as the tectiform sign we are now familiar with. At this point, the gallery is about 1.60 meters high, and the smooth, soft ceiling offers an ideal surface to work on, despite acrobatic conditions. On the ceiling here the largest mammoth in the gallery, 1.35 meters long, stretches out just above our heads, protected by a grid. Carved in deep, strong lines, it looks as though it's floating, with its wool-free hind legs extended in perspective, both outlined with a single line. Its lone front leg is quite different, suggested almost abstractly by a vertical series of hair lines. We find this particular way of representing mammoths—with a single foreleg and two hind legs—repeatedly in the cave. Is this the artist's personal touch or a stylistic convention? Not to be overlooked are the triangular eye and well-defined eyebrow, and an

exceptionally short tusk that abuts onto a small flint nodule. It, too, is asso-
ciated with digital markings, drawn beforehand as in the case of the first two
mammoths we saw. Another of these meandering motifs is carefully drawn
just below the legs, running parallel to the gallery, zigzagging neatly from
one small depression in the ceiling to another. Is it randomly placed, an in-
dependent entity, or, on the contrary, a sort of imaginary ground level for the
animal? Is it an extension of the nearby seemingly confused maze of digital
motifs, or an explicit sign indicating the way to the Great Ceiling?

The space between ground and ceiling is so narrow now that, but for the
trench, we would be crawling. The Cro-Magnon artist had to. As we move
forward, the digital lines become scarce and then stop altogether, leaving
a large section of the smooth ceiling surface with no trace of drawing or
engraving, until we come to the 65 animals grouped on the famous Great
Ceiling. What magnificent drawings! Breathtaking! Drawn in black, the 26
mammoths, 12 horses, 12 bison, 12 ibexes, and 3 rhinoceroses form an ap-
proximately 8-by-7-meter, jumbled whirl of figures floating in all directions,
with no apparent order of any kind that we can decipher at first glance. An
expert eye can, however, with time, detect some systems in the composition,
without knowing which is in any way significant. For instance, all the horses
are in the sector closest to the entrance, whereas all but two of the ibexes
are on the other side, and the two largest mammoths face each other in
the center. No matter how studies probe the logistics of the figures—for in-
stance, their superimposed combinations, their comparative sizes, the degree
of realism or stylization, whether they are whole or only partially completed,
and which characteristics prevail—we cannot ascertain which criteria were
significant at the time. How are we to interpret the systems that we painstak-
ingly unravel, quantify, and qualify? Our culturally influenced twenty-first-
century eye might even focus on criteria that never crossed the Magdalenian
artist's conscious mind.

And to further complicate interpretation, who's to say what was more
significant: the visible or the hidden? We'll soon see why this question in-
trigues me.

One option at least is clearly significant: the choice of this particular
spot. We are now about 1 kilometer from the entrance. It's a long way for the
artist to have come, in the dark, stumbling along on uneven ground, hin-

dered by fallen rocks at first, then barred by a multitude of bears' lairs. The torches or tallow lamps they carried gave off a wavering light and lit up only a limited space, casting shadows at foot level, making it difficult to see the ground's irregularities. I've tried in other caves: it's a challenge.

Another deliberate choice was to have confined all these animals to a restricted circle, even though there was ample room to spread them out. They face in all directions, frequently superimposed, interacting in various sometimes even playful ways, often in twos. At a first sweeping glance the global distribution seems mostly random. Why right here? The reason is probably associated with the deep shaft that descends, right here, to the lower gallery. It is the only way, in the whole cave, down to the next level; there one is met by 13 more animals as well as a human profile. The 65 animals of the Great Ceiling are concentrated around and above the shaft. There is no doubt in my mind that they are intimately connected with this plunging passage and with the imagery below.

Shafts or narrow cracks in caves were often given special attention, special graphic treatment, as though they constituted a sort of inner sanctum, a cave within the cave. Because of its size, Rouffignac is a particularly interesting cave for studying the distribution of the figures. Unlike the other two caves we have seen, both of which are much smaller and, because of the limited available space, understandably covered with a dense network of figures, this one is so vast that we find the art only in certain areas. Some places could have been selected for practical or technical reasons, but strategic placements of a cultural, symbolic order seem more likely: at junctions, for instance, in difficult terminal galleries, in theatrical open areas, or on the contrary hidden away in corners, and, whenever possible, close to shafts. There are several shafts or pits in the Rouffignac cave—not necessarily very deep, but in the candlelit semidarkness even the smallest of potholes looks deep—and there is invariably a graphic statement close by: one or several figures, or a major composition such as the 10-mammoths panel.

In Lascaux (Dordogne), too, there is a deep shaft, above which is a dome-like ceiling covered with paintings; in the pit, there are painted animals, signs, and a human representation. Is it a coincidence that in these two caves—so different at first glance and more than 4,000 years apart in age (Lascaux is older: 18,000 to 17,000 years BP)—the main shaft is distinguished in a similar

way? Lascaux and Rouffignac have even more in common than first meets the eye, as we'll soon learn.

Font de Gaume has no pit, but it has a vertical fissure at the end of the cave, which is just as deep and mysterious in appearance, narrow and difficult of access. Animals, signs, and a stylized anthropomorphic figure adorn the walls there, despite the logistical challenges. I have described these, as well as the dome-shaped alcove nearby, with its many figures, including a beautifully composed central circle of four bison. The fissure is just beyond. Are those two areas of the cave symbolically connected, like the open ceiling and the dark shaft here? Could Font de Gaume's alcove and fissure and the more obvious ceiling-shaft connection of both Rouffignac and Lascaux have a similar inspiration? Could there be something significant in the duality of the visible and the hidden? The visible and the invisible?

♦

Gazing up at the Great Ceiling soon becomes overwhelming, there is so much to see! Viewed from where we arrive, the more or less central horses stand out first, because of their size and realism, several being about 1.25 meters long. Their sturdy, well-proportioned bodies, their expressive heads and crested manes, their muscular legs, joints, and hooves, their long hairy tails are exquisitely detailed. They are beautiful, healthy animals, standing quietly. One can't help but notice also that their lips are curled into what looks just like a smile. Another horse, closer to the wall to the right, is so large, 2.70 meters long, that the artist, crouching or lying under the ceiling to draw it, couldn't possibly have seen it as a whole; facing right, its head is so similar to the one drawn on the flint nodule we saw above the rhinoceros that I'm certain that the same artist drew both. On all of these horse figures, a straight, vertical line is drawn between the ear and the point where the lower jaw and neck meet. What do these lines represent? They can't be bridles, as this type of horse wasn't domesticated. The overall graphic effect of the vertical line, with the horses' heads on one side and the necks on the other, both symmetrically composed at the same angle, reminds me of the tent-shaped abstract tectiform symbols found in all three caves we have visited so far, and repeated 14 times in this one.

The parallel between figures of such realism on the one hand and those so completely abstract on the other may seem far-fetched, but the idea dawned

on me a long time ago when I was studying a certain bone spear point from the Abri Morin (Gironde) at the Musée du Périgord, in Périgueux (Dordogne). Its design consists of a series of four, possibly five, stylized horses' head and neck lines, in a row, side by side, starting from the point's beveled extremity (see Fig. 20[b]). Each is taken a stage further toward abstraction from left to right, a progression ending up as a vertically pointed geometric design that looks just like a baseless tectiform. The metamorphosis from horse to symbol is clear in this case. And another, smaller tectiform a few centimeters beyond the horses, at the tip of the point, convincingly ends the graphic progression toward abstraction. These Rouffignac horses are structurally of similar design. Could the tectiform signs in the caves be horses in disguise?

Just as detailed as these horses are the ibexes, with their lively expressions; their little beards; their upturned tails; their horns, large and ribbed on males, smooth and small on females; and their typically straight, proud demeanor. Many seem to be smiling, like the horses. The pair of ibexes on our left, next to the shaft, is arranged as on a playing card: the head and horn of each mirrors the other's, their necks and backs crossing. Another pair, at the far end, where most of them are, consists of a life-size goat with, abreast and in perspective behind, a half-hidden, very young one with a stump of a horn (Fig. 12). The two together, covering a length of 1.90 meters, are alert and leaping forward in the same direction, toward the left. Certain details allow us to attribute the two to the same artist: an identical double line for the back of the neck, the same vertical chest, the same foreleg, the same expression, protruding forehead, and ears in perspective. In this cave, ibexes are found only here, on the Great Ceiling, and they are situated only on the periphery of the group, circling round the other animals, some even overlapping onto the low, bordering, vertical sides of the chamber, adapted to the natural irregularities of the limestone.

Both bison and mammoths are spread all over the ceiling, neither species confined to a specific zone. Bison are depicted in two distinct ways: their hump is represented either as a stylized, exaggeratedly protuberant bulge, drawn with a single line, or as a less prominent, bristly mane, suggested by a series of short lines. Jean Plassard observed, on the drawings that are sufficiently complete, that the first type are endowed with a penis, whereas the

latter are not. Could it be that there were stylistic conventions for males and others for females? Or might this represent the personal touches of two different artists? The degree of completion varies considerably from one to another: the large bison at the far side is fully represented, with as much detail as the horses, while others are realistic but simply outlined, and yet others consist of the forequarters only, either realistic or stylized. One is of particular interest, because it is depicted with a combination of different techniques adapted to the consistency of the limestone: drawing for the head, engraving for the legs and belly, and use of the natural marbled aspect of the wall for the body and back. This illustrates well the intelligence, the creative adaptability of its Cro-Magnon artist. Another striking observation is that some of the bison have profiles that seem almost human, either in the eye and eyebrow or in the human noselike muzzle. Are these comparable to the possible human-bison figures already noted at Font de Gaume?

◆

Of the 26 mammoths on the Great Ceiling, the most obviously composed are the two largest ones, facing each other in the center. As they are in the middle, they are not easy to see, having been worn down by early visitors crawling by, rubbing the ceiling with their backs. Two others have their heads crossed, arranged playfully so as to share the same eye; these are near the two ibexes that are arranged in playing-card fashion. The two mammoths that stand out most noticeably are at opposite ends of the ceiling, each remarkable for its detailed anatomy and excellent preservation. One is at the far end, situated in the densest group of ibexes. On this one, the dark manganese lines are sharp, defining the animal's features clearly, with certain anatomic characteristics that only someone who had been in close contact with mammoths could have known about and drawn: the anal flap, for instance, and the pronounced double extremity of the trunk, which looks like two fingers here. It displays the same graphic conventions as the others: two outlined hind legs but only one in front, represented by a series of vertical hair lines, the trunk defined on the outside by a continuous line and on the inside by a series of hair lines, and the clear-cut back, drawn in one sure gesture continuing that of the trunk (jacket photo). Drawn markings are centered on the body, seven of them grouped and two farther away; these are short and angry looking, similar to those gashed onto some of the engraved mammoths. Whether

these added markings are contemporaneous or not we don't know, but they have a spontaneous quality, more physical than aesthetic, that differs from the delicacy and care with which the animals themselves are depicted. Exceptionally, on this mammoth, each tusk is represented by two lines joined in a point, which is twisted forward at its extremity, indicating that this is an old creature. It also has a lively eye framed by a double brow.

The second mammoth is the most endearing one I know. Of all the mammoths, this and one in Bernifal are my favorites. This one is away from the crowd of animals, to the right of the entrance: a very young one, with its plump, chubby proportions superbly rendered (Fig. 13). Its back is a perfect line, with the characteristic V-shaped nape of the neck and the rounded hump sloping gracefully to its long tail. The single line turns into a series of short bristling striations for the large head, making it look soft and fuzzy, before straightening again for the full length of the trunk, which is curled up at its extremity. The rest of the body is all fuzzy again, with short parallel lines around the inside of the trunk, the legs, and the belly. Once more, the eye and the brow are drawn, as is the anal flap, much clearer here than elsewhere. The lower lip is represented for once, perhaps because the hair isn't long enough to cover it up, as it would be on adults. One technical detail is worth mentioning: a noticeable change to a heavier, darker line for the curved pads of all four feet and for both small tusks. The artist cleverly switched to a different piece of black manganese to differentiate the harder, thicker surfaces from those of the delicate, furry body. The result is subtle and remarkably effective.

The three rhinoceroses appear to be carefully distributed in a row on one side of the ceiling. The middle one is between the two central mammoths, just underneath them. Another is at the far end, back to back with the detailed adult mammoth described above, and the last one, reduced to a few suggestive lines, is near the entrance and facing my favorite young mammoth. Of all possible places, they happen to be next to the two mammoths I've just described in detail and between the largest central pair. How strange that, of the ceiling's 26 mammoths, the pair in the center and the other two I find to be the most remarkable are all closely associated with a rhinoceros—a coincidence I'm aware of now for the first time, as I write these words.

◆

The "tangle" mentioned above gradually unravels as one becomes more familiar with it. It takes time, and a certain understanding of the place. Some orchestrations are subtle indeed, and, to make things more difficult, certain essential figures are barely visible. For instance, only after years of regular visits, and after the surface had been cautiously cleaned of its smoke-dark graffiti, did I see for the first time a small, extremely stylized horse's head between the tusks of the two central mammoths. Stylized in the extreme is not an exaggeration: the simplified head consists of a straight line for the forehead, perpendicular to which are a couple of short parallel lines to suggest the ears or mane, and a dot for the eye. It couldn't be more abstract. To convince skeptics that it really is a horse, another one nearby is practically identical, except for an extra detail or two: the ears are sufficiently defined to be recognizable and so is the minimal tuft of a mane in between, and a tiny perpendicular line starts where the nose should be, giving the profile the right proportions for a horse's head.

Again, the parallel with the Lascaux cave strikes me as significant. It so happens that in the axial gallery—one of the two most spectacular sections of Lascaux—three impressive red aurochs form a circle around the ceiling, their horns pointing toward the center; three large, beautifully painted horses line one side of the narrow gallery, and three others, in poorer condition, are arranged symmetrically on the opposite side. This is such a magnificent, colorful, circular composition that the small, barely visible horse's head and neck, placed exactly in the center between the cows' horns, goes unnoticed. It is small and simple, reduced to the fine contour of the head and neck only, faintly painted in red. It is practically invisible. Yet its central position makes it, to my mind, the most important figure of all, although it is the least ostentatious.

In the same way, Rouffignac's barely discernible little horse's head, placed between the imposing central mammoths' tusks, despite being overshadowed by the huge, magnificent horses nearby, might likewise be an essential figure, if not the most relevant.

Perhaps it's the "hidden" figures we should look out for. The less visible, the more spiritual?

Down at the bottom of the deep shaft, hidden from our view, are six mammoths, six bison, and one horse, surrounding the profile of a human

head. They're all on the right-hand side of the shaft, and the human is quite realistic, once more with an amused expression; it is framed by two bison, one above and one below. All three are facing left and are drawn with a simple black outline on the rough uneven surface. Technically and artistically, the figures are unexceptional, but they certainly seem important to the few of us who have carefully edged down the 10-meter-deep shaft to look at them. It is therefore quite natural to imagine them as being particularly meaningful, despite their rather "ordinary" aspect; we have just seen how modest and simple certain depictions placed in important strategic places appear to be.

Beyond the Great Ceiling, the narrowing gallery continues for another 250 meters, along which there are 20 mammoths and two bison—often situated close to small shafts or depressions—as well as a strange-looking animal, possibly a saiga antelope, finger-drawn at the very end. It is not easy to crawl along such confined spaces, on uneven ground riddled with bears' lairs, farther and farther from the entrance more than a kilometer away. These areas are not seen by visitors; they lie undisturbed in the dark and remain all the more vivid in the memory of those who have struggled to get there.

Still, the reader mustn't feel too frustrated about not seeing the rare sections that are closed to the public, because, of all the caves, Rouffignac shows the largest proportion of depictions to visitors. In Font de Gaume and Combarelles, we get to see approximately 30 figures in each, roughly 25 percent and 5 percent of what each has to offer, respectively; here we see about 92 animals, which represents nearly 40 percent of the imagery.

◆

Two other areas not open to the public must be mentioned, because both are fascinating, for different reasons. Situated in side galleries where trapped water remained stagnant long enough to impregnate the porous limestone walls superficially with the reddish browns of iron oxides, the art is either finger-drawn or finely engraved, resulting in white drawings against a deep red background. The first gallery, a short dead-end branch to the right of the main gallery, about 300 meters from the entrance, is called the "red chamber." One has to bow down to enter the low chamber, to find, above one's head, a spacious rectangular surface of about 30 square meters, smooth and free of the ceiling's many concave upturned potholes. A superb composition occupies all the available space: six mammoths appear to be meeting in the

center, two from the right, where we've just come from, three from the left at an angle, from the deeper end, and one also coming from the left but from below, forming a triangular group with the first two mammoths. They are so large, on average 2 meters each, that the only way to see them properly is to lie on the floor. The three central figures are in close contact, as though they were intent on some form of communication, and the others are just behind, tusks overlapping their predecessors' rears. To complete the picture, two other mammoths are drawn farther along the gallery, out of sight, separated from the group of six by a simply outlined rhinoceros.

What makes this panel the most moving of all to me is not easy to define. Has it something to do with the intimacy of the reduced space, the soft reddish walls wrapped around us comfortably, reassuringly, calming our spirits? Or the harmony of composition, the graceful shapes, the delicacy of the engraving itself, consisting of the finest of lines, tightly grouped, yet at the same time light and lively, detailing the contours of the woolly bodies? The artist's sensibility is more immediately tangible because of these details. We're so close to the animals that their presence becomes familiar, and not the slightest bit menacing. We can sense that this scene—for "scene" it truly is—is conveying a message of some sort, the essence of which we are unable to grasp.

We, too, by our presence, are participating in the mammoths' meeting. The mere fact that we are focusing our attention on them at such close quarters and that they are larger than us, almost enveloping us, makes us part of their group. We are part of the story.

There is another aspect, a deeply satisfying sense of harmony. The cave, the animals, and ourselves come together in an inexplicable, irresistible form of communion.

◆

The second part of the cave that is off the beaten track is even closer to the entrance, along the first major side gallery to the right. After about 100 meters, the gallery's high ceiling drops to 1.60 meters, and a narrow, doorlike passage leads us into an open space consisting of a series of alcoves around an approximately 150–square meter junction that branches off in several directions. Here, a maze of meandering finger lines covers the ceiling, forming vast, whitish, abstract patterns on the clay-coated surfaces. It looks like

modern art. It looks like a vast Dubuffet painting! He would have liked this. There is no figurative imagery, except for a few lines that have been interpreted as snakes, one of which is even said to have a head. The "head" is defined by lines that, instead of being joined to a potential snake's body, diverge to form a meandering double line on the left and a knotted double-lined loop extending below, to the right and around a small flint nodule. This doesn't look anything like a snake to me. Five other small flint stones are included in the design, which looks more like a complex composite sign than a snake.

At first, the designs appear to be jumbled improvisations, but after a while, certain structured entities emerge from the mass of lines: for instance, on each side of the "entrance" by which we arrive, there is a large grid of grouped straight lines running parallel and perpendicular to each other. The grids mirror each other, and their geometric design stands out from the twisting and zigzagging of the other lines. Other motifs were achieved by using both hands simultaneously to trace the same lines symmetrically. Furthermore, the finger lines, which are single, double, or triple, are not just carelessly traced on the wall. Despite their densely superimposed and intermingled distribution, many of the lines stop when they arrive at others that are barring their passage, only to continue on the other side, carefully avoiding crossing them.

Finger markings, whether accidental or part of designs, invariably leave a strong impression. They bring us directly into contact with the reality of a person's touch, a hand, a human being, alive, breathing, thinking, creating, not just some anonymous *Homo sapiens*.

Other caves have digital expression of a variety of kinds; one is Montespan (Haute-Garonne). This cave, understandably, is not open to the public. I remember having to wade through freezing cold, murky water, deeper and deeper, until only enough space was left for me to be able to breathe, head bent sideways in the 10-centimeter space between the water level and the ceiling, hoping that my headlight wouldn't go out, before finally arriving on higher, drier ground. The cave is coated with wet, thick, soft clay, and there are finger marks and smudges everywhere, even marks of fingers that were poked into the clay to form lines of decorative holes on animals' bodies. Michel Garcia, a friend of mine specializing in imprints of all kinds in the caves, and chief archaeologist of this site, made molds of these fingerprints.

A negative print becomes a three-dimensional finger, the actual finger of a Magdalenian! One can also see places where clay was scooped out to model animals in relief, one of which is the life-size, freestanding, headless body of a bear, unique in all cave art. Balls of clay have been found around and against the walls, almost as though children had been playing games inside, throwing clay around. Caves are usually interpreted as forbidding, fearful places, where stressful initiations or other rituals were performed with ceremonial solemnity. Here, though, the idea that people might have enjoyed the caves and felt completely at ease in them—at home, even—is irresistible.

In Rouffignac, finger lines are present wherever they could be traced, on the more malleable wall surfaces. Because of their number, they represent one of the most extraordinary themes of the cave, along with the mammoths and the woolly rhinoceroses. Here, in this part of the cave, there is no figurative art; finger lines alone cover the walls and ceiling. Among them are some of an exceptional kind: tiny markings, made by a small child or a baby. Small fingertips with hardly any space between. There is no doubt that someone held up a baby and carefully guided the little hand along the wall, to add its contribution to the designs. It is known that adolescents and children entered the caves; their footprints, found in undisturbed sites, testify to this. In this cave, we can see that even the youngest were brought in. Whereas the animals were obviously drawn and engraved by an experienced elite, could it be that the finger designs, particularly those of children, expressed the community's participation? They appear to be contemporaneous, as abstract finger-drawn motifs are found elsewhere in the cave, superimposed, around, or underneath the animal figures. Moreover, is it a coincidence that in this cave, which has these unique traces drawn by babies or very young children, young animals also happen to be depicted, which is rarely the case elsewhere?

◆

The Rouffignac cave experience is the most awesome because of the size of the cave and the quality of its art, but we have encountered something else: it has been a joyful experience too. The animals all look healthy and strong, calm and gentle, the young and the old, male and female, in groups, in twosomes, rarely solitary. All have pleasant, even merry, expressions. The combined presence of young animals and small children's finger lines on the

walls further inspires a sense of being in a secure, familiar place—a "family" place. Once one is beyond the impressive and chaotic beginnings of the main gallery, once one is among the animals and flowing finger designs, the cave seems protective, welcoming, a place fit for a "good" experience. It is a sanctuary invoking good spirits, good magic, the continuity of the species, nature's generosity, celebrating the group's multigenerational ties, the old and the young, the living and the dead. Whatever the answer, I invariably come out of Rouffignac feeling positive and optimistic. And joyful.

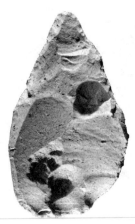

Figure 1. The Mousterian Levallois
point found in my fields, around 70,000
years old

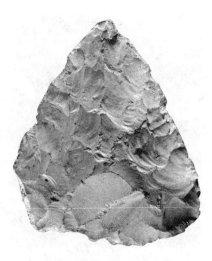

Figure 2. The Mousterian biface that
I found in my fields, around 70,000
years old

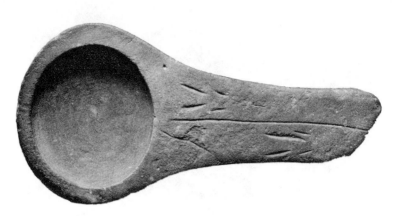

Figure 3. Lascaux. The famous red sandstone lamp, with a nonfigurative design on the handle, 22.3 centimeters long. Magdalenian period, Musée National de la Préhistoire (© N. Aujoulat-CNP-MCC)

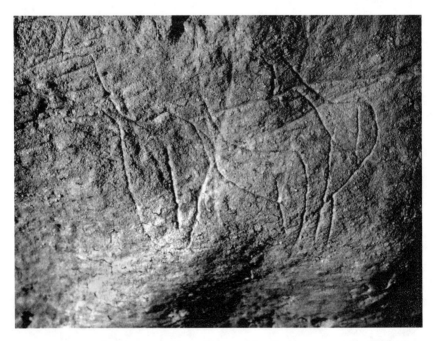

Figure 4. Combarelles. A group of three schematic female figures, one behind the other, and increasingly stylized from right to left. There are no heads, arms, or feet, and only the right-hand figure's breast is represented. The left-hand figure's thigh becomes a schematic vulva. This is a good example of deliberate abstraction. These headless profile views illustrate a typical stylistic convention of 12,000 years ago.
(© N. Aujoulat-CNP-MCC)

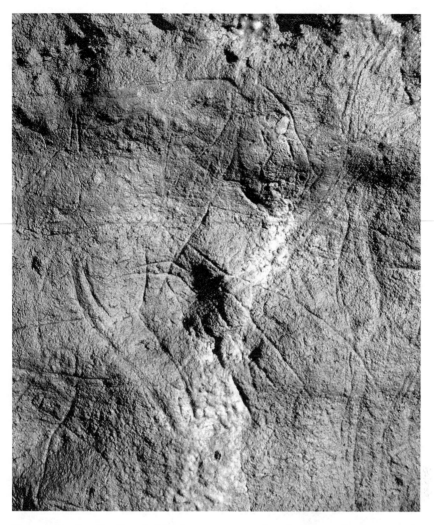

Figure 5. Combarelles. Detail of the famous mountain lion (© N. Aujoulat-CNP-MCC)

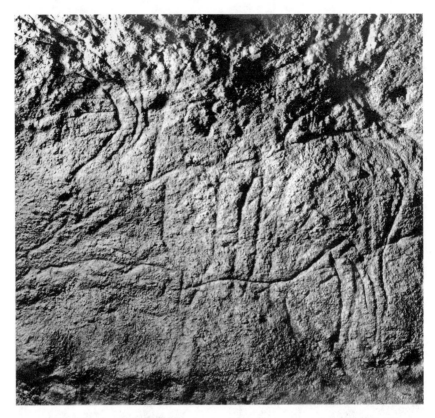

Figure 6. Combarelles. The "drinking reindeer." The name comes from the animal's position, with its head stretched out toward a small cavity in the rock that resembles a waterhole. (Courtesy of Alain Roussot)

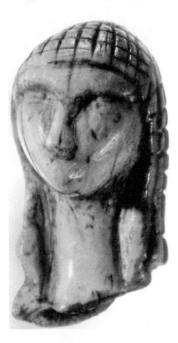

Figure 9. Brassempouy. "La Dame de Brassempouy." This is an exceptional piece: a portrait of a young person, with delicate feminine features, an elaborate headdress or braided hair, and a long graceful neck. There is no mouth, a typical Gravettian stylistic convention for human representations. Mammoth ivory, Gravettian period. Musée des Antiquités Nationales (Courtesy Alain Roussot, Collection Henri Delporte)

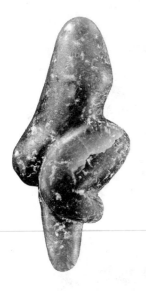

Figure 7. Abri du Facteur. Profile view of the "Vénus de Tursac" statuette, extremely stylized, with the same curved legs, protruding belly, and buttocks as the "Venus of Sireuil," 8.1 centimeters high. Amber-colored calcite pebble, Gravettian period. Musée des Antiquités Nationales (Courtesy of Alain Roussot)

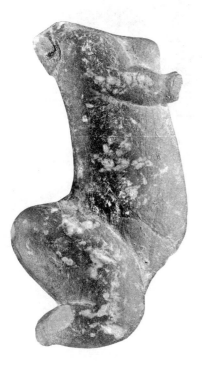

Figure 8. Goulet de Cazelle. Profile view of the "Vénus de Sireuil" statuette, stylized with high youthful breasts and shortened arms and legs, 9 centimeters high. Amber-colored calcite pebble, Gravettian period. Musée des Antiquités Nationales (Courtesy of Alain Roussot)

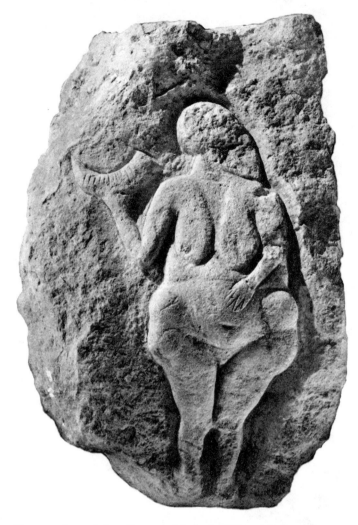

Figure 10. Laussel. On a limestone block, the "Vénus à la Corne,"
42 centimeters high. Gravettian period. Musée d'Aquitaine
(Courtesy of Alain Roussot)

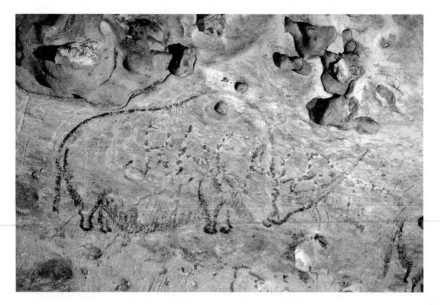

Figure 11. Rouffignac. The left-hand rhinoceros of the "three-rhinoceroses" frieze. Note the front legs: the most distant one is not joined to the body, thus effectively producing the illusion of perspective. (Courtesy of Marie-Odile and Jean Plassard)

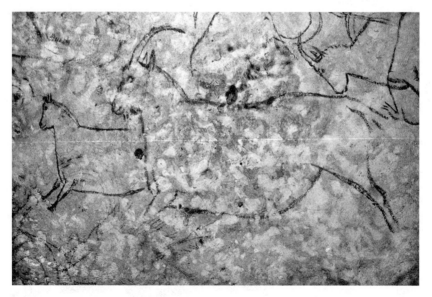

Figure 12. Rouffignac. Part of the Great Ceiling. A female and a young ibex joyfully prance forward, side by side. (Courtesy of Marie-Odile and Jean Plassard)

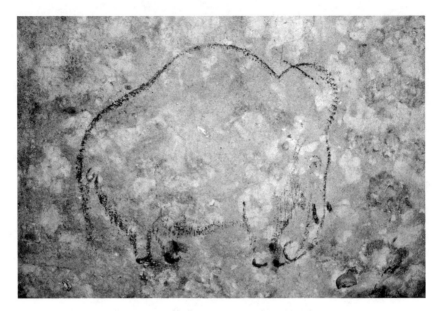

Figure 13. Rouffignac. Detail of the Great Ceiling. The "baby" mammoth displays perfect proportions and expert simplicity of line. Note such details as the anal flap and the mouth, which would indeed be more visible on a young mammoth than on its hairy elders. Note also the change to a thicker stick of manganese for the tusks and feet. (Courtesy of Marie-Odile and Jean Plassard)

Figure 14. Fourneau-du-Diable. On a huge limestone block, carved aurochs in perspective. Solutrean period, Musée National de la Préhistoire (© MNP Les Eyzies. Dist RMN. Ph Jugie)

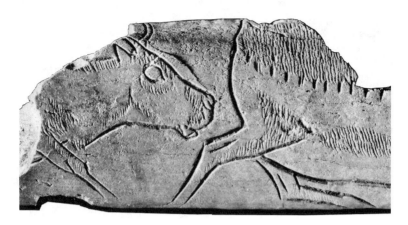

Figure 15. Abri Morin. Two reindeer, one behind the other (detail).
Bone, Magdalenian period. Musée d'Aquitaine (Courtesy of Alain Roussot)

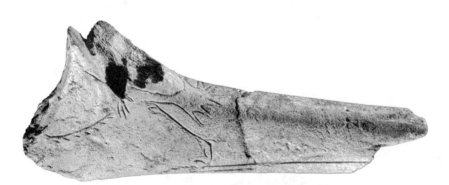

Figure 16. Laugerie-Basse. Les Marseilles, reindeer's head. Reindeer antler, Magdalenian
period, Musée National de la Préhistoire (©MNP Les Eyzies. Dist RMN. Ph Jugie)

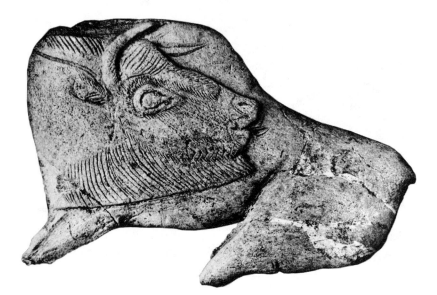

Figure 17. La Madeleine. The famous "bison licking its flank" on a probable spear thrower, 10.5 centimeters long. Reindeer antler, Magdalenian period. Musée National de la Préhistoire (© MNP Les Eyzies. Dist RMN. Ph Jugie)

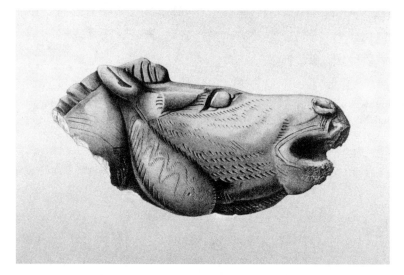

Figure 18. Le Mas d'Azil. The "neighing stallion" as drawn by Edouard Piette. Magdalenian period. Musée des Antiquités Nationales (Collection Alain Roussot)

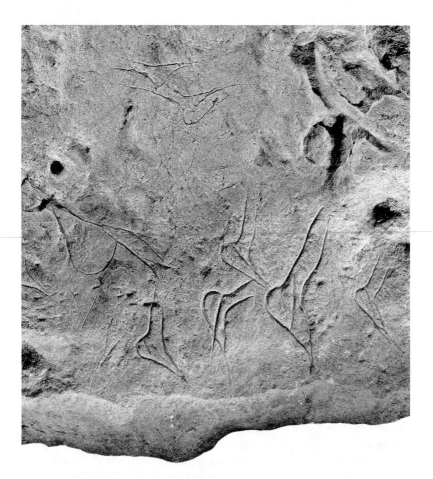

Figure 19. Roche de Lalinde. On a 63-by-50-by-13-centimeter limestone block (detail), female figures in profile view, extremely stylized but with the characteristic backlines of Late Magdalenian female representations (see Fig. 4). Musée National de la Préhistoire (© MNP Les Eyzies. Dist RMN. Ph Jugie)

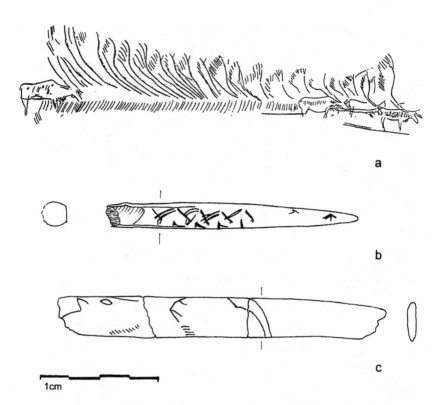

a

b

c

1cm

Figure 20. Examples of deliberate abstraction: (a) Grotte de la Mairie (Teyjat), a herd of reindeer, with central animals suggestively reduced to abstract representations of series of antlers and of either legs or characteristic fur markings, engraved on an eagle's bone, as drawn by Henri Breuil; (b) Le Morin, three or four horses' heads in a row, with double lines for the manes, becoming more and more simplified, ending with a tectiform at the tip of the point; (c) La Madeleine, an ibex and a horse depicted with simple disconnected elements that would look like abstract signs if taken separately (this is one of the pieces that led to my structuralist approach to the nonfigurative designs). All of the Middle Magdalenian period, author's drawings except for (a)

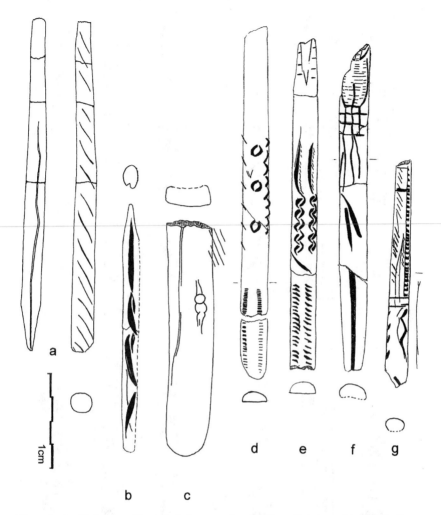

Figure 21. La Madeleine. Characteristic examples of differentiated graphic distribution of motifs for spears, chisels, and semicylindrical rods: (a) a spear (from two angles), the elements regularly repeated and centrally composed; (b) a chisel, the design deeply carved out on one side only; (c) a chisel, a unique figure and a fine line, both off-center; (d–g) semicylindrical rods, each with delimited zones of different designs, some of which are arranged in repetitive series. Middle Magdalenian, author's drawings

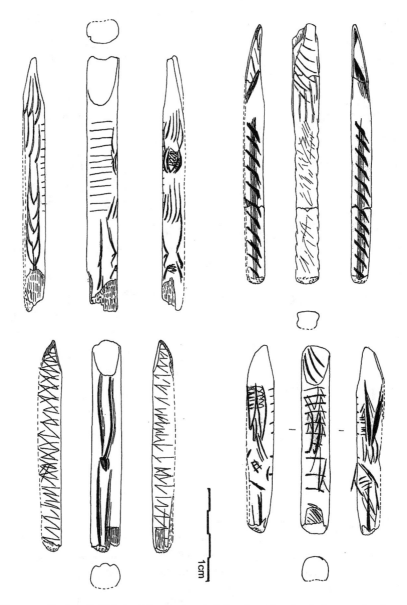

Figure 22. Rochereil. Chisels with striae on their bevels: either the designs are deeply carved or they densely cover all sides of the pieces. Late Magdalenian, author's drawings

Figure 23. Rochereil. Chisels without striae on their bevels. The designs are sparsely distributed, with open spaces left free of carvings. Late Magdalenian, author's drawings

Figure 24. Le Morin. Chisels. The designs on those with striae on their bevels are (a) deeply carved, (b) in protruding rows of ridges, or (c) cover all surfaces. Chisels without striae (d and e) have light, airy designs. Note similar graphic distinctions for both categories as for those of Rochereil (see Figs. 22 and 23). Late Magdalenian, author's drawings

Figure 25. "Strange" figures: (a) Rochereil, (b) Le Morin, and (c) Rochereil. Note the similarities between (b) and (c). Large-headed animals, a widely spread stylistic characteristic of the Late Magdalenian: (d) La Madeleine, two horses' heads, dwarfed forelegs; (e) Le Morin, two reindeer; and (f) Rochereil, two horses, one behind the other, with a dwarfed foreleg for the one in better condition. Author's drawings

Figure 26. La Madeleine. Fish representations, increasingly abstract from (a) to (d), with perhaps an even more schematic example in (e). Late Magdalenian, author's drawings

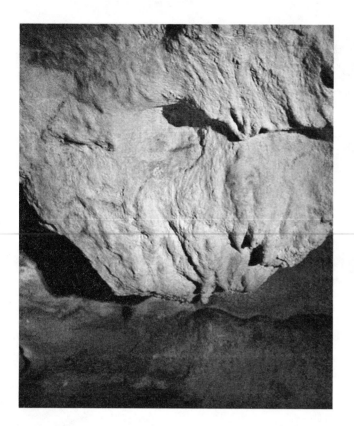

Figure 27. Bernifal. The large bison head in relief, a superimposed mammoth outlined in red at the bison's horn level, and the "face" to the right (Courtesy of Gilbert Pémendrant, photo Thierry Raimbault)

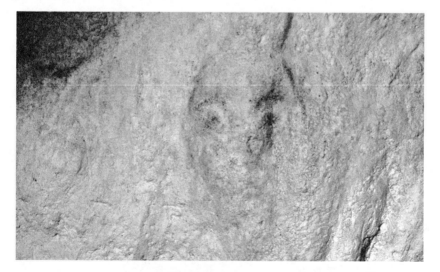

Figure 28. Bernifal. The "face," a magical, awesome apparition (Courtesy of Gilbert Pémendrant, photo Thierry Raimbault)

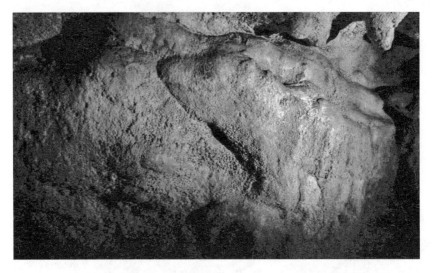

Figure 29. Bernifal. The bear in natural relief, with a drawn nose, mouth and eye
(Courtesy of Gilbert Pémendrant, photo Thierry Raimbault)

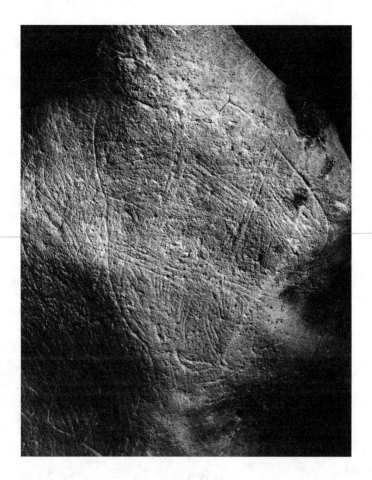

Figure 30. Bernifal. One of the finely engraved mammoths with two superimposed tectiforms, immediately to the right of the tight passage (Courtesy of Gilbert Pémendrant and Alain Roussot, photo Alain Roussot; drawing by author)

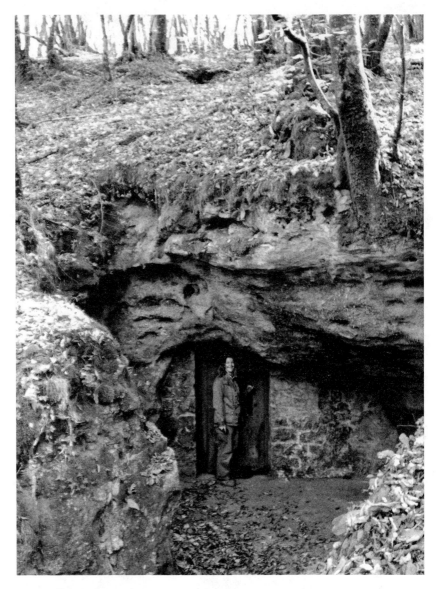

Figure 31. The author at the entrance to Bernifal.

Laurel Leaves and Needles

Rouffignac's 14,000-year-old mammoths and woolly rhinoceroses make us aware of how cold it must have been during the Magdalenian; we can easily imagine these animals in their familiar Ice Age environment, open steppes stretching far and wide. Far harsher, though, were the climatic conditions during the Early Solutrean, some 8,000 years previous.

The Solutrean period (from around 22,000 to as late as 17,500 years BP in Spain) covers a geographically limited area, confined during the first few millennia to the regions in France between the Loire and Rhone valleys, and later to those down the Atlantic coast to the Pyrenees, to Portugal and to the north of Spain. In southwestern France, it fits chronologically between the Gravettian and Magdalenian cultural periods. The Solutrean is easily identifiable by its remarkable technology, particularly its characteristic leaf-shaped and stemmed points, which are unequaled before or after the Paleolithic period. Differing from the Gravettian technocomplex, characterized by flint knappers who fabricated blades and backed items, the Solutreans returned to

biface techniques, bringing these to an exceptional level of perfection. Long, elegant points are shaped with finely chipped off retouches that can cover the whole surface of one or both sides, and that vary from broad, wafer-thin blades to narrow, subparallel ones. To obtain this delicate shaping, diverse flaking techniques were used: direct percussion with a "soft" percussor or hammer (wood, bone, or antler, for instance), indirect percussion, and pressure flaking. The last, appearing mainly during the Middle and Late Solutrean for making typical willow-leaf and stemmed points, for instance, consists of pressing a bone or antler point hard against the edge of a prepared flint blade so as to chip off small slivers from the surface and thus obtain a more even finish and a finer, sharper cutting edge.

The name Solutrean comes from the discovery in 1866 of a site in Solutré-Pouilly (Saône-et-Loire) called Solutré, or Crot du Charnier, which was strategically favorable for capturing horses by running them over a cliff. Half a century later, in 1920, at Laugerie-Haute in Les Eyzies (Dordogne), the chronological stages of Solutrean stratigraphy were first defined by Denis Peyrony. Each is characterized by the appearance of an innovative point. The Proto-Solutrean and Early Solutrean periods saw the production of elegant, flat points that were worked on one side only. The Middle Solutrean period is characterized by its superb laurel-leaf points, which are flaked on both sides; and the Late Solutrean period is known for long, slender willow-leaf points and stemmed points flaked on both sides, described above.

At this moment in the history of toolmaking, it is clear that flint technology had become an art in itself. Only highly specialized craftsmen could have produced these Solutrean points. Everyone at that time would necessarily have known how to make basic tools and hunting weapons, but only an experienced, specially trained person could have fabricated one of these. The fact that most of the flint tools that were being produced at the time are rather ordinary-looking indicates that these exquisite points were of a different order. They were made by only an expert few, no doubt for some special purpose. Furthermore, these points necessitated hours of work, far more time and effort than were required for a Gravettian point, for instance; yet I'm not convinced that they were significantly more efficient. For certain pieces, the stone was actually heated to temperatures as high as 300 degrees Celsius in order to obtain a finer texture, more appropriate for pressure-

flaking. This in itself demanded expertise: slowly bringing the temperature of the stone up to the required high level and just as gradually cooling it down, carefully avoiding splitting or cracking. The result allowed for a more regular, refined finish on a glossier, almost glasslike surface, but the process also would have made the flint more fragile. It seems more likely that the concept of these points was essentially aesthetic, if not symbolic, the cultural prevailing over the functional for the more fragile pieces.

Could it be that these points, particularly the largest, were valued for the technical performance, something for the maker to be proud of, like an individual feat? Or were they designed for a more pragmatic reason: the more effort put into their making and the more perfect the result, the more successful the group's future hunt, for instance? It's possible that they had nothing to do with hunting, that they were cultural objects of a symbolic significance to the community that we can't even begin to comprehend. The excellent condition of some, with no trace whatsoever that they were used, might suggest this. At a site called Volgu (Saône-et-Loire), a dozen laurel-leaf points were discovered grouped close together, propped up on one edge, side by side, far from any other archaeological context. These intact, beautifully shaped points are exceptional for their length, ranging from 23.5 to 35 centimeters, and a thickness that does not exceed 0.8 centimeter. The isolated position of the site led to the interpretation that it was a weapon cache, but that's just the most obvious of countless possibilities. The fact that the points show no evidence of use and that one of them is entirely coated in red ocher suggests a more symbolic role; they might have been part of a ritual of some sort.

The origin of this isolated Solutrean culture is unknown, but it probably began in France. Its restricted spread might be due to the fact that its beginnings coincided with a particularly cold, dry episode in the last Ice Age. The rigorous climate made vast regions uninhabitable, and the resulting geographic confinement of inevitably less mobile populations would have favored the development of local cultural specificities. Later, in the Middle and Late Solutrean periods, a more temperate climate came back, but the unique technology that had been developed during the Early Solutrean period would have persisted, with other cultural particularities strengthened by the difficult living conditions and isolation.

The importance given to stone technology in the Solutrean period worked to the detriment of the bone industry. The Solutreans' preference for stone is reflected not only in their tool assemblages and unique flint points but also in their taste for exotic, colorful stone collected from distant regions, and in their art: low-relief and high-relief carvings are particularly representative of this period. Two well-dated sites stand out: Le Roc-de-Sers (Charente) and Le Fourneau-du-Diable at Bourdeilles (Dordogne).

Le Roc-de-Sers, explored in 1908 at the same time as other sites in the same valley, served as early as 1909 as a demonstration of the Gravettian-Solutrean chronological sequence, as both cultures, each with its distinct characteristics, were clearly superimposed there. The graves of two adults and an adolescent found on the site were from either the Late Solutrean or the Early Magdalenian period, more likely the former, as there is little evidence of Magdalenian occupancy.

A series of about 20 large sculpted blocks were discovered at the site by Henri Martin in 1927, some of them lined up along a ridge at the back of the shelter. Most had toppled over, falling face down, before the end of the Solutrean period, and many are broken. Their present-day arrangement isn't necessarily the same as the original. In fact, it is not known how the site was organized at the time, especially as other, separate blocks were found in front of the shelter.

Superbly represented horses, bison, and ibexes are carved in low relief, as well as a human, possibly two, and perhaps a bird. The human, 50 centimeters high, standing with both legs bent, appears to be rounding the right-hand side of a stone block, followed by what I take to be a massive bison, although it's often described as a musk ox. True, the horns look like those of a musk ox, but the unusually low frontal position of the head might explain their distorted shape; convincingly bisonlike to me is the belly line, with none of the long, shaggy hair that would normally characterize a musk ox.

Do the two figures form a scene? If so, is the bison pursuing the man? This is the commonest interpretation, even though it is looking away from him and toward us. We could just as well imagine the contrary and see it as a totem figure, shielding the man protectively from an invisible enemy. Perhaps, on the other hand, the bison has nothing to do with the man, who is

already out of sight; it could be focusing instead on the animal on the neighboring block . . . or on us, the viewers.

The horses are shapely, heavy, and lively, with realistic proportions. The same goes for the ibexes, two of which are head to head, possibly competing. One of the bison, beautifully modeled, seems to have had its head redesigned into that of another animal: its pointed muzzle somewhat resembles that of a wild boar.

◆

Le Fourneau-du-Diable, also called Bourdeilles, was, during the Late Solutrean period, a 12-by-7-meter shelter habitation protected by fallen limestone blocks that had collapsed after previous Gravettian and Solutrean settlements. Discovered in 1920, it yields characteristic flint technology and varied bone and ivory work, but it is known in particular for two large, carved stone blocks. One has become world famous for the quality of its sculpted animals, particularly the two central aurochs (Fig. 14). In fact, 10 animals are carved in relief and 2 others are more lightly engraved. The aurochs, a horse, and two animals of a different species — either deer or ibexes — are for the most part represented on the widest surface, but they also overlap on the sides. In excellent condition, the two best-preserved aurochs are arranged in perspective, one in the foreground, the other behind, both facing to the left, both of the same size, and standing abreast. They are well proportioned, shapely, muscular; their curved back lines and the profiled heads, combined with a three-quarters view of the horns, remind us of the bulls in the Lascaux cave. In fact, the estimated dates for the two are similar — about 18,000 to 17,000 years BP. The legs of the closer one are in perspective, as though moving, and its heavy dewlap hangs loosely in folds down its chest. Of the treasures exhibited at the Musée National de Préhistoire in Les Eyzies, this is one of the most impressive.

Although bone work was relatively rare during the Solutrean period, some bone tools from the era do exist. The fabrication of spears, all sorts of wedges, chisels, and other bone items continued as before, sometimes even more varied, yet with comparatively little of the innovative quality materialized in the stonework. However, within the bone industry, there were two remarkable novelties: the propeller (also called the atlatl or spear thrower)

and the eyed needle. The spear thrower is a hooked device that gave the hunter extra leverage, more thrust and power, to propel the spear, which consequently gained in accuracy and covered a greater distance than if it had been held in the hand. This weapon became widespread later on, during the Magdalenian period, when it was greatly prized, to judge from the care taken in their remarkable engraved decoration.

Needles with eyes propagated during the Solutrean and are particularly numerous in the Vézère Valley and in northern Spain. Fine needles existed before, as early as the Aurignacian period, and so did awls of varied sizes, but the eyed needle was a revolutionary invention the importance of which can still be measured today. Using antler, bone, or ivory (on rare occasions stone), the maker would first chisel or split off an appropriately sized piece of the raw material; the eye was then carefully perforated by means of a sharp, pointed flint drill, after which the body of the needle was filed down to the required length and width. Grooved polishing stones were used for this, and also to sharpen the needles and revive their points when necessary.

What was the thread made of? Hair or fur, plant fiber, sinew? Nothing remains to tell us. Moreover, in the absence of detailed, full-length depictions of dressed people, it is impossible for us to visualize the style of Paleolithic clothing; as we have no surviving remnants, we don't even known what it was made of. Was there any form of woven fabric? A fragmentary fossilized print of a possible piece of weaving might confirm this, and, technically speaking, I don't see why not. Indeed, the imprint of a rope embedded in clay found in the Lascaux cave certifies that ropes were fabricated at the time, and nets are thought to have been made for trapping fish. It is more likely, though, that readily available hides would have provided the basic material for clothing, carrying bags, containers, and covers. The small size of many of the needles indicates how fine and delicate the needlework might have been, whether for adornment, for decoration of any kind, or for skins thin and supple enough for sewing.

Another aspect, linked to clothing, is body ornament, mainly beads. Let's not forget the hundreds, in some cases thousands, of beads that have been discovered, particularly in graves, where their distribution over and around the bones evokes beaded decoration on clothing and on headdresses. Why not take a further step and imagine these Paleolithic people wearing sophis-

ticated clothing embellished with complex beaded designs, such as those of Native American or Inuit populations, for instance? And think of all that has disappeared since, in the way of plant, feather, and fur adornment. The picture that we now have of these Cro-Magnons would match the splendors of their cave art much better than the popular "Flintstone" image.

Abri du Cap Blanc, view of the site, upper right, during the 1910 excavations
(Collection Lalanne, Musée d'Aquitaine. Photo Clovis Lassalle)

Cap Blanc

The Solutrean relief carvings lead us quite naturally to our fourth major parietal art site: Cap Blanc (Dordogne) — not for paintings or drawings this time, but for a sculpted frieze, one of the most impressive ever discovered. The frieze contains at least 14 animals, carved in high and low relief, the central one of which is a life-size horse. This art is not in a cave but outdoors, under an open cliff shelter.

Cap Blanc is situated in a small valley, where the slow-running Beune stream meanders from east to west and spreads into iris-filled swamps before joining the Vézère River. From an English botany professor I learned that the valley is unique in Europe because of the exceptional coexistence of Mediterranean, Atlantic, and swamp-type vegetation. Accumulated silt has built up the valley's ground level considerably since Paleolithic times, as testified by beam-support holes probably dating to the Middle Ages, which today are disappearing belowground. Fortunately, Cap Blanc, and other famous sites nearby, are on high enough ground to be preserved: on the north side of the valley are La Grèze, Cap Blanc, and the previously described Laussel

sites, and on the opposite side of the valley, practically facing Cap Blanc, lies Commarque cave (and castle). These sites together cover about 10,000 years of the Upper Paleolithic epoch, and their proximity suggests that this small, protected valley was particularly favored, either for specific cultural reasons or simply because it offered good living conditions.

It's a lovely place still today. The varied vegetation, the comfortable, human dimension of the valley, the isolation, and the balanced sculptural curves of the yellow limestone cliffs combine to make it a welcoming place. No roads, no houses, and barely a soul around: quiet and peaceful.

The first excavations, dating back to 1909, were made by Raymond Peyrille and Gaston Lalanne, who also worked on the nearby Laussel site at about the same time. The poorly documented and destructive early exploration led to inaccurate information about the stratigraphy of the 15-meter shelter, as so much was lost or overlooked. The 4-meter-high shelter was completely buried under the accumulated earth, sediment, and rockfall deposits that had built up over thousands of years. Two distinct, well-separated archaeological layers—considered at the time to belong to different Magdalenian periods—extend thickly along the outer stretch of the shelter, thinning inward toward the cliff's base. The discovery of the frieze, protected by a 3-meter overhang and buried underground, was totally unexpected, as the excavators were searching only for bone and stone artifacts. No outdoor parietal carvings had ever been found before.

A few years after the discovery, in 1912, an adult female skeleton, lying in the fetal position, was found in front of the frieze, beneath the lowest archaeological layer and under a Magdalenian hearth, which reasonably situates it sometime before that period and certainly during the Paleolithic. The owner smuggled the skeleton to the United States in 1916, in an American soldier's coffin, so the story goes, and ended up selling it in 1924 for only 1,000 dollars to the Field Museum in Chicago. On the first day it was on display, 22,000 visitors saw the already-famous "only Stone-Age skeleton" exhibited in the United States. Surprisingly, despite its celebrity, it had still not been carbon-14 dated when I wrote the first draft of these pages. Today, at last, our patience has been rewarded: it is indeed Paleolithic, Magdalenian to be precise, around 13,700 years old.

It was not until 1968–1969 that Alain Roussot and Jacques Tixier orga-

nized the excavation of a small, undisturbed section situated at the western extremity of the shelter habitation. The abundant bone and flint material that was retrieved and carefully studied proved that the stratigraphic layers were more homogeneous than first thought, belonging mainly to the Middle and Late Magdalenian. Unless the frieze was sculpted before the site was inhabited, which remains a possibility, it belongs to a period stretching from about 14,000 to 12,500 years BP.

Art found at an outdoor Paleolithic site such as this can be more readily authenticated than cave art. Its burial under earth mixed with organic elements that can be dated with carbon-14 proves that it cannot have been done in recent times; logically, it is older than the layers covering it, and there is at least a minimum age to go by: the date of the layer at the foot of the frieze.

◆

What strikes one immediately is the size of the animals and the depth of the carving. This is a breathtaking composition, unique, with no equivalent anywhere else—nothing of this amplitude. The frieze extends over a length of about 12 meters, comfortably fitting under the 15-meter-long shelter, ideally framed by the limestone roof above and the 3-meter depth of the shelter, which narrows gradually at each extremity.

From left to right, the first large animal is an aurochs, 1.37 meters long and facing right; most of it has eroded or broken off, but it is identifiable from its typically robust hind leg and its square head with one horn. Next come the first of five large horses, sculpted in high and low relief, all facing right except for one, the central figure, which is facing left. The first one, 1.92 meters long and well preserved, has a heavy, round belly sculpted 30 centimeters deep, a long tail, and a curved back line interrupted by a deliberately reserved vertical, narrow segment of the wall, the center of which has a perforation (one of those stone links that are so common during the Paleolithic). It has only one foreleg and one hind leg, the extremity of each disappearing into a vague point, as if the hooves were hidden by tall grass. Its muzzle is superb: the lower lip, mouth, sensitive nostril, and nose have that velvety softness that is so typical of horses.

In contrast to the striking realism of the horse's shapely body and detailed muzzle, its neck is a smooth, flat surface, and the rest of the head lacks definition. This is because there is a small bison, also facing right, lightly

superimposed on the prepared space; its head is carved over the horse's at eye level, the beard, snout, mouth, horn, and eye quite visible, and the humped back line and body discernible to an expert eye, despite the lightness of the engraving. As in the caves, the bison-horse combination appears to be significant; we can't be sure whether the two were created contemporaneously—possibly even carved by the same artist—but I'm convinced that they were, for reasons we'll analyze later. Altogether, the flowing lines of this first horse make it a masterpiece on its own.

The next horse is one-third smaller, 1.38 meters, and its rump and hind legs are undefined, so that they appear to be in perspective behind the first horse's head. The absence of a hind leg cannot be due to deterioration, because if this were the case, the previous horse's head would also have disappeared. Standing back to look at the two horses, we're in for a surprise: this is a perfect example of how cleverly these artists worked out how to simulate perspective on a level surface. To make the horse appear farther back, the artist not only depicted it smaller but also chose to give it less detail. This last trick is essential and really puts the horse back in the distance, despite the fact that its belly protrudes more than the previous horse's head, making the optical effect even harder to obtain. How brilliant these Paleolithic artists were, inventing ways of representing perspective that were not explored again until the Renaissance, not even by the Greeks or the Romans. This Magdalenian sculptor understood that diminishing the size of what lies behind is not sufficient on its own: there must also be less detail in order to create an optical illusion of depth and space between figures effectively. Bearing this in mind, it seems logical that certain areas of this second horse's body should be missing or less well defined: its back, belly, and neck are clear and deeply sculpted, as are both forelegs, whereas the hind legs are missing, and the mane and head are suggested only vaguely, with no details, as though lost in a haze. Or farther away.

Under these two are the lightly engraved hindquarters of another animal, facing right but unidentified because of the lack of specific characteristics. It is much smaller and is not part of the three-dimensional interaction described above; technically, it is more like the small bison we saw superimposed on the first horse.

Now we come to the central figure: a near-life-size horse, 2.20 meters

long, this time facing left, placed at a lower level than the others. It suffered greatly during the careless early excavations: part of the head is missing, as well as a portion of the rump, the tail, and all the lower section, including the legs and underbelly. An approximately 1 meter thick horizontal cut was ruthlessly pickaxed all along the base of the shelter, where the diggers had come to a greater density of archaeological finds—and, unfortunately, just where this central horse's legs were. Even so, despite the damage, it is a truly magnificent animal. The neck and chest couldn't be more realistic—muscular and polished smooth—and the tops of the forelegs are still there to tantalize us. The shapely jowl, forehead, and two ears—one behind the other, with a forelock between—are there in detail, and the crested mane prolonging the powerful neck is subtly striated with fine vertical lines, which are perceptible only in a certain light. Seen from an angle, preferably from behind, the body looks perfect, the broad rump and the slope of the back, the accurate positioning of the haunch, shoulder, and head, its mane bristling, and taut muscles that seem ready to move. Indeed, the whole animal seems to be alive.

When we stand back to look at these first three horses from a distance, this largest, most detailed one appears to be in the foreground; the two others, on its left, seem to be farther back and higher, as if on a distant hillside. To the right of the central horse, two other horses, also higher and in perspective, complete the picture symmetrically (Plate 8).

Just above the back of the central horse, the wall curves outward, and, on a narrow horizontal band of vertical flat rock between the horse and the shelter roof, two smaller animals of an undefined species face right, one close behind the other. The left-hand and foremost one has a deeply carved, flowing back line, a defined neck and head contour, an eye and an open mouth. The body of the second one is masked by the first, but its head and muzzle appear clearly from behind and to the right. The shape of their muzzles suggest reindeer to me. Could the absence of antlers be indicative of a certain season? As with the bison and the indeterminate figure, these aren't part of the three-dimensional logistics of the five large horses, although they make up a calculated part of the frieze. The same can be said of a small horse's head and neck, a bit farther on, facing right. This piece had fallen from the wall and is now propped up by a rod into its original position, just below the central horse's tail.

At this point is a thick pillar under the shelter, followed by a snug alcove, which has no sign of any inside decoration. The next five animals are slightly higher, grouped in an upward slope over the pillar to halfway above the alcove. The deep horizontal cut continues here, and the pillar is hacked away at its base.

Continuing the frieze from left to right, the next two horses are in relief and in perspective, arranged in the same way as the first two; both face right. The first is the larger, its head covering the rump of the next. It is 1.65 meters long and has a smooth, polished body, neck, and mane; little is left of the head, which was damaged by the excavators, except for a beautifully carved ear. The mane is an upward uninterrupted extension of the neck and marked by a differentiated treatment of the wall surface: polished smooth for the mane, uneven and rough on the exterior. The same goes for the deeply carved muscular neck, the chest, and the top of the forelegs, which all stand out effectively because of the way the rock was chiseled around the body: a deliberately mottled, grained surface on the outside, contrasting with the polished finish of the animal's body.

The next horse, farther along and slightly higher, is smaller, 1.15 meters, and looks as though it's behind, because its rear is masked by the former horse's head. The belly, the bulk of the body, and what would have been visible of the hind legs, if there were any, were destroyed along with the former horse's head, as can be seen from brutal pickaxe marks scarring the surface. This one's head is intact, saved by a protective cliff protrusion, and the ear, eye with lids, nose, and mouth are still clear; the two forelegs are in perspective, deeply sculpted, as is its back line.

Remember the small bison superimposed on the first and larger of the first two horses on the left of the frieze? Here, too, a small bison is engraved on the larger of these two horses. It's about 40 centimeters long, facing left this time, carved just behind the horse's forelegs, where its belly would be. It is lightly engraved and difficult to see at first, but once the familiar contour becomes clear, with its lowered head and delicate horn, it's hard to imagine how we could have missed it! Surely this isn't a coincidence, this horse-bison association repeated and symmetrically laid out. Underneath is a deeply carved, sinuous line, part of a damaged figure that is impossible to identify, although the line looks very much like a bison's humped back.

We now come to the last large animal. It is facing left, and only its rear half is represented. Its forequarters are hidden behind the fifth horse, leaving only a shapely rump, thigh, hind leg, and prominent belly in view. The short tail and general bulk and shape of the rump and hind leg are characteristic, in my mind, of an aurochs. This is another perfect illustration of how much planning went into creating the optical illusion of perspective: the wall continuing to the right offered ample space for a full-bodied depiction, so it was not for lack of space that only half the animal was carved, but a deliberate strategy on the part of the sculptor. In this case, there can be no doubt that this was an artistic option. I've also noticed an extra effect, a subtle detail: the aurochs is not directly in contact with the horse: the carved lines stop before, leaving a 10-centimeter section of the wall natural and uncarved, to separate the two animals. The viewer can actually visualize the distance between them. Not only is the horse passing the aurochs in the opposite direction, but the space between the two is suggested as well!

This image of a rump emerging from the limestone, or disappearing into it, as if the mineral surface were air instead of solid rock, reminds me of the work of another great sculptor: Rodin.

In this section, the frieze offers an example of a three-dimensional interaction, as there are three animals, fitting closely one behind the other: a large horse, a slightly smaller one facing in the same direction, and, farther back, an aurochs passing them in the opposite direction.

We must not overlook a block of limestone with an engraved bison (40 centimeters long), propped on the ground beneath the alcove. It is facing right and, despite a diagonal fracture and a large chunk missing just above the head, it is a remarkable piece: the hindquarters are superbly modeled in low relief, and the humped back, belly, front leg, and head are clearly visible. It is unknown whether this was originally part of the frieze or carved separately on a loose stone block. We are looking at a copy, as the authentic piece is in the Musée d'Aquitaine in Bordeaux.

I often wonder what this frieze would have looked like in color. Traces of pigment were detected at the time of the discovery: red ocher between the tail and thigh of the first horse, for instance. Does this suggest that red paint was added, essentially around that animal, to make it stand out in its natural yellow limestone color, against a darker, reddish background? Other

remnants of pigment, such as purplish ocher stripes, colored the head and neck of the central figure. Soon after the discovery, however, the walls were scrubbed (!) clean of lichen and moss, destroying most of these last traces of pigment.

◆

Much is lost, no doubt, the colors as well as possible additional painted figures or signs that might have been part of the composition in one way or another, superimposed on the animals, around them, or underneath, where the wall is destroyed. But no matter how much might be missing, it's what remains that counts. From what is still visible, it slowly dawns on the attentive viewer how magnificently composed the frieze is, how carefully planned and symmetrical the distribution of figures.

Looking at the wall from as far back as possible, one can see how the animals interact. The largest horse is in the center facing left; on each side of it are two horses facing to the right, arranged in the same manner, one behind the other. On the larger of each of these pairs, a small bison is engraved; the two small bisons are of the same size, and each faces the central horse from its side, and at the same distance. The symmetrical arrangement of one small bison on each side of the main horse is magnified by the presence of the two large aurochs: the whole frieze is framed by a large aurochs at each extremity, approximately of the same size, both facing the central horse and equidistant from it. I have measured the distance myself: exactly 6 meters between the rump of each aurochs and the central horse's shoulder. It's as though the bison and aurochs are there to draw the viewer's attention to the central figure.

Such a symmetrical orchestration of the figures cannot be a coincidence; this was carefully planned from the start, implying that all these carvings were done contemporaneously. I'm convinced that there was no more than one sculptor, probably with some practical assistance, but only one master sculptor at work. Don't forget that there was no room for mistakes: once a blow has chipped off too much, it can't be put back. Considering how sparse the population was then and assuming that the percentage of great artists in the population was no higher then than it is today, it is unlikely that many artists of this quality were around at one time. There probably wasn't even a master of this kind every generation.

Some observers have suggested that the less detailed carvings were done by less gifted sculptors. They're forgetting the trompe l'oeil options used to obtain the effect of perspective, which called for certain figures to be deliberately simplified or incomplete. They're also forgetting that reducing a figure to a simplified version is just as difficult to achieve as a more detailed depiction, if not more so. Another argument in favor of the hypothesis that the same expertise was used for all the figures is that, as mistakes could not be concealed, even less so where simpler lines are concerned, the seemingly minor figures had to have been done just as expertly as the more elaborate ones.

Considering the time and physical effort involved, one can sense how strong the artist's motivation was, how significant this frieze must have been, every bit as much as the art in the caves. True, this site was inhabited, unlike the caves. True also, the walls are deeply carved here, which is never the case in the caves. But the predominant horse-bovid association here is consistent with that in a large majority of caves, which suggests that these were sanctuaries of a similar kind, if not the same. The caves might have been uninhabited for no other reason than that living in them was impracticable. But wouldn't an open-air sanctuary be the ideal place to set up camp, especially when it was appropriately situated in this protected valley, its beneficial aura positively affecting the group's undertakings? Few outdoor art sites have survived, but the fact that they exist at all indicates that caves don't have a monopoly on parietal art and opens up the possibility that many more open-air sites existed at the time.

To complicate matters further, what about the grave? Is it independent, or connected to the frieze? The recent discovery of Cussac (Dordogne), where multiple burials were found in a cave for the first time, indicates that there might be an association. Cussac is, however, a unique case. As burials are generally found on habitation sites, there is nothing unusual about one being here, a shelter that was occupied for thousands of years. The frieze and the burial could just as well be contemporaneous or hundreds of years apart, so there is no way of knowing whether they are connected in any way.

Questions of a practical order come to mind. As these were nomadic or semisedentary populations, how was such a long-term project organized? Was the work advanced periodically with each return visit of the group,

or did the artist stay with a few companions until its completion while the others went on their way? Was this an individual's inspired accomplishment, a personal quest within the boundaries of established symbolic subject matter, or was it designed deliberately for a specific community—a public commission of sorts?

If we add up the remarkable sculpting techniques that had to have been mastered for these reliefs, the accurate understanding of the horse's anatomy and the capacity to correctly transcribe it, the intellectual ability to create trompe l'oeil effects such as perspective, and the essential creative spark that ultimately brought grace and beauty to the frieze, we are looking at a timeless masterpiece that is conceptually remarkably modern. Let's face it, it's unlikely that anyone could do better today.

◆

I recently learned something new from an American horse breeder whom I took to Cap Blanc. Captivated by the beauty of the central horse after spending a long while looking at it, he told me that he was certain that it was a gravid mare. He saw it clearly, despite the destruction of the lower half of the body, from a dip in the flank just above the belly. I hadn't focused on this detail but could easily distinguish it as soon as it was pointed out: a sunken telltale hollow that only a mare heavy with foal, belly sagging low, would have. How significant that the principal character should be pregnant! It sheds a different light on the scene, giving it a new dimension, and sends one's imagination racing. The horse already stands out, for all the spatial and technical reasons described above, and the other figures either face or surround it. Here is another reason to believe that it's special, another clue, an opening for further possible interpretations.

◆

We cannot leave without a final glance at the 12-meter frieze, our eyes embracing it one last time, just for the pleasure. The balanced flow of lines radiates gracefully at a gentle, oblique angle away from—or toward—the central horse, which is standing slightly lower down, close to the earth, at ground level. The interwoven back and belly lines of the other animals form an elegant network, which, because of the perspective it suggests, irresistibly draws our attention toward the central figure. The more one looks, the more subtlety there is to note and appreciate: technical, structural, or aesthetic

nuances, of which we gradually become aware. Like all masterpieces, this one needs time to reveal its secrets.

And how peaceful the animals look, gentle in expression and attitude, their bodies fitting comfortably within the shelter, which becomes a world in itself. With, perhaps, the promise of life incarnated at the center.

TEN

Art at Its Peak

All four sites we've explored, as well as the next one, belong to the
Magdalenian period, which followed the Solutrean. This is the last
of the Upper Paleolithic cultural epochs. Another culture, called
the Badegoulian, after Badegoule (Dordogne), existed between the Solutrean
and the Magdalenian periods in some regions. Its flint technology has much
more in common with that of the Solutrean than of the Magdalenian, and
it is probably an extension of the first, independent of the second. The Mag-
dalenian, from approximately 18,000 to 10,200 years BP for the most recent
sites, is by far the most prolific period in art, both parietal and portable. The
majority of cave art found belongs to the Magdalenian.

The caves of this period and the few that are much older should all be
seen while it is still possible, while they are still open to the public. All pro-
vide unique experiences, and it is well worth planning a trip to see them:
Pech-Merle and Cougnac in the Lot region not far from the Dordogne; Gar-
gas, Niaux, and Bédeilhac close to the Pyrenees; and, of course, Pair-non-
Pair, to the west, near Bordeaux. There are others that are not much farther,

just across the Spanish border in the Cantabrian region: El Castillo, Las Monedas, Las Chimeneas, and La Pasiega, which form the Monte Castillo group of caves on the same hillside near Puente Viesgo; and the nearby Altamira, Covalanas, and Hornos de la Peña caves. In the Dordogne, other caves should be added to the five described here, particularly Saint-Cirq, Bara-Bahau, Villars, and Teyjat.

We have just seen one of the finest examples of Magdalenian shelter art at Cap Blanc. While we still have these carvings in mind, another one of the same age, 14,000 years old, deserves mention, although it is not open to the public: the Roc-aux-Sorciers at Angles-sur-l'Anglin (Vienne). There is a facsimile of the site in the town.

The shelter was discovered in 1927, and its 50 meters are divided into two parts. The better preserved of the two, the Abri Bourdoin, is 20 meters long, consisting of a succession of six separate panels with representations of ibexes, horses, bison, lions, and humans. The panels are like framed compartments, separated by vertical fissures or grouped carved links.

Starting from the left, the first panel has a pair of bison looking in the same direction, the female behind the male. The second panel consists of two horses going in opposite directions, the left one with its head gracefully turned toward the other, which is grazing. Above them is a bison, lying down.

The third panel has the most extraordinary theme: a close group of three life-size women, side by side, represented from armpit level down to their ankles. They form a magnificent trio, like the Three Graces. The one on the left has a smooth, round, protruding belly, slender waist and thighs, and legs joined in flowing lines; a vertical line runs from the navel to the triangular vulva, suggesting pregnancy. The next woman, just as lovely, has an open vulva and low breasts with elongated nipples, as though ready for birthing, or just after. A masklike face is just above but quite separate from her. The third woman has a flat belly, bulging hips, and large thighs, as would be fit for a more mature person. She is superimposed on a bison, its belly coinciding with hers and its legs on either side of her thighs. Her legs are carved down to the ankles over the back of another bison, curled up underneath.

These three women evoke the sequence before, during, and after giving birth. The first two are so beautiful, youthful, tempting! One would like to

caress their polished shapes. They have the elegance of a Botticelli and the simplicity and sensuality of a Brancusi.

The fourth panel is full of lively ibexes: two males facing each other, a female, and a young goat. Hidden behind the female is a partly erased bison, and there is a vulva just beneath the young goat. The fifth panel consists of a male ibex, a masklike face below, and a grazing horse and small lion facing in opposite directions, back to back. The sixth and last panel has two male ibexes and a young goat, as well as a smiling human profile and a lion's head facing away from each other, both looking amused.

The sculpture work is remarkably well preserved, particularly where the ibexes are concerned. Their sharply defined eyes, nostrils, beards, leg joints, hooves, and tufted tails are as fresh as if they had been carved yesterday. They are lively and joyful. In fact, the frieze as a whole evokes natural, peaceful scenes of interacting animals; the presence of lions in no way appears to be a menace to the other animals. And, of course, the Three Graces, as I call them, make this a very special place.

◆

It would take too long to describe all the known Magdalenian sites in Europe, let alone in the Dordogne, but if we must choose only a few, the first would be La Madeleine (Dordogne), after which this cultural epoch is named.

This famous excavation site is situated on a bend of the Vézère River, under a cliff shelter facing south, at today's riverbed level. The configuration of the landscape hasn't changed much since Paleolithic days, except for the vegetation, which was of course different, adapted then to colder climatic conditions. Nowadays, it's a lovely place to go, to walk along the small path between the river and the yellow cliffs, in an unspoiled, peaceful setting. Not much of the overgrown, fenced archaeological site is visible. There's a ford conveniently nearby, which would have made a good spot for fishing and for hunting animals as they crossed the river. Sitting there today, under the trees, watching the water flow by, one can imagine how life must have been: an easier life than most people believe, with plentiful game close at hand and apparently lots of free time, considering the time that must have been dedicated to carving the profusion of motifs found on hundreds of functional objects and weapons, on adornment, as well as on odd bits and pieces

of stone, bone, antler, ivory, teeth, and shells. These designs, from the more complex to the simplest, are carved not only on items that required a lot of time and expert craftsmanship to make but also on the most rudimentary of bone tools and spear points and on material with no functional purpose that we know of: pebbles, stone blocks, plaquettes, and random fragments of bone and antler.

La Madeleine was excavated as early as 1863 by Edouard Lartet, who presciently understood that it belonged to a distinct culture. It is where one of the first pieces of portable Paleolithic art was discovered: a superb engraving of a mammoth on a large fragment of mammoth tusk. This depiction, rendered with remarkable accuracy and detail, of a well-known extinct species and on a piece of mammoth ivory, unquestionably prove its Paleolithic age, unlike other engraved objects discovered previously and interpreted as being Celtic or of more recent historical times. The precision of the incised lines and the excellent proportions of the animal revealed previously unsuspected artistic and technical talent on the part of its creator, triggering a new appreciation of the so-called "primitive savages," who were thereafter seen not only as clever toolmakers but as artists as well. From then on, portable artwork was actively sought, long before cave art was recognized, some 40 years later.

In 1911 Denis Peyrony's excavations revealed the exceptional importance of this site, particularly with regard to its portable art, and Henri Breuil's enlightened observations led to three stratigraphic subdivisions, defined as Magdalenian IV, V, and VI. In 1968 Jean-Marc Bouvier confirmed these subdivisions by determining and dating three major phases: a layer at the base, up to 1 meter thick, which is dated to about 14,000 years BP; another situated in two areas, one in front of the shelter and the other inside, approximately 13,000 years BP; and a third, 50 centimeters to 1.50 meters thick, about 12,500 years BP, topped by some layers of the later Azilian period. The first two correspond to what is now called the Middle Magdalenian and the third to the Late Magdalenian. The three are clearly differentiated, not only by discrepancies in their technocomplexes—each having variable frequencies of certain types of flint tools—but also by their bone industry.

One marked difference from the former Solutrean period, and the Badegoulian as well, for that matter, is the Magdalenians' keen interest in using

bone and antler for their tools and weapons, which took on certain com-
pletely innovative forms, particularly during the Middle Magdalenian, and
provided the basis for chronological subdivisions. One example is the differ-
entiated typology of spears: the presence or absence of central grooves and
the shapes of their beveled bases, for instance. Another criterion for chrono-
logical subdivision is the extensive development of spear throwers and perfo-
rated batons, both of which are often superbly decorated. And semicylindri-
cal rods carved out of antler are characteristic of the Middle Magdalenian
and totally absent during the Late Magdalenian. The invention of harpoons
characterized the Late Magdalenian. It was first thought that these developed
progressively—first unilaterally and then bilaterally barbed—a sequence that
is nowadays considered to be more circumstantial than chronological.

Generally speaking, in the field of flint technology, the Magdalenian
brought a clear return to the production of blades—large and small—for
their tools and weapons, unlike the Solutrean flake-based technocomplex.
The large numbers of scrapers and variably shaped burins, notably dihedral,
and the abundance of fine bladelets, backed and sometimes denticulated, are
of particular note. Small, triangular, denticulated tools were new, too, and
specific characteristics of the Late Magdalenian included certain types of
stemmed points, burins with a working bevel shaped like a hooked parrot's
beak, for instance, others that are star-shaped, and a profusion of tiny geo-
metric points and scrapers. The reduced scale strikes one most in objects
from this later period, a tendency that accelerated as the end of the Paleo-
lithic period approached.

Peyrony discovered a grave at La Madeleine in 1926: a child aged five
or six, lying on his or her back, the skull oriented to the south and circled
by three protective stones. It was recently dated by mass spectrometry to
10,190 years BP. The skeleton itself is not in as good condition as the hun-
dreds of beads clustered around the ankles, knees, wrists, elbows, neck, and
head: about 1,500 of them, made from a variety of shells (*Dentalia, Neri-
tina, Cyclope,* and *Turritella*), as well as a few stag and fox canine teeth and
one fish vertebra. The effort and time involved in collecting and perforating
these items suggests either that this child was someone important, possibly
of high social rank, or that the burial itself had broader cultural implications,
depending on the circumstances of the death, which might have occurred

on a special date, for instance. From the arrangement of the beads, one can picture a carefully made shell headdress and beaded motifs embellishing the child's clothes.

Other major Magdalenian graves are equally important: those at Chancelade and Laugerie-Basse, both in the Dordogne, and Saint-Germain-la-Rivière, in the Gironde. At the Saint-Germain-la-Rivière site, Robert Blanchard in 1934 uncovered one of the finest examples of a ritualized burial: a 20- to 25-year-old woman arranged in a tight (bound?) fetal position, lying underneath two large limestone slabs supported by four stone pillars. She wore 70 red deer canines around her neck, some of which bore incised geometric designs. As red deer were scarce, this was a valuable piece of adornment. Shells were grouped at hip level, perhaps constituting a belt or a beaded decoration on her clothes.

Laugerie-Basse, another discovery of the 1860s, is representative of the Middle and Late Magdalenian periods, and the profusion of portable art is as superb and varied as that at La Madeleine.

The most outstanding novelties of the Magdalenian period, as we have seen, relate to the bone work, especially the wider variety of weapons—with the invention of barbed harpoons and the development of spear throwers—and items such as perforated batons and semicylindrical rods. The bone work also included adornment of all kinds, including fine disks and animal contours. Often these artifacts are decorated with engraved designs, resulting in an unequaled profusion of portable art forms from this cultural epoch. Fine engravings are also found on fragments of bone and antler of varied sizes and shapes (Figs. 15 and 16).

La Madeleine offers one of the finest examples of portable art: a 10.5-centimeter spear thrower shaped like a whole sculpted bison, its hind leg serving as the hook against which the spear was fitted. The limited surface offered by the reindeer antler frequently called for inventive solutions, such as leaving a stump for a headpiece to be added onto, as in other decorated spear throwers. In this piece, however, we have a most original idea: the bison's head is turned back against its body as though it were licking its flank (Fig. 17). Many details—the sculpted ear, the two horns in perspective, the eye framed by a prominent lid, the mouth, nostril, jaw, and beard—are engraved with fine lines that evoke hair but also form delicate linear designs of a

more abstract kind. These decorative linear motifs, often ropelike, have been interpreted as halters when found on horses' heads; but what are we to think of similar traces on a bison or an aurochs? Unless they are simply decorative, they are probably related to the animal in a more symbolic way.

A cut-out horse's head from a different region, at Saint Michel-d'Arudy (Basses-Pyrénées), has strikingly similar designs: both it and the bison at La Madeleine have a series of lines outlining the jaw and circling the nose (evoking the cheek's musculature?), and both have long dotted lines and a series of encased herringbone motifs between the mouth and cheek.

The bison from La Madeleine is exhibited at the Musée National de Préhistoire in Les Eyzies, along with a large number of other items from Peyrony's collection from the same site. Each piece is worth admiring, those with fine geometric designs as much as those with figurative engravings. One of the latter is particularly famous: the image of a bear's head, its mouth open, in front of a motif interpreted as being a penis combined with a vulva. Another well-known engraving is the small anthropomorphic figure of a standing man, penis erect and a head more animal-like than human. Many pieces have finely carved horses' heads. Among the three-dimensional objects are bison, fish (see Fig. 26), penis statuettes, and hooved animals' legs on their own. All are remarkable, even the smallest of them. The same can be said of the imagery incised on stone, from the miniature animal figures on small pebbles to the numerous animals, including many reindeer, portrayed on limestone blocks of various sizes. Among the engraved blocks from La Madeleine, there is a magnificent prancing horse, also exhibited at the museum in Les Eyzies.

The typical Magdalenian objects known as semicylindrical rods were carefully fabricated and decorated with finely engraved designs. They are made mostly out of reindeer antler; the harder, more "noble" side of the antler is polished and worked with varied motifs, whereas the soft side is filed down to a flat surface, which is often striated, possibly for better adherence. The function of these long, slender artifacts remains a mystery. Some authors have hypothesized that they were glued together into solid spears, but their extremities are not always pointed and their engraved designs are, as we'll see later, very different from those of spears; I am convinced that they were not used as hunting spears. This doesn't exclude the possibility of their being

ritual spears or batons used during certain cultural practices. They might also have been part of larger pieces, fixed against wood or hides, for instance. The complexity of the predominantly nonfigurative designs, in high relief for some, points to a more symbolic than practical role. These rods, a few of which already appeared during the Gravettian epoch, are truly characteristic of the Middle Magdalenian, after which they disappeared.

Perforated batons fashioned out of reindeer antler existed from the Aurignacian culture onward, but their decorative designs reached their zenith during the Magdalenian period. Their diverse sizes and the shapes of their perforations suggest a variety of functions: they might have been used as slings or to make strips of leather supple, or, more likely, as a means of straightening warped spears. These were prized personal objects, no doubt, if we go by the quality and originality of their elaborate decorations, which are either in bold relief or lightly incised, abstract or figurative, or all of these combined.

New forms of adornment appeared during the Magdalenian period, such as fine perforated disks made of bone and delicate animal head contours, like the horse's head mentioned above, cut out of wafer-thin bone—a horse's hyoid more often than not. Strung side by side, these make beautiful necklaces. The finest examples are found in Pyrenean regions. Thousands of beads of all kinds have been found as well, and a variety of beautiful pendants.

◆

Two open-air French sites contribute to our understanding of how Magdalenian settlements worked: Etiolles (Essonne) and Pincevent (Seine-et-Marne). Both owe their remarkably good condition to having been slowly flooded and swamped with silt from the Seine River year after year, each occupancy thus gently embedded and lying virtually undisturbed until today.

Etiolles, discovered in 1971 and excavated by Yvette Taborin, consists mainly of a 3.50-meter-deep concentration of both contemporaneous and successive dwellings distributed over a surface of about 1 hectare. The habitations are circular, some small, others large, with diameters of 5 to 6 meters, circled by heavy stone slabs that may well have supported the roof structure. The larger ones are implanted farther away from the nearby riverbank and

show evidence of specialized activities around a big central hearth. More cumbersome outdoor activities were organized around exterior hearths in an area covering hundreds of square meters. Most informative of all is the wealth of flint material, left thickly strewn over the ground or piled up in huge stacks, as if stocked for future use. With a lot of patience and a bit of luck, it's possible to piece together flakes and blades and reassemble the original flint nuclei; this allows for a better understanding of how different techniques were mastered, which options were chosen in making various tools and points, and ultimately how specialized some of the craftsmen were. The segregated distribution of labor observed here illustrates the existence, 13,000 years ago, of organized collaboration among these Magdalenians, each member contributing his or her individual competence and talent to the success of the community as a whole.

Similar observations can be made at Pincevent (Seine-et-Marne), where distinct occupational areas are also to be found. The site was discovered in 1964 and first studied in 1985 by André Leroi-Gourhan, and its stratigraphy spans the Late Magdalenian, about 12,000 years BP, through the Neolithic period, the Bronze Age, Gallo-Roman times, the Iron Age, and the Middle Ages. The Magdalenian section is 2 meters thick and has yielded 15 archaeological layers, one of which extends over a surface of 3,100 square meters, the combinations of which cover a period lasting several hundred years. Unlike in Etiolles, where the readily available local flint provided good enough reason alone to choose it as a settlement, the inhabitants of Pincevent had to bring their flint with them, possibly from Marsangy, about 20 kilometers away. So what inspired them to go regularly to Pincevent? From the bones found throughout the site, the answer is reindeer, which represent 99 percent of the animals they hunted. From the rings of cementum deposited cyclically on the reindeers' teeth, one can calculate their age and the season during which they were killed. This, and observations on the stages of antler development and shedding, indicates that hunters returned to the site regularly on a seasonal basis, between August and early winter.

The tentlike dwellings are circular or oval, about 3 meters in diameter, with the hearth at the entrance, flanked by a large flat stone, perhaps to sit on. Most face northeast and are thus protected from the dominant south-

west winds. Methodical, thorough excavations of the distribution of bone and stone elements have given us an idea of how the space was used. The size and shape of each dwelling itself is defined by accumulated fine debris built up against the inner sides, leaving, today, a visible ring, punctuated by large stones, which probably consolidated and weighed down on the roof cover, which was most likely made of skins. The hearths are lined with stones of different types and sizes, some of which appear to have been used for cooking or for heating liquids. One side is often clear of any waste, and, in certain cases, 30-centimeter spaces are left free at intervals, possibly to make room for leather cooking utensils or containers for food and water. The concentrations of various debris in other areas around the hearths shows that they were dedicated to flint knapping or to other domestic activities. As far as halfway inside the tent, similar observations indicate an inward extension of these domestic occupations; and crushed ocher and debris kicked aside show a trodden path leading to the deepest end, where the absence of strewn material logically suggests a sleeping area.

Refuse and debris of all sorts were thrown out directly through the opening and lie in front of the entrance, the density depending on their size and weight: close to the entrance are discarded tools, charred food remains, charcoal, and large fragments of heated stones; farther out is a more scattered distribution of heavy bones and flint nuclei.

One of the dwellings, which might have played a different role, is a complex made up of three adjoining circular structures, each with a hearth and an opening. The structure covers about 30 square meters and has a common area delimited by crushed trodden ocher, which spreads out from the center and is linked to all three hearths.

Isolated stacks of flint are found outdoors, carefully grouped and put aside for future use.

There are many outdoor hearths as well, which must have served other purposes than those inside the dwellings, as the associated finds were quite different. They might have been used to condition flint, straighten antler spear shafts, or season wood, for instance. Or perhaps they were used to smoke meat or fish, to dry, preserve, and cook plants, roots, or herbs, no trace of which would have survived. The hearths with nothing more than a

few pieces of charcoal and large heated pebbles inside or around them might even be remains of a kind of sauna hut. Saunas have always been used by people of the north. Why wouldn't the Magdalenians have done the same?

◆

A new type of weapon was invented during the Magdalenian period: the harpoon. It comes in a variety of shapes and sizes—with long barbs, or short, pronged ones—but all are from the Late Magdalenian. The short, pronged harpoon, which can be forked or have minibarbs, might have been used to catch birds or fish. More numerous are the typical longer, more slender harpoons, made of bone or, more often, of antler, with a row of sculpted barbs on one or both sides, and, at the base, either a perforation or a protuberance, depending on how the harpoon was attached to a mobile shaft. The harpoons are painstakingly sculpted, some today still having astonishingly sharp barbs, and most are carefully carved with functional blood-flow channels, frequently combined with decorative designs. The care and time taken in their manufacture shows how important they were, and how efficient they were for either fishing or, more likely, hunting.

The spear thrower, also called a propeller or an atlatl, already existed at the end of the Solutrean period, but its fabrication was at its peak during the Middle and Late Magdalenian. These and the perforated batons are the most elaborately decorated objects of the Paleolithic era. Many have horses depicted on them, either whole or, more frequently, just the head.

One famous piece, measuring 16.5 by 9 by 1.7 centimeters, from Le Mas d'Azil (Ariège), is designed as three beautifully carved horses' heads. Two are three-dimensional, protruding downward from the shaft when it is held horizontally in the hunting position, their noses down, and one of them—a stallion—is neighing, with its teeth bared. The third, engraved in light relief on the shaft itself, is, exceptionally, a skinned or decomposed head: just the skull. It is easy to let one's imagination run—as I often do—and see this trio as illustrating the cycle of life: youth, adulthood, and death. Directly under the skull, on the haft, is a hoofed leg on its own; this is not unusual, as heads or legs of animals are often depicted in isolation, either engraved on a piece or in three-dimensional statuette form. This is similar to human depictions, which, we have seen, are often incomplete or reduced to an isolated, specific part of the body.

As we're on the site of Le Mas d'Azil, let us continue with a few more of its famous pieces, and then we'll look at those at other prestigious sites in the same area in southern France, close to the Pyrenees.

Le Mas d'Azil is a vast cave, 400 meters long and with a width and height varying between 50 and 80 meters. It is traversed by the Arize River and is therefore in two parts, both of which were excavated by Edouard Piette from 1887 onward. The discoveries made on the left bank, 100 meters long, are from an intermediate period between the Paleolithic and the Neolithic that is known as the Azilian. On the right bank, thousands of flint tools and hundreds of decorated objects date back to the Middle Magdalenian (around 13,500 years BP) and the Late Madgalenian (between 13,000 and 12,000 years BP). This site is exceptional for a combination of four factors: its flint industry, its remarkable portable art, its parietal art, discovered in 1902, and its status as one of the few deep caves that were lived in. Breuil, who excavated both sides in 1901 and 1902, later used this site's flint typology in establishing the various phases of Magdalenian stratigraphy.

The wall art consists of engravings and paintings of bison, horses, and indeterminate figures, but also two engraved fish, a rarity in caves.

It is the art on portable material that is most remarkable here. This includes circular bone disks as thin as 1 millimeter and between 4 and 6 centimeters in diameter, sometimes with one perforation in the center and sometimes with others around the circumference. These disks are decorated with either geometric designs or lightly engraved figurative representations. One, for instance, has a bison calf on one side and a female aurochs on the other. Another disk is unique for its human representations: on one side is a man in profile, with an erect penis, legs and arms bent forward; and on the other is a person seen from the back, arms stretched out sideways. A bear's paw is aimed at each human, and a few signs complete each side. On the second side is also a barely visible engraving of a horse's head, mane, and forequarters.

Just as delicate and of similar size are the head contours of various animals—mostly horses—cut out of horses' hyoids; these are also perforated, frequently with a double hole so that they would lie flat when strung together for necklaces. Pendants were either perforated or carved with a groove or protuberance from which they could be suspended.

Two of the pendants are unusual. The first is cut out of a sperm whale's

tooth, 12.4 centimeters long and about 5 centimeters at its widest, grooved near the top so that it could be suspended. Two ibexes are carved in high relief, one on each side. One ibex is standing normally, at midlength, with its legs down toward the pointed extremity. The other is represented sideways, legs transversal, as is the elegant horn, which forms a fine ridge at the top, above the suspensory groove. Simple geometric signs are engraved beneath both animals. The other pendant, in ivory, 9.3 centimeters long and 1.7 centimeters wide, is a realistic penis, decorated on both sides with finely engraved and dotted nonfigurative linear motifs. A damaged central perforation is partially visible at the extremity, plus two more, one on each side, a few centimeters lower. Three-dimensional phallic representations are found throughout the Paleolithic: a perforated baton discovered at the Gorges d'Enfer (Dordogne) has two penises, each emerging from a central hole and both with superimposed, nonfigurative motifs.

Another remarkable piece, possibly another pendant, is a 5.2-centimeter figurine of a woman carved out of a horse's incisor. Her body, sculpted on the tooth's root, seems to emerge waist upward from the base of the tooth, looking almost as though she was clothed from the waist down by the tooth's enamel. She has a round belly, a torso with two long breasts, a neck, and a clearly defined head, narrowing toward the extremity of the root; she has a visible, prominent nose and a detailed ear, while her eyes and mouth are suggested only vaguely.

How varied the options were in deciding how much, and which parts, to represent of each figure. Another example is the slender, perforated, 5.4-centimeter rod of antler with two bison's forelegs in line, one above the other, both sculpted in high relief, the top one with less hair than the lower one, which could be an indicator of age or season.

Among the scores of objects from this site is the emblematic piece of Le Mas d'Azil, the famous three-dimensional representation of a neighing stallion's head, 5.7 centimeters long, superbly engraved, with its ear turned back and its muscular cheek and jaw decoratively framed with the hairlike—or ropelike—designs mentioned previously (Fig. 18).

Each object—the hundreds here and the many more from other sites— deserves a detailed description. It is painfully difficult to make choices, especially where this fecund Middle Magdalenian period is concerned.

One last one, though, while we are here on this site, as it is perhaps the most extraordinary of all, known by amateurs and specialists alike. A spear thrower, not with engraved horses, but with a most unusual motif: a fully sculpted young ibex, standing with its stretched front and hind legs joined at the hooves. Its body and head are three-dimensional, perpendicular to the shaft, the hind legs lying straight along the haft, forming a triangle with its converging forelegs. In perfect condition, this propeller is 10.5 centimeters at its widest, where the ibex and the hook are, and measures a remarkable 32 centimeters in length, its slender shaft only 1 centimeter thick, with three perforations lined up along the extremity opposite the ibex.

The surprising aspect of this piece is that the juvenile ibex's head is turned, looking toward its lifted tail, from under which a voluminous turd is emerging, on top of which are perched two transversally striped birds. It is a magnificent work of art, yet perfectly functional as well, with its balanced design, one of the birds' tails serving cleverly as the spear thrower's hook. Even more impressive is the ibex's wide-eyed, startled expression, which gives the scene an irresistibly humorous touch. There is surely a story behind this unusual image, as it is on one of the most important hunting weapons. In view of the time that would have been spent on the carving, one would imagine it to have been inspired by a concept that was more serious than entertaining, despite the amusing effect it produces. How enjoyable, though, in the absence of any answers, is this fleeting illusion of sharing a good joke with one of our Paleolithic ancestors.

Unexpectedly, three other spear throwers have the same original motif. One found in Bédeilhac (Ariège) is practically identical, with exactly the same head and expression and hooves that are also joined—although the legs are folded this time. The tail isn't turned back, but the turd is there, with only one striped bird, similarly incarnating the hook. The minor differences with the first piece might be due to an adaptation of the motif to the size and shape of the antler, as no two antlers are identical. The wide-eyed expression is in fact due to large, round eye sockets, which, on this piece, exceptionally still have their inlaid fittings: a piece of orange-red amber for the right eye and some black lignite for the left one.

Another spear thrower, found in Saint Michel d'Arudy (Basses-Pyrénées), is a fragment of the body only, but we find the same elements: straight con-

verging legs like those of the first piece, joined hooves, an elegant back line, all expertly detailed, and, of course, the turd and striped bird. The fourth, even more fragmentary, comes from Labastide (Hautes-Pyrénées). It seems likely to me that the same person carved them all. All four sites are along the Pyrenees Mountains, although they cover hundreds of kilometers: Le Mas d'Azil and Bédeilhac are relatively close, but Labastide is several hundred kilometers to the west and Saint Michel d'Arudy another hundred farther.

A large concentration of Middle and Late Magdalenian sites is scattered along the Pyrenees, caves, dwellings, and the two combined: there are 60 sites to the north, on the French side, and nearly as many over the Spanish border. Among those best known for the quality of their portable art, a few have left a particularly strong impression on me.

We have just seen that Le Mas d'Azil is one of the few deep cave dwellings. Another, just as famous, is nearby at Enlène (Ariège). Enlène is one of the Volp grouping of three caves, discovered between 1912 and 1914, the others being Le Tuc d'Audoubert and Les Trois-Frères, the latter named after the three sons of the owner, Count Robert Bégouen. Enlène is known for its portable art, whereas Le Tuc d'Audoubert and Les Trois-Frères are famous for their wall art. These two are so carefully protected by the Bégouen family that only a few specialists have had the privilege of visiting them.

It would be impossible to summarize in a few words the myriad of fine engravings and paintings in Les Trois-Frères cave. There are hundreds of figures, some of them rarities, such as the painted front-view heads of two lions, side by side, their eyes alive with expression and moustaches bristling, and a couple of engraved owls, face view as well. Most impressive of all is the famous "sorcerer."

I shall never forget the first time I set eyes on him! After we had explored other parts of the cave, our hands and knees caked with silt and our minds already spinning with magnificent imagery of all sorts, at the end of a narrow passage was this mesmerizing figure dominating a small chamber. It is an extraordinary depiction of a "man," strongly outlined in black, high on the wall, above all the other creatures, a godlike figure. His body is bent forward in profile, with a flowing horse's tail and a penis dangling loosely between the legs, like that of a lion. His head, crowned with the ears and huge antlers

of a reindeer, faces the viewer, his eyes wide-open circles, as if in a trance. The imposing presence of this figure, magnified in black, his high, inaccessible, central position in the chamber, surrounded by a whirling network of hundreds of finely engraved animals, and, above all, his forceful expression, make this, in my experience, the most magical of scenes. Is it the unexpected impact of direct and powerful eye contact that makes such an immediately strong impression, drawing us inevitably into the scene, forcing us into a timeless ritual, whether we want to or not?

The only other time I experienced similar magical emotions was one evening when I was unexpectedly included in a Santería ceremony in Cuba.

The second cave of this complex, Le Tuc d'Audoubert, also has large numbers of engravings and paintings but is renowned in particular for two three-dimensional clay bison, 61 and 63 centimeters long, situated 500 meters from the entrance and arranged snugly against the wall between the floor and the low ceiling of a small chamber. Standing one behind the other, both facing right, they are modeled in clay, propped up against stones, and still as wet and as fresh as if they were done yesterday. A third bison lies nearby, its outline deeply engraved on the muddy floor, and there is even a fourth—a small clay statuette.

Both caves present a physical challenge, with perilous passages. For us present-day explorers, the distance, the depth, and the difficulty are themselves important factors, part of the event. The Magdalenians might well have been more at home in caves than we are; not all caves are deep, and the art isn't always far from the entrance. But in cases like these, I always find that the effort involved helps clear the mind, prepares us, offers a sort of initiation, opening us up for what we are to see, hear, and experience, enforcing the power of the cave's art on us.

◆

Enlène is the third site of the Volp group. This cave has no wall art but thousands of portable art pieces. Considered the only entrance to Les Trois-Frères cave, this 200-meter cave was used as a dwelling during a well-dated period between 14,000 and 13,500 years BP. It is exceptional that such a deep cave was lived in, but even more exceptional is the connection between the two caves, which were probably frequented contemporaneously by the same

people. Each, however, had a distinct role: one cave has wall art in profusion and no evidence of having been lived in, while the other was used as a dwelling, with masses of portable art but nothing on the walls.

Surprisingly, the artifacts are most numerous in the chambers farthest from the entrance: flint tools and points made on the spot, bone and antler tools and weapons, bone needles, beads made of stone and amber, pendants that are mostly perforated animals' teeth, and sculpted pieces of many kinds, such as animal figurines, decorated spear throwers, and perforated batons, finely cut-out disks, and the contours of the heads of horses, deer, and ibexes. The hearths reveal that reindeer, bison, and aurochs bones served as fuel; as these are deep inside the cave, one can easily imagine the discomfort caused by the smoke. More amazing still is the number of engraved stone slabs: more than 1,100 pieces. Some of the designs are clear and finely detailed, whereas others are crude, clumsy, or part of an inextricable tangle of lines. Often broken, some later converted into tools or used as floor paving or to line hearths, these engraved stones don't appear to have been valued much, or at least not for long. They might have been "sketch slabs," games of some sort, storytelling illustrations, or a way of passing the time during the long winter months. If they were of sociocultural or symbolic importance at the time — used as cult objects, for instance — their role seems to have been short-lived, perhaps related to specific, sporadic events, after which they were discarded, or possibly, in view of certain scattered fragments, deliberately shattered and dispersed over the ground.

While we are on the subject of stone engravings, another site must be mentioned, north of the Dordogne: La Marche (Vienne), the most famous of all for this type of art. Thousands of engravings on hundreds of stone slabs were discovered in 1937 on the floor of a 20-by-10-meter shelter and have been painstakingly disentangled and studied, with exceptional results as far as human depictions are concerned. These, numbering roughly 110, include whole bodies, sometimes reminiscent of the plump feminine statuettes of the Gravettian period, and more than 70 detailed portraits, in frontal or profile view, all of which are individualized and somewhat caricatured, with snoutlike profiles, for example. One small slab, measuring about 6 by 7 centimeters, is known for an exceptionally realistic portrait of a bearded man, well hidden behind a virtually inextricable network of lines. Another piece, mea-

suring 10 by 8 centimeters, has two or perhaps three superimposed figures, all facing left: a headless, plump body, possibly another one sharing the same back line, and a large head, which is as large as the two bodies. The forehead and eyes of the large head are formed by the same lines that outline the first figure's breasts, and the neck is one of the thighs of the standing figures. Moreover, as is so often the case, the slab is entirely covered with engraved scribbles, which might well be less random than they appear at first glance. Indeed, isn't it strange that such carefully engraved figures should so often be defaced in this manner, as though deliberately concealed?

This reminds me of some rib bone fragments from La Madeleine that I've studied. On them are a multitude of finely engraved lines, crisscrossing either regularly or in a haphazard jumble. The lines are generally interpreted as traces of butchering, but knowing the Magdalenians' predilection for entangled designs and hidden figures, I have given them special attention, with promising results. In the seemingly disorderly mass of lines, some can be seen to be parallel and regularly crossed, so they are more like part of a grid pattern than grooves left after slicing meat. Careful microscopic observation of others reveals anatomic detail, such as a perfect eye or a horn, for instance, or both, giving away the presence of a creature, hidden along the edge or in a corner, under a network of scratched lines. I've found several figurative examples that cannot be ignored, despite their subtlety, and as a result I am more cautious when analyzing nonfigurative lines. This caution is furthermore justified by the similarity of these engraved designs to the hundreds found on stone slabs, like those at La Marche, which are equally confusing and difficult to interpret.

Back to the Pyrenees again, to a site called Duruthy (Landes), which is known for its beautiful depictions of horses, including a three-dimensional head sculpted in ivory, a stone pendant consisting of a perfect horse's head and neck, another in bone found nearby, and the statuette of a whole horse resting on its folded legs. Three of the horse sculptures were found alongside horse skulls, as though they were part of some kind of horse cult. Needless to say, horses were not the Magdalenians' main food source, which was bison meat at this particular site.

Gourdan (Haute-Garonne) has so much portable art that it's hard to choose which items to describe. The perforated batons are particularly richly

carved, with all sorts of subject matter, including horses, front views of deer, detailed fish, a duck, ibexes, and even a standing man, the only one to be carved on a perforated baton. There are fine contours of animals' heads, "fish-tail" designs on perforated pendants made from hyoids, perforated bone disks, and semicylindrical rods with abstract designs, which are reminiscent of those of the distant La Madeleine. Apart from a few distinctly local specificities, the similarities of the designs found in the Dordogne and in the Pyrenees are on the whole striking and indicate how widely spread Magdalenian ideas and graphic conventions were. Some engraved parietal art has also been found in Gourdan's vast shelter, as well as 198 stone slabs with predominantly nonfigurative engravings. The figurative animal depictions, found on 41 pieces, are rarely on their own; for the most part, they're cleverly interwoven or associated with other figures.

Labastide (Hautes-Pyrénées) is particularly famous for a series of cut-out head contours, those of 18 ibexes and 1 bison, each carved out of a hyoid bone, each with its detailed features depicted on both sides. They were discovered hidden together in a narrow passage 200 meters from the cave entrance. All the ibexes have similar triangular heads and two suspensory perforations, one between the horn and the ear and the other symmetrically pierced in the lower jaw; once they are strung up, their noses all point downward. The one bison has differently arranged holes: one in the lower jaw and the other in the nostril, so that it's in a normal horizontal position when strung up. This was probably the central piece of a necklace. Traceology analysis indicates that all the pieces were carved by the same sculptor. Their relatively large size, an average of 5.4 centimeters, and their remarkable preservation make these a unique find.

If we were to mention only one more Pyrenean site for its Magdalenian portable art, it would of course be Isturitz (Pyrénées-Atlantiques). Farther west than those already described—only 50 kilometers inland from the Atlantic coast—it is part of a complex of three sites, one above the other, on a hillside called Gatzelu. Two caves have parietal art, and at the highest level are Isturitz and Saint-Martin, two huge, connected galleries that were used as dwellings from the Mousterian period onward, throughout the Upper Paleolithic to the Azilian period. About 120 meters long and 20 meters wide, both are filled with material. Isturitz, the more prolific, has

yielded 3,761 artifacts in stone and 2,937 in bone or antler. Although most of the portable art deserves detailed descriptions—including horse-head contours, perforated batons with strange figures, disks, pendants, humans and animals either finely engraved on bone fragments or in the form of stone statuettes—we'll concentrate on the Middle Magdalenian semicylindrical antler rods, which represent as much as 15 percent of the bone industry. These predominantly have exceptionally fine nonfigurative designs, some of which are of a kind exclusively found in the Pyrenean region: deeply carved geometric patterns, all in spirals and circles, covering a major part of the surface, or even all of it.

These rhythmic, meandering convolutions, expertly sculpted in low or high relief, remind me of Celtic art, particularly one piece, on which the interwoven spirals end, close to the pointed extremity, in a circled dot in relief, which turns out to be an eye, beyond which one can easily distinguish an outlined extended animal's jaw, forehead, and muzzle. My Scottish heritage surfaces: these motifs look like mythic Celtic animal figures hidden among the curves of beautifully structured geometric motifs. In the case of the semicylindrical rods, it becomes clear that if they were at one time glued back to back, as has been suggested, such elaborately sculpted items could not possibly have served as spears, the carving being too deep and the resulting protuberant designs consequently hindersome for a streamlined hunting weapon. They probably played an exclusively symbolic and cultural role, and those equipped with a point could well have been wedged somewhere or stuck vertically into the ground. The same type of design has been found at other southwestern sites, such as Espalungue (Pyrénées-Atlantique), Espélugues (Hautes-Pyrénées), and Lespugue (Haute-Garonne). The objects with these remarkable designs are truly beautiful.

Isturitz is also famous for the 14 flutes discovered there. One of these is in practically perfect condition: found virtually intact, it was made out of the ulna of a bird of prey—probably a vulture—and is 26 centimeters long, 2 centimeters wide, and 1.4 centimeters thick. It has only one narrow, transversal hole at the broadest of the two carefully cut ends; a central longitudinal band of short transversal incisions, closely parallel or crossed, decorates it. Other, similar Magdalenian flutes have been found at Le Placard (Charente) and La Garenne (Indre), whereas some of the much older Aurignacian and

Gravettian flutes are of a different type, with several perforated holes lined up along the bone.

Apart from some specific, typical Pyrenean art forms—notably the cut-out animal head contours and the spiral designs, the motifs on most of the engraved bone objects are surprisingly similar to those of other regions, the Dordogne in particular. This similarity is corroborated materially by the presence of nonindigenous flint material on the sites: in Isturitz, for instance, there is flint material brought all the way from the Bergerac (Dordogne) region.

◆

The spread of the Magdalenian culture is further illustrated by the remarkably codified way of representing women in profile, like those observed in the Combarelles cave (see Fig. 4). These depictions focus on the back line, an essential, stereotyped line comprising the back, the arched small of the back, the buttocks, and the thigh. A line can suffice, or complementary notations may be added to indicate the front of the body: breasts, arms, or legs, for instance, or a simple line instead, curved or straight, in which case the figure, no longer resembling a human, can become a quasi-triangular geometric sign. A deliberate conceptual move toward abstraction is clear from some examples of several figures grouped together on a stone slab or on a wall, like those we saw in Combarelles: a gradual metamorphosis from one to the next, a progression from a recognizably female profile to a version that is transformed or simplified to the extreme. No matter how stylized, though, the curved back line always remains identifiable. Other examples include those discovered in Germany at Olknitz, Andernach, and Gonnersdorf and in the Dordogne at La Roche de Lalinde and Gare de Couze.

In Olknitz and Andernach, they come in the form of figurines: statuettes made of ivory or stone. These are the most abstract of all, reduced to a triangular, hypertrophied buttock, with, if any, variably developed extensions for the legs and torso and an occasional breast. In Gonnersdorf, there are 11 ivory statuettes, which are as geometric and stylized as those at the other two sites, plus more than 200 that are finely engraved depictions on stone slabs. These are headless and stereotyped like the others, yet with more realistic proportions, some with defined breasts, and even details such as knees or arms. The figures are sometimes on their own, in twos, head-to-head as if

embracing, or in groups, such as a piece with four figures lined up one be-hind the other, all facing right, their bodies decorated with horizontal and vertical lines. Frequently they are bent slightly forward in a dancing position, reminding me of certain African ritual dances that imitate a snake's undulat-ing motion.

On a 63-by-50-by-13-centimeter stone block found at La Roche de Lalinde (Dordogne), 11 schematic feminine figures appear to be dissemi-nated randomly in all directions (Fig. 19). On another stone block found at the same site, four or five figures fan out at the level of their converging necks.

It could be argued, although I don't believe this to be the case, that the spread throughout Europe of the typical Gravettian female figurines, earlier by more than 10,000 years, might have been due to the simultaneous devel-opment of archetypes and not to any form of communication among distant populations; after all, the plump, possibly fertile model could be considered a logical way of representing womanhood, as it served time and time again, even long after the end of the Paleolithic. The extreme stylization of these Late Magdalenian profiles, however, whether finely outlined or in statuette form, found in western and central Europe and all dating back to the same period, around 12,000 years BP, is an unusual way of representing women and wouldn't have come naturally. It is therefore unlikely that such a schematic version was conceived independently and simultaneously in distant, isolated locations. To my mind, these are the illustration of a concerted intellectual transcription from figurative to abstract, a form of conventional symbolic imagery, the coded message of which must surely have been understood and shared by the artists in order to have spread so far and wide. This, in turn, suggests the existence of a language that was sufficiently complex and concise to be understood by many, if not all—or at least by an enlightened few, in the case of cultural practices—materialized here by specific, controlled graphic expression.

Schematic statuettes have likewise been found in distant Mezine (Ukraine), although they are a couple of thousand years older. These are sometimes short and squat or have long sticklike bodies with buttocks that are either protruberant or flat. Seen from the front, some have shapely hips. They are frequently decorated with geometric designs and pubic triangles.

Three major sites in Ukraine are known for such statuettes: Mezine, Meziritchi, and Dobranichevka, all three of which also have circular mammoth-bone dwellings. The four habitations found at Meziritchi are particularly well preserved, with mammoth mandible, shoulder, and leg bones forming herringbone and parallel patterns that are different for each hut. Some large mammoth bones with typical geometric motifs drawn in red ocher were first interpreted as percussion instruments, but they are now thought to have been hung up in the huts as mural decorations. These sites date back to about 15,000 or 14,000 years BP and belong to the eastern European Epigravettian period, which corresponds chronologically to the western European Magdalenian. Mezine is furthermore famous for its ivory diadems and its broad ivory bracelets, superbly decorated with evenly distributed, delicate, geometric designs; these consist of series of engraved parallel zigzags and interwoven angular, labyrinth-like motifs, which are also found on many anthropomorphic statuettes. At Meziritchi, a large mammoth skull is similarly decorated with red ocher designs.

Herringbone, zigzag, and parallel straight-line motifs, as well as tight honeycomb designs, are also predominant in Eliseevitchi (Russia). These and other sites have much in common, despite the distances between them: Eliseevitchi is at least 500 kilometers north of Mezeritckhi, and Mezine lies in between.

◆

As in eastern Europe, nonfigurative motifs also prevail in the contemporaneous western European Middle Magdalenian period. Until now, we have paid particular attention to the figurative art forms, the sophistication of which is easily perceptible and measurable—which is why they were the first to be described at length and in detail—but in fact, there is even more of the nonfigurative art. We should not neglect this vast and varied realm of expression. True, it is easier to appreciate a recognizable subject, to measure the accuracy of line and proportion, the degree of stylization, and the scope of the artist's imagination when viewing a theme with which we can identify. Figurative subject matter, moreover, allows for interpretations of all kinds, from the obvious first-degree recognition of a species to those of a more complex and metaphysical order. Amateurs and specialists alike find such interpretation irresistible. But what can be said about the nonfigurative de-

signs? Few archaeologists have approached the subject, which is one of the reasons why I made it my priority. I have always been interested in today's abstract art, so why not specialize in the nonfigurative expression of the Paleolithic epoch? Furthermore, I longed to handle and study objects that were not only decorated but actually used. Objects that were part of a person's life. Objects that still bear some lingering trace of the owner's hand.

My initial plan was to study the bone material from a major site known for the abundance and quality of its Middle Magdalenian artifacts and to discover some graphic system that would prove to be specific to that site, a means of distinguishing it from the others, like a recurrent design. What better site could I choose than La Madeleine, only a few kilometers from where I live in the Dordogne, a large part of the collection of which is conveniently housed at the nearby Musée National de Préhistoire in Les Eyzies?

From the start, I decided that every piece deserved to be carefully studied and drawn—not only the famous ones but also the less remarkable items: fragments, those with only a line or two, those that at first glance seem of little interest. Every scratch mark needed to be considered, because who are we to decide which were the more significant? Remember the numerous examples of "hidden" figures, for instance.

I soon found out, though, that none of the 231 objects I examined closely had designs that showed evidence of being systematically repeated. No two motifs were identical, no matter how simple. Even when the designs consist of series of transversal or oblique lines, they're never quite the same; their spacing, size, and thickness vary, a bit like the signs in the caves, which are never identical. But here we are dealing with functional tools and hunting weapons found on a home site, not the imagery in a sanctuary. One would at least expect some kind of locally or ethnically codified marking. Once I abandoned that and any other preconceived focus, I decided instead to be open to whatever the designs themselves might offer in the way of explanation. I would take my time, drawings spread out before me, absorbing the designs with an open mind in the hope that the objects would reveal some of their secrets.

It gradually became clear that there were indeed systems, but of an unexpected kind: distinct graphic conventions appeared that were specific to the functional category of each object. To perceive this, I had to see the design

globally. What was important was to see the way the design was laid out on
the piece—the structural organization of the various components—rather
than the components themselves.

Nonfigurative designs on portable art are often considered from a purely
technological angle, with macrophotography, which reveals the preparation
of the support, the typology of the flint chisels—a change of tools, for in-
stance, the sequence of superimpositions, the depth, angle, and direction of
line, and finally the individuality of the author's "hand." When motifs are
examined for their graphic qualities, they are generally seen as the conjunc-
tion of a variety of signs, which are listed and catalogued differently, depend-
ing on the researcher's priorities. Dozens, if not hundreds, of categories are
arbitrarily defined. I started off in that direction, yet soon found it difficult
to describe a sign objectively. A simple V shape, for instance: Is it a single
"chevron" sign or two converging—or diverging—oblique lines? When they
are lined up side by side, are we seeing a series of separate Vs or a consistent,
unique zigzag sign? When they overlap, do we have a series of overlapping
Vs or a series of Xs? Should a cross with a small empty space in the center
be catalogued as a cross or as four converging—or diverging—lines? Con-
verging and diverging lines might have completely different meanings, and
there is no way of knowing which is the correct interpretation. These are just
a few examples, and of the simplest cases. The more complex the signs, the
broader the scope of options. In describing a design, one is constantly con-
fronted with such ambiguities, and I was beset by hesitation.

That is, until the day when one of the figurative designs caught my eye
and changed my approach completely. It is a fragment, with two engraved
heads facing each other, those of a horse and an ibex. They're both simpli-
fied, the horse in particular reduced to a small zigzag for the ear and neck, a
straight line for the forehead, an oval for the eye, and a series of short parallel
markings for its hairy mandible (Fig. 20[c]). None of the elements are joined
at any point, and yet it's a horse without question. Had the head been broken
in two, it could not have been identified, and each element would have been
interpreted as a separate nonfigurative sign. If we automatically perceive
that horse as a constructed unity—because, in this case, we can immedi-
ately recognize the species, despite the lack of detail—why not approach
nonfigurative motifs in the same manner, as a structured whole? It's highly

probable that, like the horse, these too were designed with the final effect in mind.

From that point onward, I became aware of the spatial organization of the motifs and how the various components were orchestrated on the surface they were confined to. The understanding that their frequency and distribution varied according to the function of the object followed naturally.

To verify this, it became necessary to focus on bone objects that had different functions but were of the same basic shape, in order to be sure that it wasn't the shape of the implement that dictated a certain type of design. I put aside harpoons, spear throwers, and perforated batons as a result, whereas spears, semicylindrical rods, spatulas, and chisels, with their similar long, slender proportions, offered an ideal basis for comparisons.

The results are significant. Spears have designs that are centrally composed along the shaft and consist of either longitudinal lines—sinuous or straight—or elements repeated in series, mainly in regularly spaced unidirectional oblique lines; no unique, independent signs ever come into the composition, nor do transversal lines (Fig. 21[a]).

Semicylindrical rods have far more complex designs, which are carefully assigned to delimited—often separate—transversal sections of the piece, and are composed of a wider variety of elements, which are either isolated or repeated, simple or elaborate. The result is often one of sophistication and originality. What is striking are the deliberate transversal subdivisions along the shaft, either a clear-cut transversal line or, more subtly, a blank space, creating separate compartments with distinct designs; these can be so different from one space to another that one wonders what links them to the same piece. They seem to hold some mysterious, coded message (Fig. 21[d–g]).

Unlike the spears, fine chisels have motifs that can include individual signs, both simple and complex, which are not necessarily symmetric but can be centrally composed or eccentric, although they invariably encroach on one if not both sides. There is probably a technical reason for this: to allow a better grip on the tool, for instance. The motifs on the chisels appear to be more freely composed, arranged in all possible ways—far from the controlled semicylindrical rod designs or from the repetitive motifs of the spears (Fig. 21[b]). Observation of these graphic conventions confirms the idea that the semicylindrical rods weren't used as spears, and at the same time indi-

cates that the chisels probably aren't recycled spears, as has been argued frequently, as we don't find chisels with characteristic spear designs. The designs of other functional objects—fine spatulas, slender spoonlike utensils, and other flat objects with smooth, rounded, or pointed extremities—resemble those of chisels: they are original, they frequently have unique motifs, and more often than not they are eccentrically composed (Fig. 21[c]).

To my surprise, as though to confirm that premise, I found that the rarer figurative designs follow the same rules of axial or eccentric composition as the nonfigurative ones.

Once established, these graphic differences can be of great help in identifying fragments that have lost one or both extremities. They illustrate, moreover, that not only was graphic expression closely regulated in the caves and on certain portable objects but that conventions also existed for marking or decorating personal weapons and functional objects. The fact that no two designs are identical seems to indicate, however, that, within these restrictions, there was room for individual expression and that the "personal touch" was allowed, possibly even encouraged and appreciated.

◆

I found the variety and originality of the bone chisel designs fascinating, which is why I pursued this field of research at a further level: a comparative study of the designs of chisels from three sites of the Late Magdalenien period. Only one category of tools this time, but those of three well-dated sites: Le Morin (Gironde), Rochereil (Dordogne), and La Madeleine. I chose the Late Magdalenian period for this because chisels were particularly abundant then. Chisels are easily identifiable from the hammered extremity opposite their variably shaped bevel. The bevel of a chisel can be mistaken for that of a spear point. This is why it has frequently been thought that chisels are recycled spears. Their engraved designs tell us a different story, as we have just seen. It is therefore essential for identifying a chisel that some trace of hammering be present: a flattened or blunted extremity, with characteristic fractures, splinters, or small scalelike flaking around the edge. Of the 110 decorated chisels that I drew and studied, 73 were intact or in excellent condition—29 from La Madeleine, 27 from Le Morin, and 17 from Rochereil. Not a large number to go by, but the remainder—each of which has a hammered

extremity but perhaps only part of the bevel, for instance—served afterward to corroborate my observations.

During the detailed observation of each piece, it appeared that the bevel varies in shape; as this is the working edge, there must have been a functional reason. The bevels were subsequently categorized according to their typology: those that are subcircular in section; those that are simple or double-sided; those that are concave, convex, or flat in profile; those whose sides are parallel when viewed from the front, or wider or narrower toward the edge; those with a straight, inclined, or rounded cutting edge; and those with or without multiple striations. It turned out that in the chisels from these three sites, three criteria were significant: the shape of the cutting edge, the shape of the sides when viewed from the front, and the presence—or absence—of deliberately incised striations. Corresponding to each type, a different graphic approach repeated itself. The differences are subtle at times, as the designs are extraordinarily varied, and only when the tools are grouped into typological categories does it becomes possible to detect morphographic correlations. Once more, it is necessary to see the designs globally, however simple or complex, figurative or geometric, and to pay as much attention to the distribution of the components—their spacing, their rhythmic distribution—as to the originality and degree of complexity of the elements.

It is the general impression that counts, which is not always easy to quantify. For instance, the designs of round-edged beveled chisels incorporate longitudinal lines, whereas the straight-edged tools have none, the result being that the round-edged ones have a more fluid, continuous effect. Chisels from both La Madeleine and Rochereil show this. The shape of the bevel's sides significantly affects the designs on those from Le Morin: those that narrow toward the edge have broad, deeply carved motifs; those that are parallel have fine geometric designs; and those that widen toward the edge have complex compositions with exceptional components. The designs that are perhaps the most obviously affected are those on chisels that have bevels with or without striations: all those with striations have complex, elaborate designs with a dense, network-type distribution that leaves little space free (Fig. 22), whereas those without striations have motifs that are either simple and geometric or complex with original figures but, in both cases, composed with an

open-spaced, even, regular orchestration, leaving at times whole areas free of carving (Fig. 23). Chisels from both Le Morin and Rochereil have these characteristics (Figs. 22–24).

As for the components themselves, each site has one or more exceptional motifs that are exclusive or typical, such as La Madeleine's "fish" figures and leaflike designs carved in high relief; the sophisticated ribbed, oblique motifs of Le Morin; and the uncanny figures—resembling squid, strange plants, or insects—of Rochereil. At the same time, though, the chisels from all three sites have horse figures with disproportionly large heads. These large-headed animals—horses and reindeer—illustrate a widespread Late Magdalenian stylistic convention (Fig. 25).

Graphically, the chisels from La Madeleine and Le Morin have a lot in common, in particular a large number of simple, oblique line motifs, always on the sides, often symmetric, and superbly engraved.

The designs on chisels from Rochereil are completely different from those at La Madeleine, yet at the same time, the two have in common the proportion of straight and rounded bevel edges and the subtle graphic systems mentioned above, which are related to each.

The pieces from Le Morin have much in common with those from Rochereil graphically, such as certain original, schematic, squidlike figures, laterally sculpted oblique reliefs, and deeply incised zigzag motifs, combined with a multitude of fine, oblique scratch lines on the backs or the sides of the tools. They also have the same design systems according to the presence or absence of striations on the bevels.

Geographically, the three sites form an approximately equilateral triangle, 100 kilometers on each side. Le Morin to the west and La Madeleine to the east are directly linked by the Dordogne and Vézère river valleys, which could be one explanation for their graphic similarities, whereas Rochereil is more isolated, toward the north, with disconnected streams and rivers, which might be why it has so little in common with La Madeleine; yet how then can we explain its obvious relation to Le Morin? The movements of the Magdalenians were logically focused on two essential needs: hunting resources and access to flint; but we should also take into account cultural motivations that we cannot begin to understand. We have no idea which factors might connect one site to another or one region to another.

What does this study add to our understanding of these people? Nothing revolutionary. It does, however, open up a new understanding of what was considered to be a relatively simple tool, and it brings to light a little more of the complexity of the artistic approach in Magdalenian expression. We learn from the observed correlations between carved design and bevel that these tools—all conveniently called "chisels"—should, in fact, no longer be put in the same bag: their varied bevels are adapted to different functions. This is corroborated further by their correspondingly specific design systems. Yet we still don't know precisely what each type was used for.

We have learned that the designs follow structural rules, which is interesting in itself as it applies to everyday, "ordinary" personal belongings, but we don't understand the reasons behind them. Were these specific graphic codes imposed by the social group, or were they personally valued by the creator, who was no doubt culturally conditioned and impregnated with beliefs and superstitions of all sorts? The design might be magnifying the efficiency of the tool or weapon, but it might just as well be identifying the tool's owner. Which leads us to a basic question: were the designs related to the tool's function only, to the life of the tool, to the engraver, or to its user? To complicate matters further, the maker of the tool, the creator of the designs, and the user were not necessarily the same person. We can be certain that a motif was related to the tool's function, yet at the same time, the final effect is not a stereotyped design, indicating, once more, that there was room for personal expression, whether that of the artist or of the user. We have learned that each site has distinct features, but also that the sites had shared graphic systems, varied in several ways.

The abundance of original, inventive designs certainly illustrates the artists' creativity in the face of codified structural rules. This latitude for "free" expression holds a message of its own; it's telling us something important about the type of society these people belonged to: organized and controlled on the one hand, open-minded and respectful of the individual's personality on the other.

If anything, the recognition of greater complexity is positive in itself. It reflects more of the fecundity of this brilliant Magdalenian culture, and compels our admiration. It's humbling as well. Adding to the little we already know about these elaborate cultures inevitably reveals the extent of the task

to come, the extent of what we haven't yet grasped and probably never will. The impossibility of knowing what lies behind each graphic option leaves us frustrated, no matter how much our efforts are momentarily crowned with satisfaction by analyses of all sorts. We can, in any event, rely on our own response to an object's aesthetics and the emotional impact it has on us. Why not? In the absence of documented answers, it's something to go by.

◆

With the end of the last Ice Age comes the end of the Magdalenian culture, and of Paleolithic times as a whole.

After this stretch of at least 25,000 years of what appears to have been relative cultural continuity—implying, in my view, the sharing of certain symbolic concepts, beliefs, and traditions, however extraordinary this might seem—it is surprising that the subsequent Azilian cultural phase was so strikingly different. After all, there had been climatic fluctuations before without dramatic effects on cultural cohesion; so why were the consequences so radical this time? As we have seen, archaeological evidence is less well preserved under warmer, humid climatic conditions than during colder weather. Fewer data survive, thus less information on these transient times remains for us archaeologists to study. However, it is easy to imagine the Magdalenians' predicament. With the change of climate, they would have had to adjust to the consequent changes of flora and fauna and the reindeers' migration toward the north, for instance, either by following them into unfamiliar territory or, if they stayed behind, adapting to a different lifestyle. Either way, their secure, well-oiled, established ways had to evolve. Perhaps the Magdalenians were unable to take the turn. It is common knowledge that the more "advanced" and specialized a culture is, the more set in its ways and the less adaptable it is. And the more vulnerable. Civilizations come and go, particularly the more brilliant ones.

The Epipaleolithic Azilian culture marks the beginning of Mesolithic times. It was an era with very different art forms: there are no more of the elaborate figurative animal depictions so magnificently developed during the Paleolithic epoch, for instance, none of the superb portable art forms, and no more cave art at all. Instead, an abundance of simple designs, such as painted dots and lines on modest pebbles. Vanished the 25,000 years of remarkable artwork, painted, drawn, engraved, sculpted. Gone the mastering of perspec-

tive, three dimensions, movement, expression. Gone the subtlety of color, the sophistication of the drawn line, the artistic sensibility and unending creativity of the Aurignacian, Gravettian, Solutrean, and Magdalenian people. The beginning of a new era.

◆

The last cave I wish to share with you is Bernifal. Perhaps the most secretive and magical of the five, it gives us another opportunity to linger a little longer in the wake of Magdalenian times.

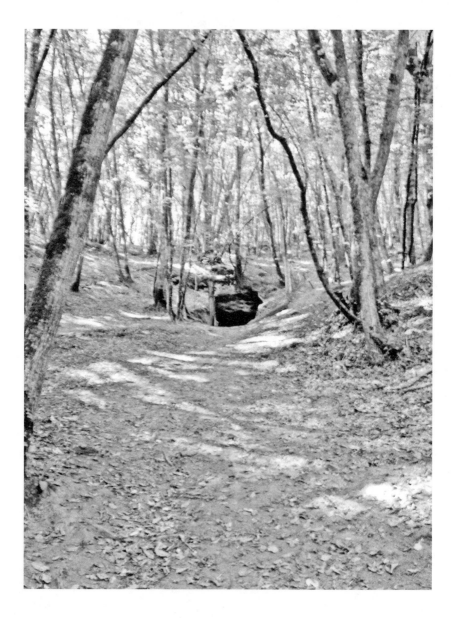

Bernifal, cave entrance

Bernifal

B ernifal cave, our fifth venture, is situated in the Petite Beune Valley about 6 kilometers east of Les Eyzies. The walk from the road to the entrance is already a delight: a distance of approximately half a kilometer through hornbeam woods, among which are scattered maple trees and large oaks. The beauty of hornbeams is not only in their lacy, light green foliage but in the fact that the ground beneath them remains clear of bush and thorn, like a grass garden carpeted with thick moss, wild primroses in the spring, and all sorts of mushrooms in the autumn. The cliffs bordering the path to the left, after a steep climb, were used during historic times for shelter. Farther along, a small golden valley curves away to our left. No matter how gray and cloudy it might be, the delicate green leaves somehow always diffuse a permanent, lingering glow. In the heat of summer, it is surprisingly cool, despite the lightness of the foliage. In autumn, the path is illuminated by myriad shiny acorns and yellow leaves, and the potent smell of humus and moss is strong on our tongues. Mosses appear in all their voluptuous phosphorescence come winter, when the fallen leaves become dark and slip-

pery. Wild boars come here by the dozen to feast on the acorns and plow the soft earth in search of grubs, their abundant traces turning the ground into a battlefield as we near the entrance.

The path curves gently to the right, but instead of following it, our steps lead us to the left, and suddenly there it is before us: a dark hole up on the hillside among the tall trees, with a small, unhinged iron gate in front, modestly announcing this to be the cave. The short climb can be treacherous, the earth covered with leaves hiding knobby, slippery, protruding roots. Once in the snug shelter entrance, we discover a solid iron door protecting the sanctuary. As soon as it's opened, the cool air gusts out from within, sharpening our senses, which are already alert with anticipation and stimulated by the pungent scent of the damp earth framing the entrance.

The cave art was discovered by Denis Peyrony in 1902. At that time, the original entrance was blocked off and filled with sediment, and the only access was an opening situated a little farther up on the hillside: a 6-meter vertical shaft that dropped the first visitors directly onto the floor of the first room, only a few meters from the original shelter entrance. Today, we enter by the Paleolithic arched entrance cleared in 1936. It is a relatively small cave, only 90 meters long, but decorated from the entrance onward, which is not often the case, and, even more unusually, with rarely depicted subject matter.

There is less for us to see in this cave than in the others. In 1984 Alain Roussot observed 53 figures: 24 mammoths, largely predominant here, 7 horses, aurochs and bison together adding up to 7, deer and ibexes adding up to 3, 1 wild donkey, and 9 undetermined animals. There are also 2 anthropomorphic figures, 4 hands, 11 tectiforms, and 26 other signs. Agheda and Denis Vialou reported a total of 110 figures, figurative and nonfigurative together, about 60 of which are engravings. This inventory needs to be completed. It is important once again to remark upon the fact that all four caves described in this account have in common a large percentage of mammoths, horses, and bison, as well as tectiforms. It becomes apparent that all four are thematically linked, despite the individual character of each site.

At first glance, the art seems less impressive, less spectacular than that at the sites seen so far, but what we are about to discover will prove to be fascinating for different reasons. The figures are harder to distinguish, being at times inconveniently situated in nooks and corners and frequently thickly

coated with calcium carbonate. As they are less profuse, as many as possible will be mentioned, whatever their condition. The owner, Yvon Pémendrant, a youthful 80-year-old farmer, accompanies us, his stooped back distorted by the heavy battery he has had to carry in with him all these years. For there is no electricity in the cave. Over the many years we have known each other, he has learned how I like to present the work, in which order, and without the usual faulty interpretations that might distract our attention. He obviously loves the cave. Our mutual admiration and respect for the site has forged a quiet, unspoken friendship.

◆

As soon as we enter, we are in another world. The air, always at the same temperature, 11.5 degrees Celsius, seems harshly cool on our skin during the hot summer months and comfortably warm in the winter. Earthy smells linger, magnified by the humidity. Glistening walls and puddles shine in the dark, haphazardly lit by the one flashlight while it is being plugged into the portable battery deep inside Yvon's bag. The cave, much larger than one would imagine from the narrow entrance, is alive with growing stalagmites and stalactites, wet pillars, dripping folds. The sound of water drops fills the darkness. The natural colors are amazing: all sorts of shades of iron oxide impregnate the rock, from pale to deep yellows, from pinks to bright ocher reds, and there is the dark bluish-black of manganese, in streaks or in broad patches. The white of calcium carbonate illuminates the cave walls, in either a thick, soft, woolly-looking cover or in a hard, translucent sheen. The ground is intact, apart from some sand and gravel along the central path. Dusty, dark gray calcium carbonate coats the floor, with its glossy smoothness inter-rupted here and there by slow-growing stalagmites. One of these, to our right, is starred with glowing crystals.

The first images are immediately to our left: two finely engraved hands, side by side. Examples of negative and positive handprints exist in caves, but these are the only two engraved ones ever to be found. The hands are slen-der, the size of an adult's. Other lines are visible on the calcified wall sur-face, but it is unclear what they represent. Throughout the cave are drawn or engraved lines that aren't understood, because they are badly preserved, partially destroyed, or masked by thick calcium carbonate. It is also possible that some are deliberately unintelligible, as I suspect might be the case to

a certain degree in all the caves. We shall concentrate on the recognizable figures.

Virtually opposite the engraved hands are two others, on the right side of this first chamber. Both are black manganese negative prints, one above the other, but with the color applied differently: on the one below, the contours of the fingers appear to have been boldly drawn or brush-painted, whereas the other is in a cloud of diffused pigment, clearly spray-painted. Some simple vertical stick lines lie to the right of these. Three techniques are thus assembled for these four hands, which because of their proximity I suspect are interrelated.

Back to the left side of the chamber, just beyond the engraved hands, are an aurochs's neck and head, with the horns pointed toward the entrance. It is a simple, rather thick, black outline: a profile view of the head and eye, combined with a three-quarter view of the horns. This reminds us of the "twisted perspective" we saw in Font de Gaume, and which is particularly characteristic of Lascaux. If we relied only on stylistic conventions to establish the work's age, we would think that this aurochs was around 17,000 or 18,000 years old—the age of Lascaux, but today there is more circumspection about the estimated dates of specific graphic options and their possible interactions. It is generally agreed that the art in Bernifal is Magdalenian, more precisely Middle Magdalenian, but there is room for conjecture, and much older dates may be attributed one day to this cave, as to others.

Immediately after the black aurochs, there is a spectacular three-dimensional bison's head in red (Fig. 27). It, too, is facing the entrance, but it is much larger, perhaps even larger than life, with 50 centimeters between horn and nose alone, and it is part of a huge fold in the rock. The eye and curved horns are delineated in red. The forehead, nose, and muscular cheek follow the rock shapes, but there also appears to be additional fashioning of the three-dimensional prominence: the protruding rock surface was sculpted at the level of the forehead in order to accentuate a voluminous, hairy brow. It is exceptional to find any kind of carved modification of the wall surface inside caves, almost as though it were sacrilege to do so. This is the first, but not the last, in this cave: another is on the opposite wall, and more are farther inside. Within the bison's head, superimposed on the horn, is the contour of a small mammoth, also facing left and in red, with its stomach and hind leg

adapted to the shapes of the wall. Another red line, crossing the mammoth's back, might suggest the superimposition of another animal. Close above are more mammoths in the folds of the limestone, one of which has a large dot of an eye added in black.

And this is where we make a magical discovery.

Directly to the right of the mammoth is a small face, so unexpected that it almost appears to be an optical illusion, a trick of our imagination. Before us is one of the most moving visions of all cave art: a realistic face looking straight out at us from the wall. A small portrait, only 19 centimeters high, outlined in black, with delicate features: expressive eyes with arched brows, the nose centered on a slight fold, two dots for the nostrils, the mouth and jaw barely visible, but definitely there. These show up best within the shadows of the wall in the dimmest of lighting. The hair could be up in a bun— or is it a cap of some kind? A few lightly engraved lines mark the separation between it and the top of the head. Those lively eyes seem to be looking into ours through the glazed calcified coating of the wall, part astonished, part questioning (Fig. 28).

I have noticed how silent viewers are at this moment, each to his or her own thoughts, depending on their mood and sensitivity. For all, without exception, this is an unforgettable encounter.

That searching look seems to echo our own, as though a mutual curiosity is linking us to the past in a tangible way at last. We can identify with this, an expressive human face, someone just like ourselves. We are in direct contact with our ancestors here, there's no doubt about that, and all of a sudden we would like to have the answers, all the answers, to our unending questions. There is magic in this moment, and frustration. Is this a woman or a young man? The narrow face and hairdo remind me of another portrait, which is almost exactly the same: the famous 25,000-year-old portrait described above, found in ivory statuette form in Dolni Vestonice (Czech Republic).

What is he, or she, doing here, in a world of codified symbolic expression, where humans are so rarely depicted in their true appearance? What special circumstances could account for this exceptional participant?

Reluctantly turning away, we are in for another surprise: a bear is depicted on the opposite wall. It is just above the black negative handprints. Its whole body, which is in natural relief, covers a length of about 80 centi-

meters, the head and neck are stretched forward toward the inside of the cave, the ears among a few bumps, shoulder, back, and possibly bent fore-legs following the rock shapes (Fig. 29). An eye, nose, and mouth have been added in black manganese, with another straight line branching up and down from the mouth. Here again, there is sculpted modification of the wall surface: a deep line is hollowed out under the throat, giving more volume to the neck. An approximately 60-centimeter panel of parallel, vertical, black stripes covers the bear's rear half and continues along the wall to the right.

It is exceptional that a bear should be found so close to the entrance, but then so much is unusual in this first small chamber: the engraved hands, the sculpting of the wall to enhance the bison and the bear, the bear figure itself, the face.

Farther along on the left, a cloud of more than 30 broadly sprayed black dots, plus some smaller, more dispersed red ones, form a compact group. Standing back to look at them, one can't help but notice how, right there, the cave wall takes on the shape of a huge, larger-than-life bison or, more likely, aurochs, standing on the ground. The back line is there, the body is concave but appears to be convex with less light; but most impressive and realistic of all are the belly, the two front legs in perspective, the folds of a heavy dew-lap hanging loosely, the neck and the head, all in relief. Massive and three-dimensional, it can't be missed. Everyone can see the animal, yet it's not ac-knowledged by all as such because certain details, such as the eye and horns, don't seem to have been depicted. One should, of course, always be cautious and not jump to conclusions when a natural shape looks just like an animal. We should be wary of what might be a trick of our imagination and always search for the human touch, either engraved or in color, that will testify that a shape was actually "recognized" at the time and included as a part of what was being expressed. What then about those dots that happen to cover the body at neck and shoulder level? Is it a coincidence that they are there? I don't think so. I'm certain that if I can see the aurochs so clearly, it would have been even clearer to the Magdalenian artist, and that those dots are related to that "seen" animal for a good reason, either making a decorative or a symbolic contribution to the animal or, perhaps, attracting the viewer's attention.

The cave now widens into a large chamber, and the ceiling soars up above us, magnificent, colorful stalactite formations hanging in graceful

folds, taking on all sorts of shapes, from fine needles to thick, layered pillars. Stalagmites litter the ground, some white with glistening crystals. A setting fit for an opera, imaginary mythological ventures, legendary tales. Straight ahead lies a small circular cavity, naturally bright red with ocher, with bears' claw marks on the sides: this was once a cave bear's lair. To the right of it, a concentrated series of tiny black dots forms a small—barely 10 centimeters long—diagonal line underneath a ridge, practically out of view.

Another sign—one solitary black mark—lies hidden about 5 meters above our heads, on the side of a slender stalactite. It could be described as a dot or as a short line, dark and clear and deliberately painted there. And yet it is completely invisible from ground level. What could possibly have inspired the artist to go to so much trouble, building a ladder or scaffolding to reach that high amid the chaos of rock formations, for such a modest contribution, too high to be seen from below?

◆

A low passage lies before us, leading to the right, toward the narrowest part of the cave, densely filled with art. Just before it, a glossy stalagmite, about 70 centimeters tall, stands in the way. The perfectly central and isolated position of this formation, its glowing smoothness and sculptural, balanced, upright oval shape, make it especially remarkable. So appropriately placed, so tempting. I can't help comparing it with the polished phallic lingas so often encountered on my southern Indian travels. It would be natural to touch it before ducking down to go through the tight passage before us, an almost spiritual, ritualistic gesture that would seem to be perfectly in tune with the whole experience; but, of course, we must restrain our impulse to touch anything in the cave. Just to the right of the stalagmite, under a low horizontal overhang, is a small mammoth facing right, drawn in black; here again, the artist altered the limestone, first scraping it to obtain a flatter, more regular surface, before cleverly drawing the animal around the few remaining natural bumps. The mammoth is virtually hidden from sight; one has to crawl underneath and lie down to see it.

Careful not to touch the ceiling with our backs as we go through the low, vaulted passage, we find ourselves in a narrow gallery, filled with engravings, including seven tectiforms and seven mammoths. Here, in the most confined section of the cave, is the greatest concentration of art, for the most part in

poor condition. Immediately to our left is a complex, grid-shaped sign, followed closely by two tectiforms, deeply incised, side by side, slightly overlapping. Such geometric tent-shaped signs, also observed in Font de Gaume and Combarelles, are found as well in Rouffignac and La Mouthe, sites all within a short distance of one another. Most of the seven tectiforms in this small chamber have a stereotypic shape, consisting of five vertical, parallel lines for the central pillar, on either side of which multiple subparallel oblique lines create a "roof" or "pine tree" effect. Each is about 17 centimeters across. Unlike those seen in the other caves, practically none of those in Bernifal has a horizontal base. Among those with a base are two incised side by side and overlapping, on a mammoth just to our right on the opposite wall (Fig. 30).

Next to the two tectiforms on the left-hand wall, there is a small—only 17 centimeters long—wild donkey facing to the left, with two pointed ears and legs that seem to be prancing along, its long tail flicking. It's a lively creature, certainly a donkey, not a horse, because of its big ears and the absence of a mane. This species is hardly ever fully depicted. Decidedly, Bernifal is full of surprises.

A pointed, beaklike protrusion follows immediately to our left, with a shallow ocher-colored concavity, 10 centimeters wide at most, holding a complex, confused design; among the fine lines, one can just about distinguish a star-shaped sign, possibly with terminal circles on each branch, plus a few other diagonal lines. The smooth shape of the rock doesn't look completely natural here: it might have been partly sculpted or polished.

Some red lines and simple engravings continue on the same left-hand side—a bison, a horse, a mammoth, a tectiform—but most noticeable are two triangular signs of the same size and shape. With horizontal bases 20 centimeters long, they are deeply engraved, one above the other. The lower one is thickly covered with calcium carbonate and only partly visible, whereas the upper one is clear and superimposed on a tectiform. Its symmetric proportions and rounded corners make it special. Particular care was obviously given to its execution, the equilateral sides carefully measured and angles rounded, as opposed to the easier solution of leaving them pointed. The calculated shape effectively makes this motif appear important. The fact that there are two of them emphasizes this.

On the right side of the passage the majority of the cave's known fig-

ures appear in a complex maze of interacting engraved lines, including four mammoths, three of which are engraved on the tender limestone surface beneath a ledge protruding at shoulder level. For the relatively limited available space, these are large, about 67 centimeters long. The first two overlap, and the third is close behind, all facing left and endowed with large, curved tusks, well-defined eyes, and excellent proportions. The one behind, which is the closest to the narrow passage we have just come through, has the two superimposed tectiforms mentioned above, each with a base (Fig. 30). Above its back is a small triangular sign with rounded corners similar to the two already described, except for the base, which isn't connected to the sides: it has the aspect of a hut or igloo. A multitude of fine lines are interwoven, striations representing mammoth hair, as well as other figures, most of which are difficult to identify.

A fourth mammoth, drawn in black, is underneath the one farthest to the left. Beneath the group of mammoths, in a small concave space close to the ground, is an engraved bison, facing left, with particularly well-defined hindquarters and legs in perspective; it has an unusually pronounced round belly, and, on its foreleg, there is a small oval sign, interpreted by some as a vulva symbol. Farther to the right, also practically at ground level and close to the passage we just came through, is a small, delicately engraved deer facing right, neck stretched up and head lifted, as if calling; its front legs in perspective are superb, with detailed joints, musculature, and hooves. This representation in particular gives us an idea of how precise and detailed the engravings might have been originally—just as fine as those in Font de Gaume and Combarelles. A pair of hind legs, too far away to be part of the deer, no doubt belong to another animal. Just beneath, there is a small engraved horse. And higher up, the head of an indeterminate animal facing right.

Still on the right-hand wall, to the left of the mammoths and facing in their direction, are a small horse and many other lines. One can easily see the single engraved line for the tail, the curved back line, the proudly held head and neck. It couldn't be more simplified, yet there it is, as clear as can be!

This whole area deserves to be studied and described, centimeter by centimeter—a difficult task, in view of the poor condition of the partially eroded engravings, further defaced by graffiti. The rock is like sandstone here, crumbling away at the lightest touch. The fine engravings are fragile,

vulnerable. What a shame that here, where the lines are the most delicate and where there is imagery in profusion, there is hardly any calcite to protect the art. Many more figures are before us, caught up in a maze of tangled lines, but few of them are identifiable.

The intimacy of this passage now gives way to a spacious, perpendicular gallery leading off to the left. But before we go in that direction, let's make a short dead-end turn to the right: some red figures that are difficult to identify and several finely engraved ones, including an elegant horse. In front is either another horse or a bison facing left, depending on how one interprets the series of parallel lines on the back: a horse's mane or a bison's hump? I see it as a bison. Before we pursue our exploration and follow the gallery that lies before us to our left, we can't help but notice a low, dark red, alcoved space immediately opposite us. It has no directly visible figures. But if you crawl in on all fours, after twisting into a narrow side passage, you will discover four parallel, vertical lines grouped on the right, virtually out of sight. The lines are thick and uneven, painted in black; just in front of them, even harder to see, are two longer ones. Strange, these bold lines tucked away in such an inaccessible, secretive corner. When compared with the delicate engravings, they are crude, incongruous, all the more mysterious and impressive.

◆

The cave widens, and the ground slopes downward, toward what seems like impenetrable darkness. Sculptural mineral shapes cast shadows on both sides as we move. Thick white calcite coats the wall to our left, like bulging cauliflowers. Reddish markings might well indicate paintings hidden underneath.

In the dark, out of view to our left, is a vertical 9.5-meter shaft. I've been up there. It is the most difficult cave climb I've ever undertaken: slippery, clay-coated walls, with no obvious cracks or ledges to secure one's hold. I nearly gave up after several attempts, as others had before, thinking of accounts that I knew to be true of sprained or broken ankles in the undertaking. But, from above, Yvon encouraged me on, and finally, with a strong grip, he pulled me up the last meter. Then, sitting on a comfortable ledge, still shaking from the effort, I was rewarded by a masterpiece. A superb mammoth drawn on the alcoved ceiling's curved, smooth surface. Dipping three fingers into some nearby red clay, the artist had outlined the mammoth in

a single sweeping gesture, rendering the rounded shapes to perfection. The finest mammoth I have ever seen, and from that moment onward one I most cherish, along with the chubby youngster on Rouffignac's Great Ceiling.

I don't remember well whatever else is there—another large mammoth to the right of the red one, outlined in black, and a face staring out from a deeper end of the shaft—as this central figure eclipsed the rest. Being so close to those simple lines, I could identify with the hand, the gesture, the expert at work. The intelligence behind it. The sense of beauty guiding the hand.

Down on the cave's floor again, the path slopes down steeply into what seems to be the heart of the cave: a spacious subcircular room with a high ceiling soaring above. To the left of the descent, the irregular walls have multiple traces of pigment, including two well-defined figures, each in its separate protective niche: a mammoth on the right and a small ibex on the left, both outlined in black, both facing left.

A practically horizontal calcified disk looms above our heads as we finally arrive on the flat ground of this last vast chamber. The majestic beauty of the cave is even more striking here. This is where the colors and volumes vary the most, from white to the deepest reds, from the finest forms to monumental ones. Magnificent stalagmites of all sizes stand solitary or in organ-like series; crystalline, beaded points glitter high above, like shining gems or stars; folds hang heavily or form delicate meanders, some in translucent reds; huge sculptural shapes emerge from the walls, ridged, gnarled, swollen with ungainly protrusions; and even more mysterious are the dark crevices, the secret nooks and corners. The glistening walls metamorphose into imaginary landscapes and huge creatures as the light shifts.

As we stand in the center of this huge chamber, the very heart of the cave, only one image attracts the eye: a red tectiform to our right. The bright color is most noticeable at first, then the intriguing shape. Blurred by overlying calcite, the details are not clear, but the contours remain perceptible: a 20-centimeter base, a 14-centimeter-high central pillar transversed by a central horizontal line, a "roof" linked to the base by two vertical lines on each side. Just like a "house" that we would draw. Small half-circles inwardly festoon the roof and base. Infrared photography has revealed that the red lines consist in reality of hundreds of tiny red dots in rows. Far more complex than the other tectiforms, does this example really belong to the same category

of signs? I find that many nonfigurative designs are rather too conveniently locked into groups without sufficient justification, groups that don't in fact cohere. Should tectiforms with and without bases be put in the same category, for instance? The base might be a significant, distinguishing feature, for all we know. Straight lines or rows of red points could be another.

We saw the same pointillist technique used for two red tectiforms in the Font de Gaume cave, a factor that links the two caves, along with the predominance of the mammoth-horse-bison trio.

A short row of tiny, close red points is arranged horizontally to the left of the tectiform and another diagonally underneath, practically touching it; a long vertical red line flows upward from the point of the "roof."

Here, the high, isolated position of the symbol stresses its importance further. There is no other figure around. It stands out against the wall, far above our heads. Beneath it is a sort of platform, built up with piled stalactites, in turn sealed by calcite, which could bring a climber to the level of the tectiform. The solid foothold looks as though it was meant to stay, unlike the temporary scaffolding usually used in caves for the higher figures. Is it contemporaneous with the tectiform or more recent? If it is of the same period, what purpose did it serve? What could have been staged here so close to the tectiform: man, object, or some special visual illusion caused by the flickering light? Or could it have been for sound: a high position for better tonality or resonance throughout the cave, so that sounds were harder to identify in the dark, and all the more awesome? It is too theatrical a setting for us not to imagine some kind of performance or event staged here.

The tectiform is not placed just anywhere. It is exactly facing the dark mouth of a passage on the opposite side of the chamber: a tortuous, narrow passageway slanting upward. Inside are figures. But before we enter it, there is something else worth discovering: to the left, sticking out over a small, high ledge, is the tip of a fine flint blade, long and delicate. The angle at which it lies, its high position, completely out of reach, and the fact that it is just at the mouth of the passage—and pointing toward it—all contribute to the idea that it was deliberately placed there. Objects have been found placed similarly in other caves: shells, bones, and stones hidden in cracks or corners, like secret offerings.

The public is not allowed into this bowel-like passage; it is far too dan-

gerous. But it's a strategic part of the cave and related to the rest, no matter how well hidden away, which is why it is important to know what's inside.

Several treacherous meters of climbing along the passage, over a sheer drop, bring the visitor to four mammoths and a human profile. First, to the right, is the human head, facing toward the far end, engraved on a vertical slice of rock protruding from the sculptural wall: the forehead, nose, and mouth are all natural, adapted to the smooth rock outcropping, and a few simple engraved lines have been added to finish the nose, give the mouth a smile, and indicate an eye. It reminds me of one of Rouffignac's jovial faces. The top of the head loses itself within the ripples of the rock, like wavy hair. The passage narrows and is virtually obstructed by prominent horizontal ridges to each side, which practically join in the center. Symmetrically arranged on the underside of each ridge—on the roof of the protrusions—are two engraved mammoths. It is hard to see them, because of their inconvenient position, but they are superb. Farther along on the right is another engraved mammoth, then a fourth on the same side, drawn in black and of lesser quality. Four disorderly engraved lines are directly above.

On the way back to the main chamber, the red tectiform is clearly visible, straight ahead on the distant opposite wall, perfectly placed, exactly in the perspective of the narrow passage I'm edging through. This is probably what explains the isolated position of the sign: it is strategically related to the difficult passage, effectively linking it to the main chamber.

Like a glowing torch, showing me the way.

The last figures we will see are two mammoths situated about 6 meters high on the ceiling. The surface above is relatively smooth, dome-shaped amid the profusion of pillars and stalactites, and with a natural circular splash of deep-red ocher in its center. The mammoths, simply outlined in black, face away from each other and almost seem to be supporting this central mass of red on their backs. I've never heard them described in this way, but that is how I see them. Indeed, why not? Is it a coincidence that the mammoths frame part of that large red stain with their sloping backs?

Why would anyone go to so much trouble—building scaffolding to get up to that height—for these two relatively modest figures, completely out of view for anyone using the kind of lighting Cro-Magnons had at the time? Once more, no answers can be offered, but the effort involved is enough to

dispel the idea of random composition. It could be that the red-colored zone itself is the essential element, central and smooth, standing out against the surrounding turmoil of massive, tortuous rock shapes and calcified folds.

Red. I have noted the powerful presence of the color red at many sites. It can be in the natural ocher-red coloring of pillars, walls, or pools, which might be reason enough to influence the choice of certain caves over others. It can be in the form of bright markings and stains, strategically placed on walls or pillars. It can exist as a statement on its own, sometimes grossly splashed or violently projected onto cave walls, in total contrast to nearby, delicately painted figures. It's as though it were taking possession of the cave, like a warning to the viewer. In these cases, red ocher is no longer a simple medium or a partner in the art, it is an entity on its own. As though the color itself has power.

The cave continues, narrowing to a small passage. First, though, on the spacious left wall of this main chamber, is a sign: the diffused shape of an omega, thickly traced in black, with a black stain underneath, both lost in the irregularities of the rock. Under a low overhang to the right, an unidentified animal is drawn in black, completely out of sight; the only way to see it is to lie down in the mud and squeeze under, on one's back.

There is nothing more for us to see. There are no further figures, apart from a few black dots on the right of the confined passage ahead, a simple sign, which might be a way of indicating that nothing else lies beyond. We have already seen that many caves have simple terminal motifs that seem to mark the end of the section holding the imagery, even those with the most abundant or elaborate series of figures.

How extraordinary that the rare figurative elements in this huge main chamber are so dispersed and out of view, either too low, too high, or in the folds of a difficult passage. Only the tectiform is visible from all sides.

◆

The return to the entrance appears to be easy and surprisingly quick. The cave is short, yet it seems as if we've been here for ages. Time and distances are relative in caves. This sense of intemporality is perhaps meant to be part of the experience, one of the reasons why caves were chosen in the first place.

Darkness and shadows fill the space around us, the walls and ceiling no

longer visible, intangible. The sound of water dripping from stalactites is all the more perceptible. The longer we stay, the more we become aware of the musicality of the place, anticipating the next drop, the acuteness of our perception adjusted to our mood of the moment, to our own inner music. We can hear our own breath.

Did they, the Magdalenians, hear the same? Were they quiet like us here today, or were they noisy, exuberant, possibly playing music, chanting, talking, beating the ground with their feet? Without extrapolating one way or the other, we can be certain that they had a more acute ear than we, saturated as we are with noise today. In Senegal, I remember walking with a young Bassari man in the hills around Etiolo, and, as we made our way along the track, he was talking with a friend on the next hillside, without raising his voice at all. The quietness of African village people in their everyday lives always astonishes me; I don't remember ever hearing a child cry, or a parent shout at one, for that matter. How different we must seem to them: loud and conspicuous, impolite even, however hard we try to fit in and go unnoticed. It's certain that Cro-Magnon's hearing was more acute and subtle, through necessity tuned in to natural sounds, but also capable of discerning the most subtle of intonations in their complex forms of communication. Another example comes to mind as I write: in the same region of Africa, just before dawn one day, a distant group of singing women could be heard moving through the forest, informing the population of the death of a member of the community; the soft polyphonic modulations of the voices, seemingly repetitive yet with infinitely subtle variations, rang gently through the forest like a dream, over distances far and wide, for all to hear. The forest, still cloaked in night's darkness, became alive in a timeless, magical way. Just as, today, the cave vibrates with our breathing.

This leads me to another point: was the art intended to be seen? It is now thought that it was meant to be seen by very few, if at all. Recently discovered caves, where great care has been taken to avoid trampling on the soil, show few traces of human visitors. In Chauvet, for instance, ancient bear bones—which date back to before the 32,000-year-old paintings—litter the ground, but there is little evidence that they were trodden on. Some caves, on the contrary, hold multiple Paleolithic footprints, by the hundreds in the case of the Réseau Clastres in Niaux (Ariège), but it is not known whether they

were made on one unique occasion or at several times. Often, the prints are those of children or adolescents, which has led people to imagine youth initiation rites, but that presumption ignores the fact that children's prints are more likely to be found than those of adults simply because adults keep to a designated path, whereas youngsters tend to wander off the beaten track and dart around corners, thus leaving isolated, and better preserved, traces. The impression given by those prints I have had the privilege of seeing is more playful than solemn: in the Réseau Clastres of Niaux cave, for instance, are footprints of two children walking side by side; in the clay-coated Montespan cave (Haute-Garonne), alongside innumerable hand- and footprints, are what appear to be clay pellets, carelessly, joyfully, thrown around.

The idea of ceremonial rituals involving many people is automatically abandoned wherever spaces are confined or galleries are narrow, as at Combarelles. Yet we have also seen chambers that display a definite sense of staging. And some paintings were deliberately distorted or changed in order to create the right proportions when seen from a specific viewpoint. In Cougnac (Lot), for instance, one can see an attempt to rectify the curved belly line of a red male megaloceros so that it seems correct to a viewer approaching it from the right-hand side; and in Lascaux, high paintings are deliberately distorted in order to be seen correctly from below, at floor level. Michelangelo did the same in the Sistine Chapel. Someone was meant to see these, even if it was only one person.

There is always the possibility that the act of creating the images was enough on its own, and that the figures were not meant to survive the "event," as is common in many populations. The inhabitants of Vanuatu, for example, have no wish to preserve the magnificent masks and objects designed for special rituals, even though they spend months making them. In Brazil, certain Amazonian societies burn their costumes and masks as soon as the events that inspired them are over.

Nevertheless, seeing the time span that the art in certain caves covers—several thousand years for Font de Gaume and Combarelles and even longer for others, such as Cougnac and Pech-Merle—it seems more likely that these were spiritual places, meant to last, perhaps serving as indelible references for past and present populations, possibly a cohesive bond between distant peoples, or between the living and the dead. A sacred place lying in the dark,

which people knew about. It need not necessarily be seen or visited, but could as well be mentally communed with from a distance. Similar beliefs and practices, associated with correlative telepathic faculties, exist in various cultures around the world—those inherent to Australian aboriginal practices, for instance.

◆

Throughout, we have observed how closely related are the figures to the shapes of the walls, how cleverly the art—how could anyone consider this as anything other than art!—achieves a symbiosis between the animals and the cave itself—between the mineral world (the cave, the pigments), the elements (air, firelight, water, earth), and living creatures. Our Western way of rationalizing the world tends to draw a line between the living and the mineral, whereas, in reality, a rock, a tree, an insect, an animal, and a human are all basically constituted of the same elements; very little differentiates them. This fundamental understanding has been overshadowed by the concept of *Homo sapiens*'s superiority over all creatures, including animals and other human forms. Reconstitutions of human evolution have represented early humans as coarse and hairy—Neanderthals, for instance—and have undermined large apes' faculties, though we are at last beginning to measure their mental complexity. *Homo sapiens* is at the top. Instinct, considered to be an animal quality, is opposed to intelligence, considered to be human, whereas the two are clearly interdependent. A French biologist and philosopher whom I greatly admire, Michel Serres, recently described animal instinct as "an accomplished (perfected) intelligence," implying that human intelligence needs yet to mature.

Perhaps this is why humans are creatively searching for their way.

I can't resist comparing again these Paleolithic art forms with more recent ones. The intimate interaction between the cave and its imagery reminds me, incongruous as it might seem, of the Land Art Movement of the 1960s, when there was a strong impulse to bring to light man's interdependence with nature. Outdoor installations made people aware, for the first time, that we need to find a balance if we wish to survive. The positive dynamics between the art, the environment, and the viewer's presence eventually had a strong impact on ecological politics. Those were, of course, different times and different situations, and the pressures and priorities were

obviously not the same, but could it be that there was a similar universal need for harmony, equilibrium, and peace of mind, triggered in modern times by urgent ecological issues and in the past by the necessity for spatiocultural cohesion?

◆

In all the caves, we've admired the liveliness of the animals and seen how important it was to show them as individuals: young and old, male and female, breathing, moving, interacting, very much alive. The sophisticated tricks that the artists conjured up to convey perspective, motion, and individual expression tell us that the transcription of life itself was an essential aspect of the meaning, a motivation valued on its own, alongside other symbolic implications inherent in the closely controlled subject matter. How else can one explain the inventive effort expended on trompe l'oeil effects, the equivalent of which did not appear again until the Renaissance?

The painstaking adaptation of the figures to the rock furthermore shows how closely cave and animals are locked together, the three-dimensionality of the cave being complementary to the spirit of the figures, or vice versa. . . . Is it the animal that brings the cave to life, or the cave that gives life to the animal?

Leaving aside just for a moment all possible complex interpretations, the sensitive manner in which the animals are depicted shows the immense respect and admiration the artists had for them, not only for the power each might hold but for their beauty as well. We are left with a strong, persistent, general impression of a sort of ideal communion among all, interacting, interwoven. A positive, utopian vision of the world, perhaps, either the real world or the spiritual, or both. Remember how peaceful the scenes seemed, how healthy the animals, how amenable and even joyful their attitudes, with only a few exceptional, and debatable, examples of possible animosity.

The symbiosis, of course, naturally includes humans, although in a veiled way: self-represented physically in the form of modest, caricatured, or incomplete anthropomorphic figures, and more indirectly present in the transcription of a multitude of signs. Infinitely human, indeed, are all the nonfigurative motifs: a codified language made up of dots, grids, triangles, squares, crosses, circles, flowing lines, lines in series, combinations of all kinds, including extreme simplifications of figurative subject matter. The

conceptual mind behind abstraction and symbolism is exclusively human, infinitely human—as is the artist's touch and savoir faire, the quality of line and color. What could be more representative of the sensitive, creative human mind than the art before us?

More physically tangible are the painted hands and meandering finger tracings and the mysterious objects placed deliberately in obscure corners. These are deeply moving, as are the inadvertent physical traces, the foot- and handprints, the finger smudges, the artists' material left behind, a solitary palette, extra color, tools, lamps, or the remains of a meal.

The strain and effort put into each venture fill each cave with humanity, the vital energy and motivation still somehow lingering on, palpable.

Lastly, there is the eye of the viewer: theirs, yours, and mine. We, too, are modestly part of it all.

The underground and the outer world are here together; the mineral world and living creatures are also together, without antagonism, in harmony. Figurative representation and abstraction interwoven. The visible and the hidden, interdependent. It's art that makes it possible. Shamanism, totemism, animism? Or beliefs we have no idea of. There is no way we can know the cosmogony, myths, stories, or spirituality of Paleolithic societies. We might as well abandon such ambition and simply learn to look at the art for what it is, and enjoy it, measure its multiple facets, its complexity, the intelligence and sensibility of the artists, and imagine the quality of the cultural groups these were part of, populations capable of supporting, valuing, and appreciating such refinement.

If one thing has slowly become clear to me over the years, after traveling far and wide and being so involved with Paleolithic art, it is the existence of a timeless, universal appreciation of beauty. Whatever the aesthetic criteria of the moment or the place, however conditioned it is by specific cultural standards and traditions and by differences in individual experience, an exceptional work of art is acknowledged not only by the local, directly implicated social group but also by open-minded viewers of totally different cultural horizons. Whether the perfect Russian icon, the Vermeer, Braque, or Giacometti, a Buddha's expression—the statue of the Kmher Jayavarman 2 in the National Museum of Cambodia!—these rarities are recognized by all as universal masterpieces, prized above all because they are endowed with

some undefinable inspiration and because they emit a mysterious, deeply satisfying, transcendent form of harmony.

What moves us today, whether for aesthetic or mystical reasons, also touched these Paleolithic artists. I'm certain of this. Stylistic conventions, techniques, cultural motivations may vary over time, but a certain expression, a perfect line, a balanced composition, a particular shade of color can lift our spirit today, as it did then. Beauty is spiritual.

◆

There's no stopping on the way back to the entrance of Bernifal, except for one irresistible moment. A last glimpse of the small face again. Just enough time to look into those startled, inquisitive eyes again, to penetrate the wall's surface beyond its hard, calcified crust, to enter into communion with this vision of the past. That surprisingly familiar person before us, one of our most ancient ancestors. We steal a few more lingering instants, time enough to be one with the rock walls, the air, the familiar odor, the wetness, and the sounds of the cave. Under its spell, we are reluctant to leave the sanctuary, the animals and signs all wrapped around us.

We must come to terms with the fact that we'll never know what this is all about, that the true meaning will remain secret, far beyond the visible. The vast, complex variability of past and present cultures has taught us that much. We are left with bright, subtle, extraordinary imagery, and with pervasive emotions and intuitions, to each of us our own. We must trust our impressions.

At last we are ready to step out into the open again. To unlock the iron door, and, our eyes squinting in the sudden light, to breathe in the outer world, the tall trees, the rustling leaves, the buzzing insects, the earthy smells. We are grateful for the long walk through the woods, which draws us slowly away from the cave and all it holds. Under the hornbeam trees, the soft light has shifted and evening shadows have lengthened. We savor each step in silence, until we get to the bubbling Beune waters, which joyfully bring us back to the present, just before we reach the road.

Afterword

Sadly, Yvon Pémendrant is no longer with us. His brother, Gilbert, younger by a few years, has replaced him for the visits of Bernifal cave.

Exciting news was reported in June 2009: a bone flute dated to at least 35,000 years was discovered at Hohle Fels cave in the hills west of Ulm, Germany. The preserved portion of the flute, made from a griffon vulture bone, is more than 21 centimeters long, includes the mouth end of the instrument, and has five fingerholes. This is the oldest known musical instrument. Experts say that it could be as old as 40,000 years!

A few years before, a three-holed flute of mammoth ivory was found nearby, as well as two other flutes made of swan wing bones.

Hohle Fels cave had already made front-page headlines in September 2008, with the discovery of a small ivory Venus statuette less than 2.5 centimeters high. It has large round breasts, broad buttocks, an oversize vulva and no feet; in the place of the head there is a ring, suggesting that it was a pendant. It has the same graphic features as the Gravettian Venus figurines, and yet it has been dated to at least 35,000 years, meaning 10,000 years earlier.

Appendix

Paleolithic cave art and excavation sites open to the public (all authentic except for Lascaux II and the Roc des Sorciers center) and museums exhibiting Ice Age tools, bone work, and portable art

The five major shelter and cave art sites described in this book

GROTTE DE FONT DE GAUME, GROTTE DE COMBARELLES, and ABRI DE CAP BLANC

The ticket office for all three sites is at the same address: Grotte de Font de Gaume, 24620 Les Eyzies. Telephone +33(0)553066800, fax +33(0)553352618, fontdegaume@monuments-nationaux.fr.

Open all year except Saturdays and January 1, May 1, November 1, November 11, and December 25. May 15 to September 15, 9:30 AM–5:30 PM; September 16 to May 14, 9:30 AM–12:30 PM and 2:00–5:30 PM.

Note: Advance booking is strongly advised as each visit is limited to twelve people in Font de Gaume and to six in Combarelles. For all three sites, some tickets may be available at the entrance of Font de Gaume at 9:30 AM, but these sell out quickly during the high season.

I particularly recommend the bookshop of the ticket office at the Font de Gaume for its extensive choice of reading material on Paleolithic art.

GROTTE DE ROUFFIGNAC

24580 Rouffignac-St-Cernin. Telephone +33(0)553054171, fax +33(0)553354471, grottederouffigna@wanadoo.fr, www.grottederouffignac.fr.

Open July 1 to August 31, 9:30–11:30 AM and 2:00–6:00 PM; Easter Sunday to June 30 and September 1 to October 31, 10:00–11:30 AM and 2:00–5:00 PM.

GROTTE DE BERNIFAL

24220 Meyrals. Telephone +33(0)674963043.

Open June 1 to September 30, 9:30 AM–12:30 PM and 2:30–6:30 PM.

Other decorated caves, shelters, excavation sites, and museums
in and around Les Eyzies and elsewhere in the Dordogne

MUSÉE NATIONAL DE PRÉHISTOIRE

For its remarkable collection of Paleolithic stone tools, portable art (including decorated bone and antler objects from La Madeleine), carved stone blocks, adornment, lamps, skeletons, etc.

24620 Les Eyzies. Telephone +33(0)553064545, fax +33(0)553064567, mnp.eyzies@culture.gouv.fr, www.musee-prehistoire-eyzies.fr.

Open July and August, 9:30 AM–6:30 PM; June and September, 9:30 AM–6:00 PM; October to May, 9:30 AM–12:30 PM and 2:30–5:30 PM. Closed on Tuesdays except in July and August.

ABRI DE CRO-MAGNON

Site of the discovery (and namesake) of the first Paleolithic *Homo sapiens* skeletons.

24620 Les Eyzies. In the open, for all to see freely. Next to the Hotel Cromagnon.

ABRI DU POISSON, LAUGERIE-HAUTE, LA MICOQUE, LA FERRASSIE, and LE MOUSTIER

Abri du Poisson is the site of a carved salmon under a cliff shelter; the others are excavation sites.

Booking and tickets at the entrance to Font de Gaume (see above). Laugerie-Haute and Abri du Poisson, every Tuesday at 10:00 AM or on request. La Micoque and La Ferrassie, every Tuesday at 2:30 PM or on request. Le Moustier, every Thursday at 10:00 AM during French school holidays or on request.

ABRI PATAUD

Excavation site, museum, and carved ibex.

24620 Les Eyzies. Telephone +33(0)553069246, fax +33(0)553061314, contact@semitour.com, www.semitour.com.

Open July and August, 10:00 AM–7:00 PM; April to June and September, 10:00 AM–12:30 PM and 2:00–6:00 PM; February, March, and October to December, 10:00 AM–12:30 PM and 2:00–5:30 PM. In February, March, and October, only groups with prior reservations, on Fridays and Sundays. Closed in January and on Saturdays, except in July and August.

GROTTE DE BARA-BAHAU

Cave art.

24260 Le Bugue. Telephone/fax +33(0)553074458, grotte-bara-bahau@hotmail.fr.

Open July and August, 9:30 AM–7:00 PM; February to June, 10:00 AM–noon and 2:00–5:30 PM; September to December, 10:00 AM–noon and 2:00–5:00 PM; closed in January.

ABRI REVERDIT, ABRI CASTANET, ABRI ROC D'ACIER, ABRI LABATTUT, and ABRI LA SOUQUETTE

Abri Reverdit is the site of a rock shelter with animal carvings; the others are excavation sites.

All are grouped at the same address in the Vézère valley: Site de Castel-Merle, 24290 Sergeac. Telephone +33(0)553507970 or +33(0)553537778, fax

+33(0)553507479, castelmerle24@aol.com, www.prehistoirepassion.com/Castel%20Merle.htm.

Open July and August, 10:00 AM–7:00 PM; Easter to June 30 and September, 10:00 AM–noon and 2:00–5:30 PM, except Wednesdays.

Note: I highly recommend a visit to René Castanet's remarkable private museum at the same address (tools, carved stone blocks, beads, etc.). For this, prior booking is necessary.

GROTTE DU SORCIER

Cave art.

24260 St Cirq. Telephone +33(0)553071437, fax +33(0)553085671.
Open March 1 to November 11, 10:00 AM–6:00 PM.

MUSÉE DU PÉRIGORD

24000 Périgueux. Telephone +33(0)553064070, fax +33(0)553064071, musee-perigord@wanadoo.fr, www.ville-perigueux.fr.

Open April 1 to September 30, 10:30 AM–5:30 PM; October 1 to March 31, 10:00 AM–5:00 PM; Saturdays and Sundays year-round, 1:00–6:00 PM, closed on Tuesdays and holidays.

GROTTE DE VILLARS

Cave art.

24530 Villars. Telephone +33(0)553548236, fax +33(0)553542173, contact@grotte-villars.com, www.grotte-villars.com.

Open July and August, 10:00 AM–7:30 PM; April to June and September, 10:00 AM–noon and 2:00–7:00 PM; October, 2:00–6:30 PM.

GROTTE DE LASCAUX II

Facsimile of Grotte de Lascaux.

24290 Montignac. Telephone +33(0)553519503, fax +33(0)553508283, contact@semitour.com, www.semitours.com.

Open in July and August, 9:00 AM–8:00 PM; April to June and September, 9:30 AM–6:30 PM; October, 10:00 AM–12:30 PM and 2:00–6:00 PM;

February, March, November, and December, 10:00 AM–12:30 PM and 2:00–5:30 PM; closed in January, closed on Mondays in the low season.

Important: between Easter and the end of September, tickets must be purchased at the office in the center of Montignac.

Other decorated caves in France

GROTTES DE COUGNAC

46300 Gourdon. Telephone/fax +33(0)565414754, grottes.de.cougnac@wanadoo.fr, www.grottesdecougnac.com.

Open July and August, 10:00 AM–6:00 PM; April to June and September, 10:00–11:30 AM and 2:30–5:00 PM; October and November 1, 2:00–4:00 PM; closed on Sundays.

Special note: this is one of my favorite caves, and it is not far from Les Eyzies.

GROTTE DE PECH-MERLE

46330 Cabrerets. Telephone +33(0)565312705 or +33(0)565312333, fax +33(0)565312047, info@pechmerle.com, www.pechmerle.com.

Open April to November 4, 9:30 AM–noon and 1:30–5:00 PM.

Special note: As this cave is closely related—culturally and artistically—to the abovementioned Cougnac cave, I recommend seeing both, one after the other.

GROTTE DES MERVEILLES

L'Hospitalet, 46500 Rocamadour. Telephone/fax +33(0)565336792, contact@rocamadour.com.

Open July and August, 9:30 AM–7:00 PM; April to June and September to November, 10:00 AM–noon and 2:00–6:00 PM.

GROTTE DE GARGAS

65660 Aventignan. Telephone +33(0)562397239, fax +33(0)562397618, contact@gargas.org, www.gargas.org.

Open July and August, 10:00 AM–noon and 2:00–6:00 PM; September to June, 10:00 AM–noon and 2:00–5:00 PM.

GROTTE DE NIAUX

09400 Niaux. Telephone +33(0)561051010 or +33(0)561058837, sesta3@wanadoo.fr, www.sesta.fr.

Open July and August, 9:00 AM–5:45 PM (last visit); September to June, 10:30 AM–4:15 PM (last visit); closed December 25, January 1, and Mondays from November to the end of March.

GROTTE DE BÉDEILHAC

09400 Tarascon-sur-Ariège. Telephone +33(0)561059506, fax +33(0)561051315, contactgrotte@clubinternet.fr, www.grotte-de-bedeilhac.org.

Open July and August, 10:00 AM–5:30 PM (last visit); April to June and September, visits at 2:15 and 5:00 PM, with an extra visit on Sundays at 3:15 PM; October to March, Sundays at 3:00 PM.

GROTTES DE ISTURITZ AND OXOCELHAYA

64640 Saint Martin d'Arberoue. Telephone +33(0)559296472 or +33(0)559470706, fax +33(0)559473017, cromagnon@grottes-isturitz.com, www.grottes-isturitz.com.

Open July and August, 10:00 AM–1:00 PM and 2:00–6:00 PM; June and September, 11:00 AM, noon, and 2:00–5:00 PM; March 15 to May 31 and October 1 to November 15, 2:00–5:00 PM and, on holidays, 11:00 AM.

GROTTE DE PAIR-NON-PAIR

33710 Prignac-et-Marcamps. Telephone/fax +33(0)557683340, www.monum.fr.

Open for visits at 10:00, 10:45, and 11:30 AM, 2:30, 3:30, and 4:30 PM; between June 15 and September 15, there are extra visits at 12:30, 1:30, and 5:30 PM; closed Mondays, January 1, May 1, November 1, November 11, and December 25.

Other museums

MUSÉE D'AQUITAINE

33000 Bordeaux. Telephone +33(0)556015100, fax +33(0)556442436, musaq@ mairie-bordeaux.fr, www.mairie-bordeaux.fr.

Open 11:00 AM–6:00 PM all year except Mondays and holidays.

PARC DE LA PRÉHISTOIRE

Near Niaux and Bédeilhac caves; for the museum and the facsimiles of the cave art in Niaux, which is inaccessible to the public.

09400 Tarascon-sur-Ariége. Telephone +33(0)561051010, sesta3@ wanadoo.fr, www.sesta.fr.

Open July and August, 10:00 AM–8:00 PM (ticket office closes at 5:30 PM); April to June and September to November 7, 10:00 AM–6:00 PM (7:00 PM on weekends and holidays); closed on Mondays September to May except during school and national holidays.

ROC-AUX-SORCIERS

Facsimile of the 20-meter sculpted frieze of Roc-aux-Sorciers.

86260 Angles-sur-l'Anglin. Telephone +33(0)810699771, info@roc-aux-sorciers.net, www.roc-aux-sorciers.com.

Open July and August, 10:00 AM–12:30 PM and 1:30–7:00 PM; April to June and September to early November, 10:00 AM–12:30 PM and 1:30–6:30 PM, closed on Mondays and Tuesdays except during school holidays; February, March, mid- to late November, and December, 1:30–5:30 PM on Sundays and school holidays only; closed after Christmas holidays until January 31.

MUSÉE DES ANTIQUITÉS NATIONALES

Edouard Piette's remarkable collection of portable art and ornaments and the famous carved blocks from the Roc de Sers and the Roc-aux-Sorciers at Angles-sur-l'Anglin.

78105 St Germain-en-Laye. Telephone +33(0)139101300, culturel.man@ culture.gouv.fr, www.musee-archeologienationale.fr.

Open May to September, Saturdays, Sundays, and holidays, 10:00 AM–6:15 PM, other days, 9:00 AM–5:15 PM; closed on Tuesdays and on Mondays except for groups with advance bookings.

MUSÉE DE LA PRÉHISTOIRE LE MAS D'AZIL

09290 Le Mas d'Azil. Telephone +33(0)561699722, fax +33(0)561699926, info@sesta.fr, www.sesta.fr.

Open June 1 to August 3, 10:00 AM–noon and 2:00–6:00 PM; April, May, and September, 2:00–6:00 PM and, on Sundays and holidays, 10:00 AM–noon; March, October, and November, Sundays, 2:00–6:00 PM; closed December to February.

MUSÉE DE LA PRÉHISTOIRE DE TAUTAVEL

66720 Tautavel. Telephone +33(0)468290776, fax +33(0)468294009, contact @tautavel.com, www.tautavel.com.

Open July and August, 10:00 AM–7:00 PM; April to June and September, 10:00 AM–12:30 PM and 2:00–6:00 PM; October to March, 10:00 AM–12:30 PM and 2:00–5:00 PM.

MUSÉE DE PALÉONTOLOGIE HUMAINE DE TERRA AMATA

06300 Nice. Telephone +33(0)493555993, fax +33(0)493899131, www.musee-terra-amata.org.

Open all year, 10:00 AM–6:00 PM; closed on Mondays, December 25, January 1, Easter Sunday, and May 1.

◆

General advice: for the cave visits, because of their restricted opening times and limited number of visitors per visit, it is wise to avoid the tourist months of July and August.

I also highly recommend the magnificent cave art sites in Spain, most of which are just across the border, on the northern Cantabrian coast: Covalanas, El Castillo, Las Monedas, Chufin, Hornos de la Peña, El Pendo, El Pindal, Altamira II (for its remarkable facsimile and museum), and, farther south, Tito Bustillo and La Pileta.

Recommended Reading

Anati, E. 1989. *Les origines de l'art et la formation de l'esprit humain*. Paris: Albin Michel.

Animalia. 2007–2008. Exhibition catalogue. Paris: Musée Dapper.

Archambeau, M., and C. Archambeau. 1989. *Les Combarelles*. Périgueux: Fanlac.

Au fil de la parole. 1995. Exhibition catalogue. Paris: Musée Dapper.

Aujoulat, N. 2002. "La grotte ornée de Cussac." *Bulletin de la Société Préhistorique française* 99: 129–137.

————. 2005. *Lascaux: Movement, Space, and Time*. New York: Abrams.

Bahn, P. G., and J. Vertut. 1997. *Journey Through the Ice Age*. Berkeley: University of California Press.

Barrière, C. 1997. *L'art pariétal des grottes des Combarelles*. Les Eyzies-de-Tayac: SAMRA Hors série Paléo.

Barthes, R. 1970. *L'empire des signes*. Geneva: Skira.

Bégouin, H., and H. Breuil. 1958. *Les cavernes du Volp*. Paris: Arts et Métiers Graphiques.

Bégouin, R. 1991. "Portable and Wall Art in the Volp Caves, Montesquieu-Avantes (Ariège)." *Proceedings of the Prehistoric Society* 57: 65–79.

Bégouin, R., and J. Clottes. 1981. *Apports mobiliers dans les cavernes du Volp*. Madrid: Altamira Symposium.

Bilot, A., G. Calame-Griaule, and F. Ndiaye. 2001. *Masques du Pays Dogon*. Paris: Adam Biro.

Bonfante, L., et al. 1990. *Reading the Past: Ancient Writing from Cuneiform to the Alphabet*. London: British Museum Publications.

Bordes, F. 1992. *Leçons sur le Paléolithique*. 2 vols. Paris: Presses du Centre National de la recherche scientifique.

Bosinski, G. 1990. *Homo sapiens.* Paris: Errance.

Bouvier, J.-M. 1977. *Un gisement préhistorique: La Madeleine.* Périgueux: Fanlac.

Breuil, H. 1952. *Four Hundred Centuries of Cave Art.* Trans. M. E. Boyle. Montignac: Dordogne Centre d'études et de documentation préhistoriques.

———. 1984. *Art des cavernes.* Paris: Imprimerie Nationale.

Brézillon, M.-N. 1968. *La dénomination des objets de pierre taillée: Matériaux pour un vocabulaire des préhistoriens de langue française.* Supplément 7. Paris: Gallia Préhistoire.

Buisson, D. 1990. "Les flutes paléolithiques d'Isturitz (Pyrénées Atlantiques)." *Bulletin de la Société Préhistorique Française* 87: 420–433.

Capitan, L., H. Breuil, and D. Peyrony. 1924. *Les Combarelles aux Eyzies (Dordogne).* Paris: Masson.

Capitan, L., and D. Peyrony. 1928. *La Madeleine, son gisement, son industrie, ses oeuvres d'art.* Paris: Publications de l'Institut International d'Anthropologie 2.

Chollot, M. 1964. *Collection Piette.* Exhibition catalogue, Musée des Antiquités Nationales. Paris: Editions des Musées Nationaux.

Chollot-Varagnac, M. 1980. *Les origines du graphisme symbolique: Essai d'analyse des écritures primitives en Préhistoire.* Paris: F. Singer-Polignac.

Clottes, J., and J. Courtin. 1996. *The Cave Beneath the Sea: Paleolithic Images at Cosquer.* Trans. M. Garner. New York: Abrams.

Clottes, J., et al. 2003. *Chauvet Cave: The Art of Earliest Times.* Trans. P. G. Bahn. Salt Lake City: University of Utah Press.

Cohen, C. 2003. *La femme des origines: Images de la femme dans la préhistoire occidentale.* Paris: Editions Belin-Herscher.

Conkey, M. W. 1984. "To Find Ourselves: Art and Social Geography of Prehistoric Hunter-Gatherers." In *Past and Present in Hunter-Gatherer Studies,* ed. C. Schrire, 253–276. New York: Academic Press.

———. 1996. "A History of the Interpretation of European 'Palaeolithic Art': Magic, Mythogram, and Metaphors for Modernity." In *The*

Handbook of Human Symbolic Evolution, ed. A. Lock and C. R.
Peters, 288–349. Oxford: Clarendon.

———. 1997. *Beyond Art: Pleistocene Image and Symbol.* San Francisco:
California Academy of Sciences.

Curtis, G. 2006. *The Cave Painters.* New York: Knopf.

Debenath, A., and H. Dibble. 1994. *The Handbook of Paleolithic Typology,*
vol. 1, *The Lower and Middle Paleolithic of Europe.* Philadelphia:
University of Pennsylvania Press.

Delluc, B., and G. Delluc. 1991. *L'art pariétal archaique en Aquitaine.* Paris:
Editions du Centre National de la recherche scientifique.

———. 1995. "Les figures féminines schématiques du Périgord."
L'Anthropologie 99: 236–257.

Delporte, H. 1990. *L'image des animaux dans l'art préhistorique.* Paris:
Picard.

———. 1993. *L'image de la femme dans l'art préhistorique.* Paris: Picard.

D'Errico, F., et al. 2003. "Archaeological Evidence for the Emergence
of Language, Symbolism, and Music: An Alternative
Multidisciplinary Perspective." *Journal of World Prehistory*
17: 1–70.

DeSalle, R., and I. Tattersall. 2008. *Human Origins: What Bones and
Genomes Tell Us About Ourselves.* College Station: Texas A&M
University Press.

Desdemaines-Hugon, C. 1993. "Les décors non-figuratifs du mobilier
osseux des niveaux du Magdalénien IV et V de la Madeleine
(Dordogne): Observations et comparaisons." *Bulletin de la Société
Préhistorique Ariège-Pyrénées* 48: 123–203.

———. 1999. "Art et fonction au Magdalénien: Les décors et biseaux des
ciseaux du Magdalénien supérieur de trois sites en Aquitaine:
La Madeleine (Dordogne), Le Morin (Gironde) et Rochereil
(Dordogne): Comparaisons et correlations." *Bulletin de la Société
Préhistorique Ariège-Pyrénées* 54: 141–220.

Dixon, E. J. 1993. *Quest for the Origins of the First Americans.* Albuquerque:
University of New Mexico Press.

Farris Thompson, R., and S. Bahuchet. 1991. *Pygmées? Peintures sur écorce
battue des Mbuti (Haut-Zaire).* Paris: Musée Dapper.

Fitzhugh, W. N., and S. A. Kaplan. 1982. *Inua: Spirit World of the Bering Sea Eskimo*. Washington: Smithsonian Institution Press.

Garcia, M. A. 1999. "La piste de pas humains de la Grotte Chauvet à Vallon-Pont-d'Arc." *International Newsletter on Rock Art* 24: 1–4.

Garcia, M. A., and H. Duday. 1993. "Les empreintes de mains dans l'argile des grottes ornées." *Les Dossiers d'Archéologie* 178: 56–59.

Geneste, J.-M., and H. Plisson. 1993. "Hunting Technology and Human Behaviour: Lithic Analysis of Solutrean Shouldered Points." In Knecht, Pike-Tay, and White, *Before Lascaux*, 117–135.

Gould, S. J. 1980. *The Panda's Thumb*. New York: Norton.

Griaule, M. 1966. *Dieu d'eau*. Paris: Arthème Fayard.

Johanson, D., and M. A. Edey. 1981. *Lucy: The Beginnings of Humankind*. New York: Simon and Schuster.

Knecht, H., A. Pike-Tay, and R. White, eds. 1993. *Before Lascaux: The Complex Record of the Early Upper Paleolithic*. Boca Raton: CRC Press.

Kozlowski, J. K. 1992. *L'art de la préhistoire en Europe occidentale*. Paris: Presses du Centre National de la recherche scientifique.

———. 1992. "The Balkans in the Middle Paleolithic and Upper Paleolithic: The Gateway to Europe or a Cul-de-sac?" *Proceedings of the Prehistoric Society* 58: 1–20.

Kozlowski, J. K., and M. Otte. 2000. "La formation de l'Aurignacien en Europe." *L'Anthropologie* 104: 3–15.

Lauber, W., et al. 1998. *L'architecture Dogon: Constructions en Terre au Mali*. Paris: Adam Biro.

Leroi-Gourhan, A. 1964. *Les religions de la préhistoire (Paléolithique)*. Paris: Presses Universitaires de France.

———. 1965a. *Treasures of Prehistoric Art*. New York: Abrams.

———. 1965b (rev. 1971, 1995). *Préhistoire de l'art occidental*. Paris: Mazenod.

———. 1982. *The Dawn of European Art: An Introduction to Paleolithic Cave Painting*. Trans. S. Champion. Cambridge: Cambridge University Press.

———. 1984. *Pincevent: Campement magdalénien de chasseurs de rennes*. Paris: Ministère de la Culture.

Levêque, F., and B. Vandermeersch. 1980. "Découverte de restes humains dans un niveau castelperronien à Saint-Césaire (Charente-Maritime)." *Academie des Sciences* D 291: 187–189.

Lévi-Strauss, C. 1958. *Anthropologie structurale.* Paris: Plon.

———. 1962. *La pensée sauvage.* Paris: Plon.

Lorblanchet, M. 1977. "From Naturalism to Abstraction in European Prehistoric Rock Art." In *Form in Indigenous Art: Schematisation in the Art of Aboriginal Australia and Prehistoric Europe,* ed. P. J. Ucko, 44–56. London: Duckworth.

———. 1995. *Les grottes ornées de la préhistoire: Nouveaux regards.* Paris: Errance.

———. 1999. *La naissance de l'art: Genèse de l'art préhistorique dans le monde.* Paris: Errance.

Marshack, A. 1991. *The Roots of Civilization: The Cognitive Beginnings of Man's First Art, Symbol, and Notation.* Rev. and expanded ed. New York: Mount Kisko, Moyer Bell.

La materia del lenguaje prehistorico: El arte mueble paleolitico de Cantabria en su contexto. 2006. Exhibition catalogue. Cantabria: Editores P. A. Cabal y R. O. Peredo.

Maureille, B. 2002. "La redécouverte du nouveau-né néandertalien Le Moustier 2." *SAMRA Paléo* 14: 221–238.

McLuhan, T. C. 1993. *Touch the Earth: A Self-Portrait of Indian Existence.* New York: Promontory.

Movius, H. L. 1975. *Excavation of the Abri Pataud, Les Eyzies (Dordogne).* Cambridge: Harvard University Press.

Page, S., and J. Page. 1982. *Hopi.* New York: Abrams.

Pfeiffer, J. E. 1982. *The Creative Explosion: An Inquiry into the Origins of Art and Religion.* New York: Harper and Row.

Piel-Desruisseaux, J.-L. 1990. *Outils préhistoriques.* Paris: Masson.

———. 2007. *Outils préhistoriques du galet taillé au bistouri d'obsidienne.* 5th ed. Paris: Dunod.

Piette, E. 1907. *L'art pendant l'age du renne.* Paris: Masson.

Plassard, J. 1992. "Reflexion sur l'art de Rouffignac." *L'Anthropologie* 96: 357–368.

———. 1999. *Rouffignac: Le sanctuaire des mammouths.* Paris: Seuil.

Plotkins, M. J. 1993. *Tales of a Shaman's Apprentice*. New York: Penguin.

Roussot, A. 1972. "Contribution à l'étude de la frise pariétale du Cap Blanc." Santander Symposium. Santander: Actas del Symposium Internacional de Arte Prehistorico.

———. 1984. "Abri de Laussel." In *L'art des cavernes: Atlas des grottes ornées paléolithiques françaises,* ed. A. Leroi-Gourhan, 167–169. Paris: Imprimerie Nationale.

———. 1994. *L'art préhistorique*. Bordeaux: Editions Sud Ouest.

Sauvet, G., S. Sauvet, and A. Wlodarczyka. 1977. "Essai de sémiologie préhistorique: Pour une théorie des premiers signes graphiques de l'homme." *Bulletin de la Société Préhistorique Française* 74: 545–558.

Sauvet, G., and G. Tosello. 1998. "Le mythe paléolithique de la caverne." In *Le propre de l'homme: Psychanalyse et préhistoire,* ed. F. Sacco and G. Sauvet, 55–90. Lausanne: Delachaux et Niestlé.

Sauvet, G., and A. Wlodarczyka. 2000–2001. "L'art pariétal: Miroir des sociétés paléolithiques." *Zephyrus* 53/54: 215–238.

Sawyer, G. J., and Deak, V. 2007. *The Last Human: A Guide to Twenty-Two Species of Extinct Humans*. New Haven: Yale University Press.

Sieveking, A. 1979. *The Cave Artists*. London: Thames and Hudson.

———. 1987. *A Catalogue of Palaeolithic Art in the British Museum, London*. London: British Museum Publications.

Taborin, Y. 1993. "Shells of the French Aurignacian and Perigordian." In Knecht, Pike-Tay, and White, *Before Lascaux,* 211–227.

———. 2004. *Le langage sans la parole, la parure préhistorique*. Paris: Le Seuil.

Tattersall, I. 1993. *The Human Odyssey: Four Million Years of Human Evolution*. New York: Prentice Hall.

———. 1995 (rev. 1999). *The Last Neanderthal: The Rise, Success, and Mysterious Extinction of Our Closest Human Relative*. New York: Macmillan.

———. 1998. *Becoming Human: Evolution and Human Uniqueness*. Orlando: Harcourt Brace.

———. 2002. *The Monkey in the Mirror: Essays on the Science of What Makes Us Human*. Orlando: Harcourt.

———. 2008a. *New Oxford History of the World,* vol. 1, *The World from Beginnings to 4000 BCE.* New York: Oxford University Press.

———. 2008b. "An Evolutionary Framework for the Acquisition of Symbolic Cognition by *Homo sapiens.*" *Comparative Cognition and Behavior Reviews* 3: 99–114.

Tauxe, D. 2007. "L'Organisation symbolique du Dispositif pariétal de Lascaux." *Préhistoire du Sud-Ouest* 15: 177–266.

Tixier, J., M.-L. Inizan, and H. Roche. 1980. *Préhistoire de la pierre taillée,* vol. 1, *Terminologie et technologie.* Paris: CREP. E. Durand.

Tosello, G. 2003a. *L'art mobilier dans le Périgord magdalénien: Espace symbolique, territoires culturelles.* Paris: Gallia Préhistoire.

———. 2003b. *Pierres gravées du Périgord magdalénien: Art, symboles, territoires.* Paris: Gallia Préhistoire.

Ucko, P. J., and A. Rosenfeld. 1967. *Palaeolithic Cave Art.* New York: McGraw-Hill.

Vandermeersch, B., and B. Maureille, eds. 2007. *Les Néandertaliens: Biologie et Culture.* Paris: CTHS.

Vialou, D. 1991. *La préhistoire: Univers des formes.* Paris: Gallimard.

———. 1998. *Prehistoric Art and Civilization.* New York: Abrams.

White, R. 1986. *Dark Caves, Bright Visions: Life in Ice Age Europe.* New York: Norton.

———. 1993. "Technical and Social Dimensions of 'Aurignacian-Age' Body Ornaments Across Europe." In Knecht, Pike-Tay, and White, *Before Lascaux,* 277–299.

———. 2003. *Prehistoric Art: The Symbolic Journey of Humankind.* New York: Abrams.

Zervos, C. 1959. *L'art de l'époque du renne en France.* Paris: Editions Cahiers d'art.

Index

Note: Numbers in **boldface** indicate photographs.